HISTORIC PHOTOS OF
NEW YORK STATE

TEXT AND CAPTIONS BY RICHARD O. REISEM

TURNER
PUBLISHING COMPANY

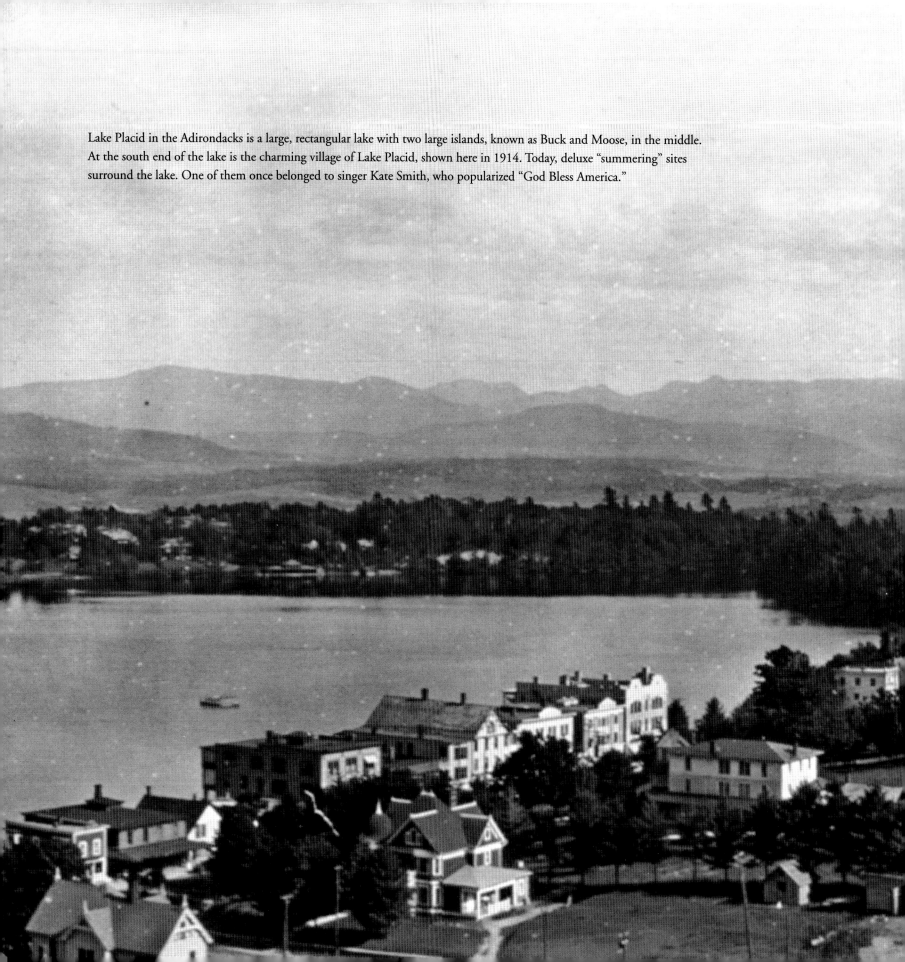

Lake Placid in the Adirondacks is a large, rectangular lake with two large islands, known as Buck and Moose, in the middle. At the south end of the lake is the charming village of Lake Placid, shown here in 1914. Today, deluxe "summering" sites surround the lake. One of them once belonged to singer Kate Smith, who popularized "God Bless America."

HISTORIC PHOTOS OF
NEW YORK STATE

Turner Publishing Company
200 4th Avenue North • Suite 950
Nashville, Tennessee 37219
(615) 255-2665

www.turnerpublishing.com

Historic Photos of New York State

Copyright © 2009 Turner Publishing Company

Library of Congress Control Number: 2008910974

ISBN-13: 978-1-59652-522-1

Printed in China

09 10 11 12 13 14 15 16—0 9 8 7 6 5 4 3 2 1

Contents

Acknowledgments..VII

Preface ...VIII

The Empire State
 (1850–1880) ...1

Age of Extravagance
 (1881–1916) ..13

Wine, Women, Want, and War
 (1917–1945) ...119

A Changing World
 (1946–1967)...189

Notes on the Photographs ...201

Storm clouds loom ominously over Niagara Falls in 1911. Sightseeing bulwarks are visible at the American Falls at lower left, with densely vegetated Goat Island situated above, another observation point that separates the two falls. A steamboat taking visitors toward the Canadian Falls is just visible at center-right. The rising mists are formed by plunging water striking the water and rocks below at great speed and volume.

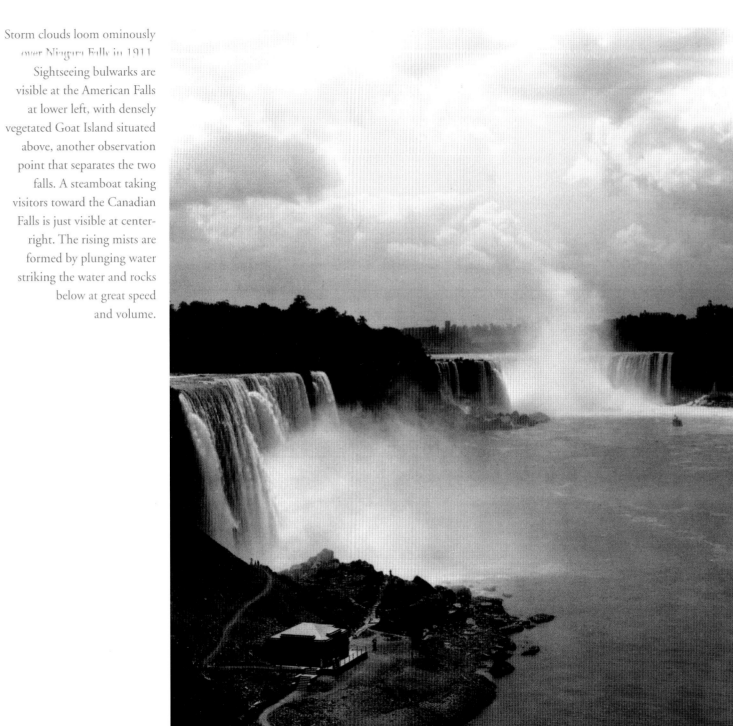

ACKNOWLEDGMENTS

This volume, *Historic Photos of New York State,* is the result of the cooperation and efforts of many individuals and organizations. It is with great thanks that we acknowledge the valuable contribution of the following for their generous support:

Library of Congress
National Archives and Records Administration
New York State Archives
Thomas Cox Collection

We would also like to thank the following individuals for valuable contributions and assistance in making this work possible:

Ralph Amdursky, Tamarack, Florida
Larry Barnes, City Historian, Batavia, New York
Sam Campanaro, Rochester, New York
Susan L. Conklin, Genesee County Historian, Batavia, New York
Grace Good, Chesterfield Town Historian, Keeseville, New York
Josef Johns, Rochester, New York
Sandra Maceyka, Johnstown, New York
Randi Minetor, Rochester, New York
David Minor, Pittsford, New York

With the exception of touching up image imperfections that have accrued with the passage of time and cropping where necessary, no changes have been made. The focus and clarity of many images is limited by the technology and the ability of the photographer at the time they were recorded.

PREFACE

New York is unique among the thirteen American colonies for having been a colony of two European countries, namely, the Netherlands and England. From 1609 to 1664, it was a Dutch colony called New Netherland. On August 29, 1664, New Netherland became New York. The history of New York, therefore, combines those two quite different cultures, and their impact is still evident today.

In 1609, the famous explorer Henry Hudson sailed from Amsterdam on behalf of the Dutch East India Company, in search of a northwest passage to Asia, which, if found, would be of great benefit to the Dutch trading company. Hudson sailed his ship, the *Half Moon,* up the deep, broad river that would later be named for him, riding the incoming ocean tide. But the tide stopped at a point that is now called Albany. From there on northwest, the river was not navigable.

All was not lost, however. Hudson claimed the river and the surrounding territory for the Netherlands, which set up a manorial system of colonization in America. This system established patroonships, which were giant private estates owned and managed by patroons. One of the first patroonships was that of Kiliaen Van Rensselaer, which covered a staggering more than one million acres. All of the farms, villages, and hamlets that formed in that enormous acreage reported to Van Rensselaer.

By the early 1660s, English colonies in America were seeking to expand their territories, and England's king, Charles II, gave his brother, James, the Duke of York and Albany, a grant to an area that included a good portion of New Netherland. The duke formed an invasion fleet, and the Dutch, with totally inadequate armed forces, surrendered at New Amsterdam. The duke renamed the city, New York.

Dutch ways, however, persisted after the English takeover. Today, Albany, the capital of New York State, still displays more historic Dutch architecture than anywhere else in the country. Dutch words have contributed to American English, including Santa Claus, sleigh, cookie, cole slaw, waffle, poppycock, dumb (for stupid), and many more. Place names to this day also preserve their Dutch originals, like Catskill, Rensselaer, Amsterdam, Rotterdam, and Staatsburg.

Although the Dutch extended their influence to the west along the Mohawk River, the English regarded western expansion seriously. France, with a colony in Canada, looked equally seriously at expansion into New York. A series of wars

with the French resulted in a firm British hold of the area now defined as New York State. After the Revolutionary War, a number of people in the new State of New York began to think about increased settlement of New York's heartland with its rich natural resources. The largest obstacles were the coastal mountain ranges and the dense forests beyond, which made travel to the interior difficult.

New York Governor DeWitt Clinton and others proposed a canal through the only relatively easy passageway, the Mohawk River Valley. The river itself was, for the most part, not navigable, but a canal with locks to overcome the changing elevation of the landscape could provide a smooth water highway across the entire state to Lake Erie. The idea of the Erie Canal was born. Without a penny of support from the federal government, which scoffed at the plan, it became totally a state project. No other government project, state or federal, had a more profound influence on our country.

The Erie Canal, built between 1817 and 1825, focused economic growth in New York State rather than in Canada, which bordered the navigable St. Lawrence River and Lake Ontario. The canal overcame prodigious obstacles to become a masterpiece of construction. It created the science of engineering in the U.S., which led to New York's predominance in the Industrial Revolution. And it transformed New York from a wilderness into the agricultural, industrial, commercial, and financial center of the country in the nineteenth century.

The enormous success of the Erie Canal led to the construction of a number of lateral canals—six of them in the first decade after the completion of the Erie and another four soon after. The Champlain and Oswego canals ran northward, and the others ran to the south, connecting vast parts of New York to the Erie Canal. By 1877, the New York canal system, which was the largest in the world, had an impressive 907 miles of canals with 565 locks.

The first U.S. president from New York State was Martin Van Buren. He became the eighth president and served from 1837 through 1841.

By 1850, where this book begins, photography existed, but it was practiced by the very few who learned its complex and cumbersome procedures. Early photographs in this book are daguerreotypes and wet glass-plates created by skilled craftsmen. Then in 1880, George Eastman in Rochester, New York, invented roll film, sheet film, and simple cameras. It is these photographs, made almost exclusively on Kodak film, that fill the following pages. The pictures are presented in chronological order of their being made, even though photos may contain subject material from an earlier time. Our text history of New York State also continues in the chapter introductions and photo captions. It is, as we hope you will find, a fascinating story.

—Richard O. Reisem

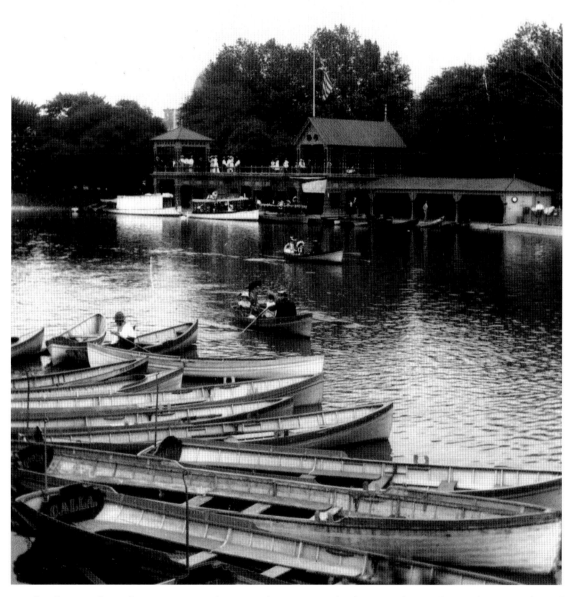

Frederick Law Olmsted, Sr. (1822–1903), America's preeminent landscape architect, designed many parks and city boulevards, but his most famous is New York City's Central Park, which he created beginning in 1856. This 1904 image shows the lake, near the south end of the 843-acre reserve. To this day, it is a popular place to rent a rowboat. Olmsted's purpose in park design was to provide the illusion of wilderness and peace in the midst of an urban environment.

THE EMPIRE STATE

(1850–1880)

In a speech to the New York State legislature, DeWitt Clinton said, "The canal, in reaching out to the Great Lakes, would pass through the most fertile country in the universe and would convey more riches on its waters than any other canal in the world. It remains for a free state to erect a work more stupendous, more magnificent, and more beneficial than has hitherto been achieved by the human race." Indeed, the Erie Canal created all that and more. New York City soared to become the leading center of transcontinental shipping and climbed to preeminence in communications, finance, law, population, and publishing. The western wilderness of New York became the most productive area in America. Vast forests yielded superior lumber, and the earth was mined for many riches. Wheat and other grains, fruits and vegetables, meat and dairy products all flourished.

Industrial growth was phenomenal. America's big guns were made in Watervliet, and Remington rifles and typewriters in Ilion. Men wore collars, cuffs, and shirts from Troy. Knitting mills in Cohoes and Utica clothed a worldwide population. Corn was grown in the Mohawk Valley to make brooms to sweep the world's carpets produced in Amsterdam. The best cheese came from Herkimer County. People dined elegantly with silver tableware from Oneida. Hydraulic cement from Chittenango kept underwater masonry intact. Salt from Syracuse preserved and flavored food around the world. Plaster of Paris was superseded by plaster of Camillus. Starch for collars and shirts was supplied by Auburn. Fairport provided baking soda. Rochester produced more flour than anywhere else on earth. Queen Victoria preferred Rochester flour. "It makes the best cakes," she said. Brockport introduced the McCormick reaper to the agricultural world. Medina sandstone built grand buildings in eastern American and European cities. The finest lumber that anyone had seen was harvested in western New York. And this is just the tip of the iceberg, since it covers just the path of the Erie Canal itself. The point is that the canal made New York the Empire State. Its size and productivity, its culture and influence, its power and wealth were unmatched anywhere in this period of the nineteenth century.

The second U.S. president from New York State was Millard Fillmore (1850–1853).

On April 20, 1861, a few days after the surrender of Fort Sumter to secessionist forces, a rally was organized in New York City to support the Union in the Civil War that was now certain. The organizers of the rally expected a small crowd, but more than 250,000 New Yorkers demonstrated. New York's involvement in the war dominated the manpower and resources of the state for the next four years. Mathew Brady from Lake George, New York, took on the job of photographing the war from the Union perspective. His and the photos of others appear in this section.

The Niagara River empties water from Lake Erie, moving it over the great falls to Lake Ontario on its way to the Atlantic Ocean. Three men in a boat ventured too close to Niagara Falls, losing control in the 25 M.P.H. current, and crashed into a rock. Two were thrown from the boat and carried over the falls to their deaths. In this 1800s daguerreotype, Joseph Avery managed for 18 horrible hours to cling to a jammed log before losing his grip and being swept over the brink. Today, accidents and suicides average one to two a week during summer months.

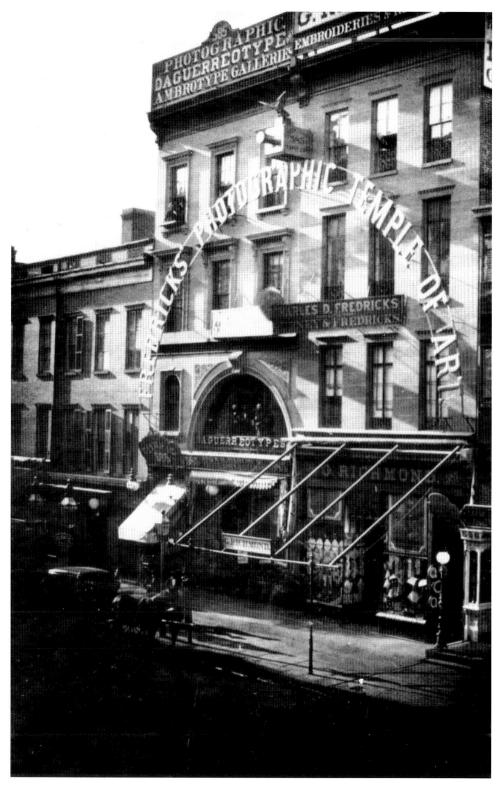

In 1839, the French painter Louis Daguerre invented the daguerreotype, a silvered copper plate that recorded an image in a camera. Portraits could be made provided the subject could sit still for several seconds. Fredricks' Photographic Temple of Art in New York City offered such a service around 1850 when this daguerreotype was made. In 1851, an Englishman invented the wet-plate process, and in 1884, George Eastman in Rochester invented roll film. Eastman's breakthrough made the story of photography a New York State story from then on.

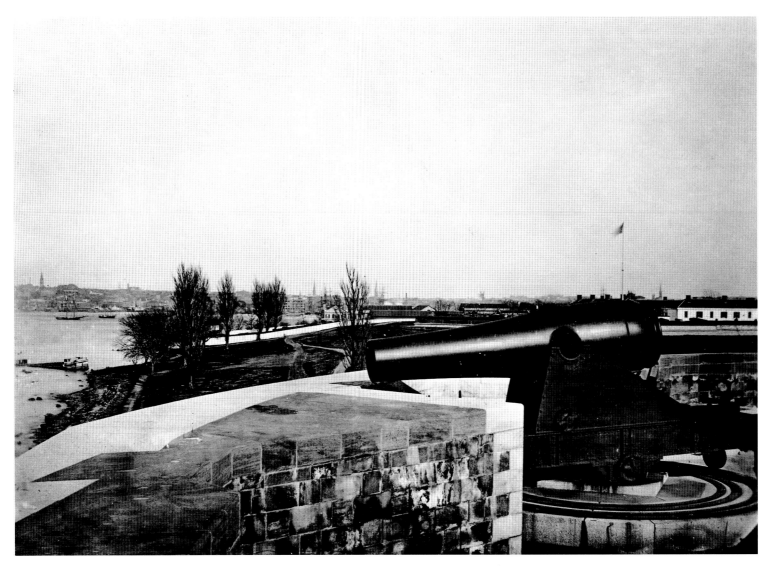

In New York's colonial days, Governors Island, off the tip of Manhattan, was once the home of the British colonial governors. Today, it is the headquarters of the First Army area of the United States Army. Naturally, such headquarters need protection, so there is a fort on the island, which was photographed here by Mathew Brady, the famous photographer of the Civil War.

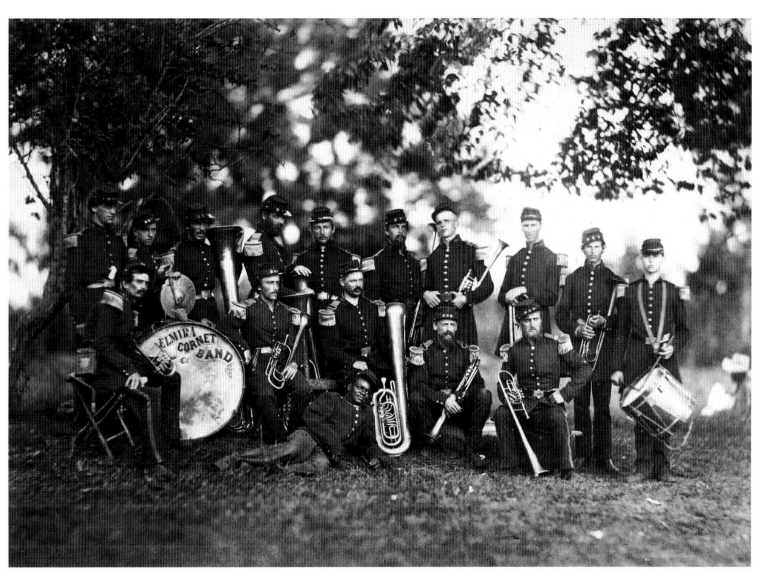

Sixteen young men from Elmira, New York, formed the Band of the Eighth New York State Militia. They were called into service in the 33rd Regiment of the New York State Volunteers and posed outside Arlington, Virginia, for a group photo in June 1861, with the U.S. Civil War looming before them. The First Battle of Bull Run would occur nearby just days away on July 21.

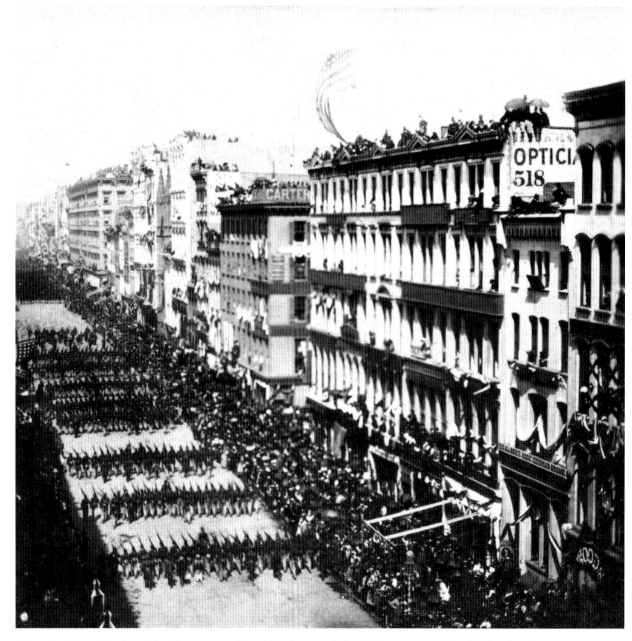

When President Abraham Lincoln was assassinated by the crazed, fanatic former actor John Wilkes Booth, on April 14, 1865, the nation was stunned in grief. New York City held a funeral for the great leader on April 25. It was accompanied by an elaborate procession down Broadway seen here with armed soldiers in military formation and crowds of mourners lining the broad avenue. Lincoln's body was placed on board a train that visited communities across New York State with enormous crowds paying respect at each location.

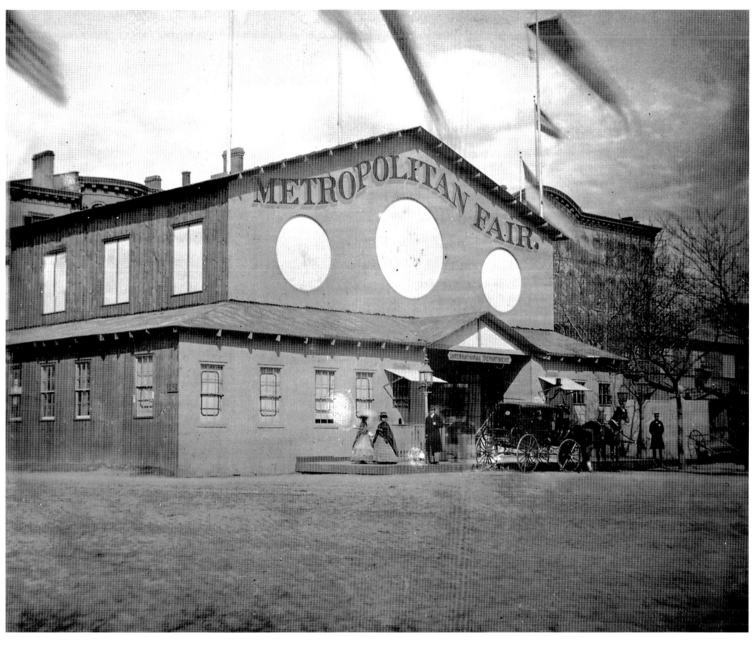

Fairs were popular in the nineteenth century. This photograph of the Metropolitan Fair at a New York location not known is attributed to Mathew Brady. Period dress dates the fair to before the 1870s.

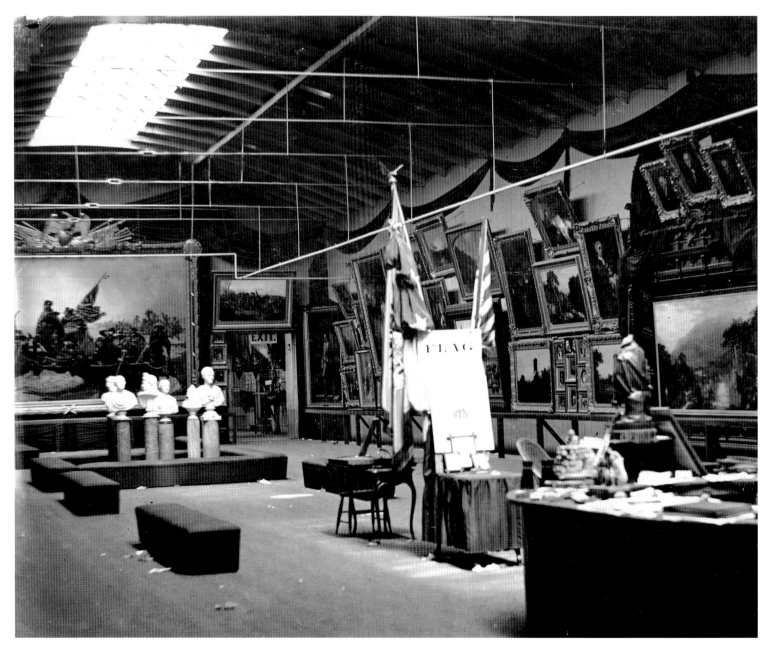

In the nineteenth century, exhibitions of American artwork drew large crowds to view paintings by significant artists and often to buy them as well. There was a customary charge to enter the exhibit. Behind the plaster busts is the famous oil painting *George Washington Crossing the Delaware,* completed in 1850 by the American artist Emanuel Gottlieb Leutze (1816–1868). On view today at the Metropolitan Museum of Art in Manhattan, the painting depicts General Washington leading boatloads of American troops across the Delaware River at dawn to surprise the British forces in the Battle of Trenton on the day after Christmas, 1776.

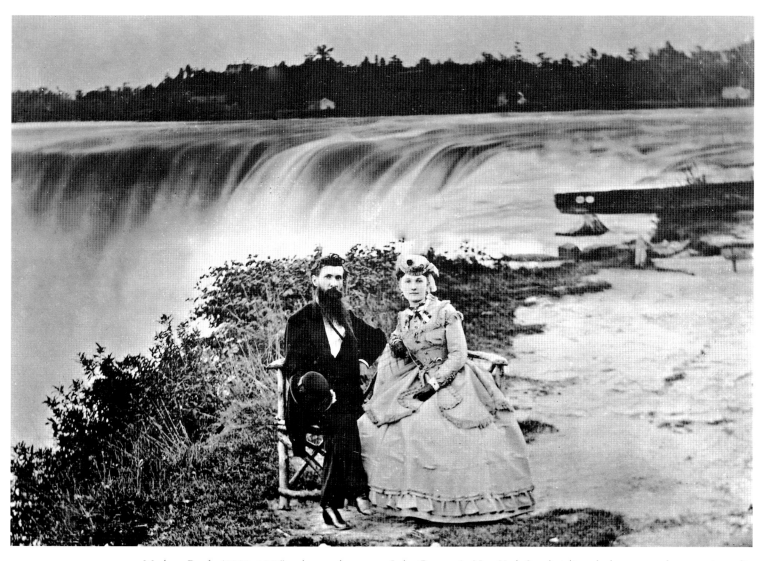

Mathew Brady (1823–1896), who was born near Lake George, in New York State's Adirondacks, operated a portrait studio in New York City. He ventured away from the studio as the need arose, here to Niagara Falls to photograph this Victorian couple at the edge of the impressive cataract. Nearly 45 million gallons of water flow over Niagara Falls every minute. The American Falls shown here are 185 feet high.

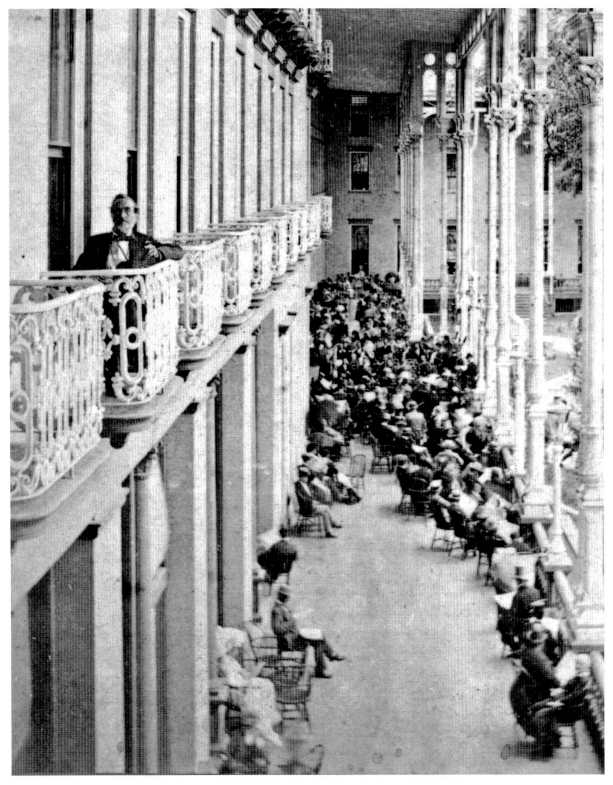

Saratoga Springs, New York was a summer playground for wealthy New Yorkers in the 1870s when this photograph was made. Thousands of visitors enjoyed the mineral springs, the casino gambling, and, of course, the horse races. Saratoga boasted 26,000 hotel rooms—the four largest hotels providing 6,000 of them. The Grand Union Hotel was one of the largest hotels in the 1800s. The rear piazza was covered to protect guests from rain and permit them to enjoy the air and the view across lawn and gardens.

Born in Manhattan (he popularized Gotham as a moniker for New York City), Washington Irving (1783–1859) was the famous author of *Rip Van Winkle, Life and Voyages of Columbus, The Legend of Sleepy Hollow, The Alhambra*, and a five-volume biography of George Washington. He wanted to live in a picturesque cottage and designed, with the help of his friend George Harvey, a Dutch-style cottage called Sunnyside on land that he purchased on the Hudson River near Tarrytown. Although the house was built in 1836, Irving attached ornamental iron numbers announcing a construction date of 1656, as fictional as his stories. Sunnyside still stands and is open to the visiting public.

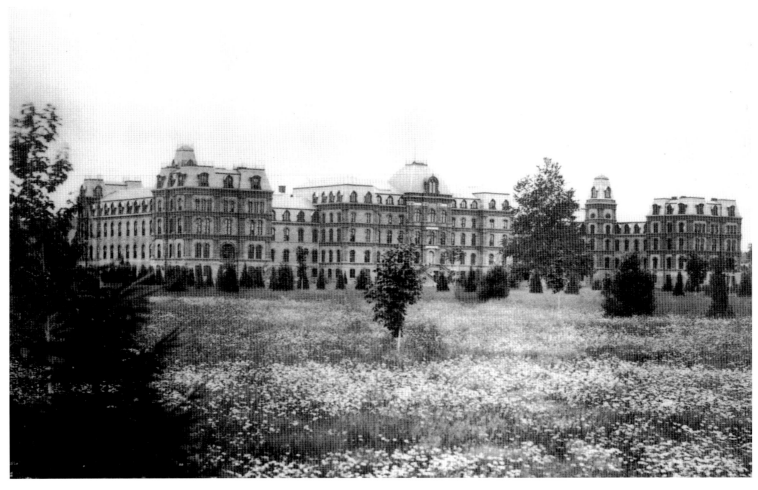

The Main Building at Vassar College, Poughkeepsie, in the Hudson River Valley, is a monumental, five-story Second Empire–style brick building that covers four acres. It was designed by James Renwick, Jr., and completed in 1864. When Vassar opened in 1865, the entire college was housed in this building: living quarters for students and faculty, dining hall, library, art museum, classrooms, offices, and more. Today the building is a National Historic Landmark.

AGE OF EXTRAVAGANCE

(1881–1916)

From the 1880s to the First World War was a period of conspicuous displays of wealth on one hand and abject urban poverty and cramped immigrant housing on the other. Photographs of both follow. Henry George (1839–1897), editor, activist, and author of *Progress and Poverty,* aptly expressed the mood of the period: "Get money—honestly if you can, but get money!"

The Astors, Goulds, Morgans, Rockefellers, and Vanderbilts all accumulated vast fortunes. In 1880, the financier Jay Gould (1836–1892) bought a famous mansion in New York—Lyndhurst, in Tarrytown, as a get-away from his Manhattan mansion. In summer, he commuted to work on his 150-foot yacht down the Hudson to his office on Wall Street. John Pierpont Morgan (1837–1913), banker, had a summer cottage with 52 rooms on the Gold Coast of Long Island. He amassed a renowned art collection, which he gave to the Metropolitan Museum of Art along with a wing to hold it. At his dock on Long Island Sound was his 343-foot yacht where he gave dinner parties for 250 people. He commuted to his office on Wall Street on his smaller steamboat, which employed a crew of ten men. Frederick William Vanderbilt (1856–1938), railroad tycoon, had residences in Manhattan, Newport, Bar Harbor, Palm Beach, the Adirondacks, and Hyde Park on the Hudson River. Alfred Gwynne Vanderbilt (1877–1915) selected a summer retreat in the Adirondacks. Called Camp Sagamore, the main three-story lodge on the 1,526-acre estate overlooked a beautiful lake. The complex included guest cottages, dining hall, boathouse, pump house, laundry, icehouse, casino, theater, workshops, blacksmith shop, carriage house, barns, and bowling alley with a loop-de-loop ball return.

Grover Cleveland from Buffalo became the 22nd and 24th U.S. president during 1885–1889 and 1893–1897. The 26th U.S. president, another New Yorker, was Theodore Roosevelt (1901–1909).

In 1901, the city of Buffalo staged a world's fair, called the Pan-American Exposition. At the turn of the century, Buffalo, with 350,000 people, was the eighth-largest city in the country. A distinguishing feature of the fair was the electric lighting provided by a power plant that generated electricity from Niagara Falls 25 miles away. The exteriors of most of the buildings were covered with thousands of light bulbs. It was at this fair that U.S. president William McKinley was assassinated by an anarchist, Leon Czolgosz. Later in this section, there is more about the fair and Vice-president Theodore Roosevelt's arrival to be sworn in as president.

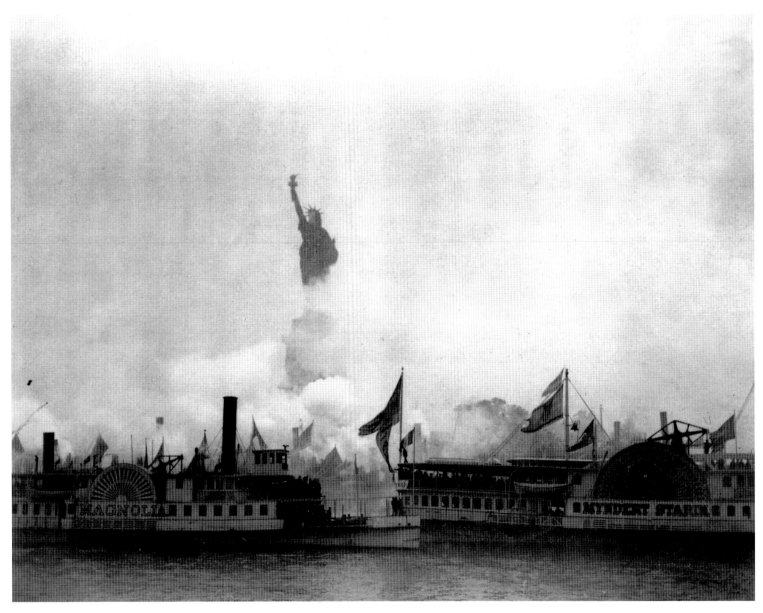

Liberty Enlightening the World, known worldwide as the Statue of Liberty, was erected in the New York City harbor as a gift of friendship from the people of France to the people of the United States. It was created by French sculptor Frederic Auguste Bartholdi. The colossal copper sculpture was inaugurated on October 28, 1886, with a military and naval salute, the smoke from which partially obscures the statue in this image. President Grover Cleveland, a native son of New York State, delivered the inaugural address.

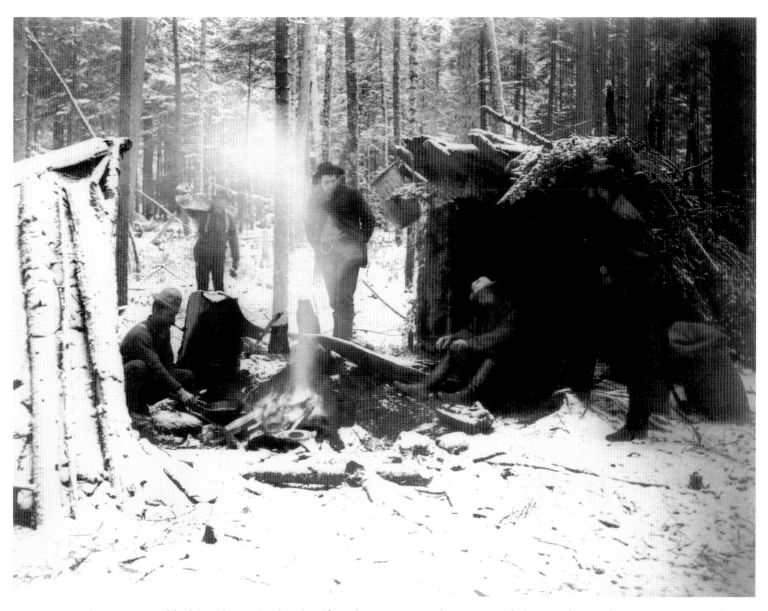

Seneca Ray Stoddard (1844–1917), a largely self-taught artisan, naturalist, writer, and photographer, got his start painting numbers on freight cars. His lobbying efforts to persuade the New York State Assembly to preserve the Adirondacks as a wilderness were influential. Stoddard's two most successful guidebooks, published in the 1870s, introduced thousands of visitors and readers to the sublime qualities of the Adirondack Mountains of upper New York State. This is one of Stoddard's images of winter camping in the region.

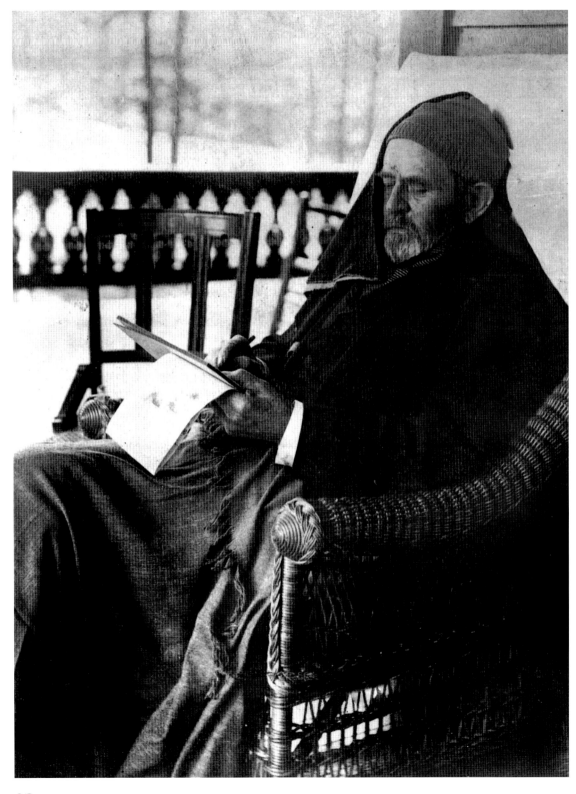

In his day, Ulysses Simpson Grant (1822–1885) was one of the most popular men in the U.S. Not only was he a hero in the North for leading the Union armies to victory in the Civil War; he became popular in the South by granting humane peace terms to the Confederates and as U.S. president uniting the nation with his fairness and compassion. Here he is in 1885 in his cottage on Mount McGregor in the Adirondacks, writing his highly praised autobiography, while dying of throat cancer. Mark Twain, who summered in Elmira where he did most of his writing, assisted Grant in preparing the memoirs.

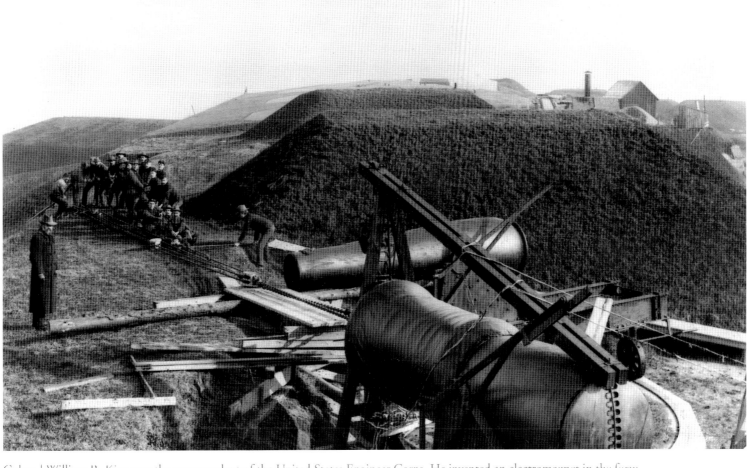

Colonel William R. King was the commandant of the United States Engineer Corps. He invented an electromagnet in the form of a gun. In its day, it was the most powerful magnet in the world. In this 1887 photograph of the site at Willets Point on Long Island, King, standing at left, oversees installation. In a demonstration, the magnet suspended in the air five cannonballs, each weighing 350 pounds, from the muzzle of the gun.

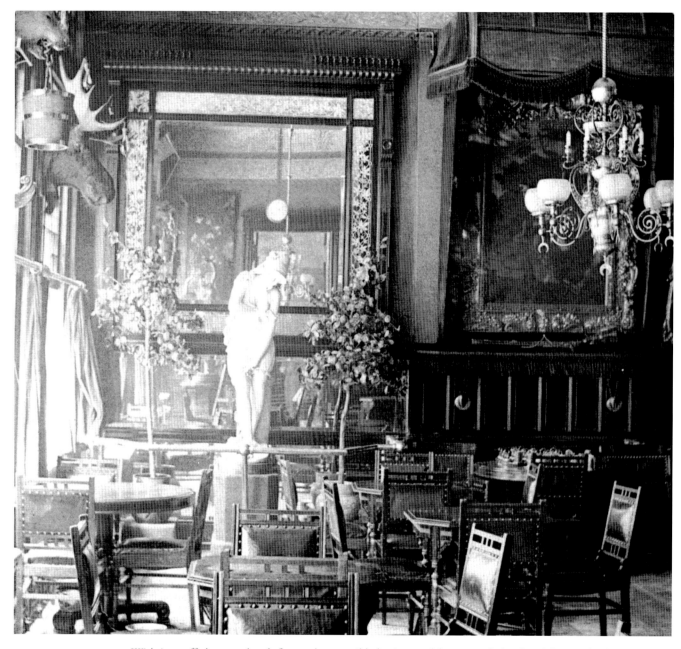

With its stuffed moose head, fine sculpture, gilded mirrors, elaborate gaslight chandelier, and other Victorian fittings, the Grand Saloon in New York City's Hoffman House was considered by the hotel and perhaps by its customers to be the finest saloon in the world in 1888.

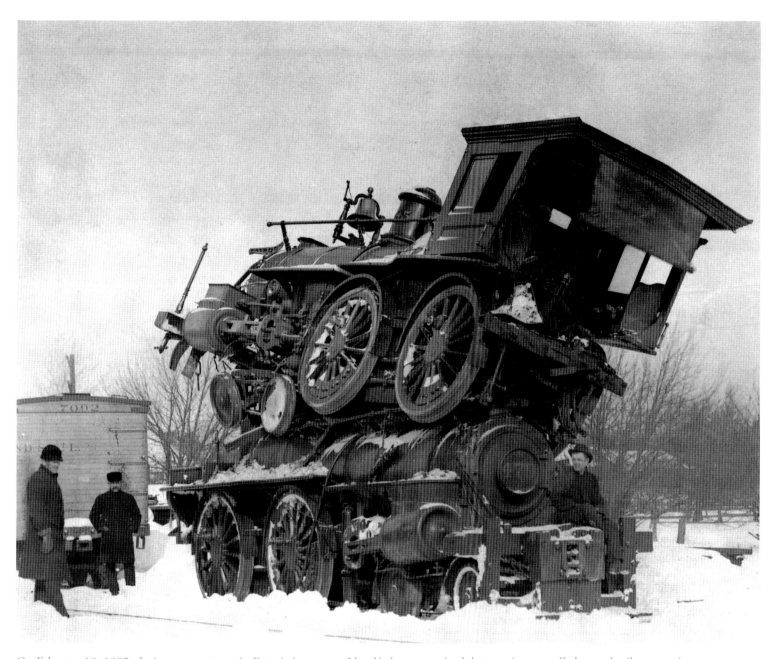

On February 18, 1885, during a snowstorm in Batavia in western New York, news arrived that a train was stalled several miles away. A Batavia train fitted with a plow headed out to rescue the stalled train. The locomotive pushing the plow reached a 15-foot snowdrift, backed up and charged, thinking that the stalled locomotive was farther down the tracks, not imbedded directly on the other side of the snowdrift. In the collision that followed, one of the locomotives landed on top of another, shown here in this well-known photograph. The engineer of the plow engine suffered minor bruises, and the locomotives were repaired and returned to service.

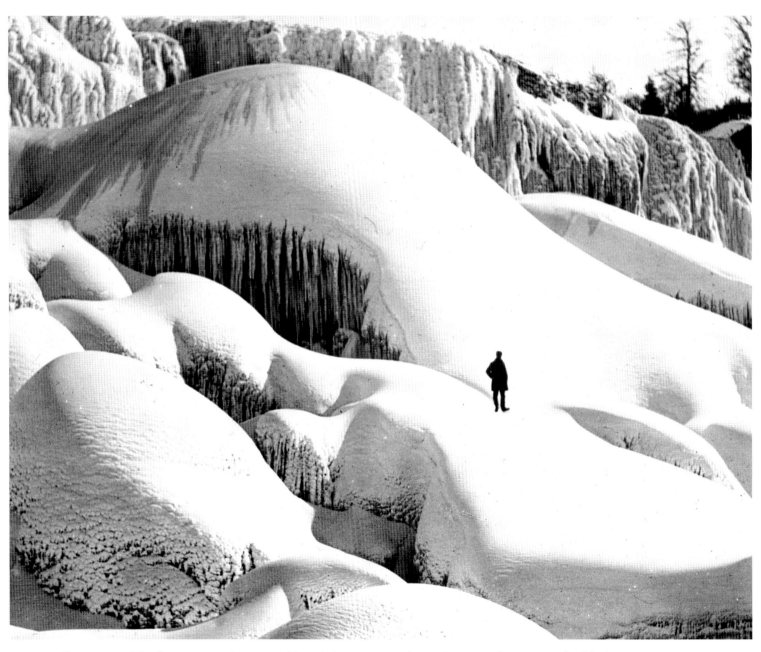

Niagara Falls is on record for freezing more than once, although the immense volume of water in play prevents the falls from ever freezing completely. In this image from the late 1800s, fresh snow has covered the buildup of ice on the American Falls. In recent times, a deepening of the American Falls rapids prevents ice from settling there and forming a dam, thereby increasing the discharge of water over the falls, which lessens the chance of freezing.

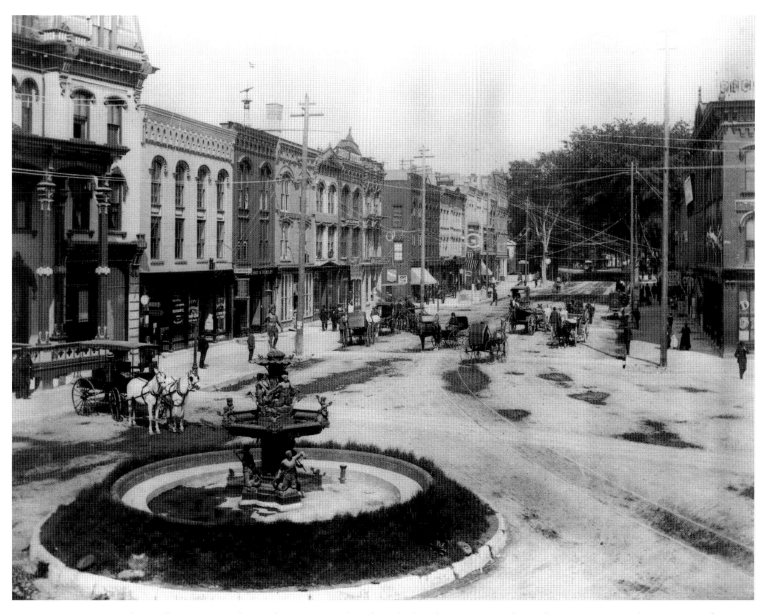

Glens Falls is a city on the Hudson River in the Adirondacks. This 1889 view shows the town square with its cast-iron fountain. The square forms Centennial Circle where five streets intersect. Although settlement here dates to 1766, Glens Falls was incorporated as a village in 1839 and chartered as a city in 1908, celebrating its centennial in 2008. A canal connected Glens Falls to the Champlain Canal and New York State Canal system, through which lumber, marble, lime, and agricultural products were shipped from the area in the nineteenth century.

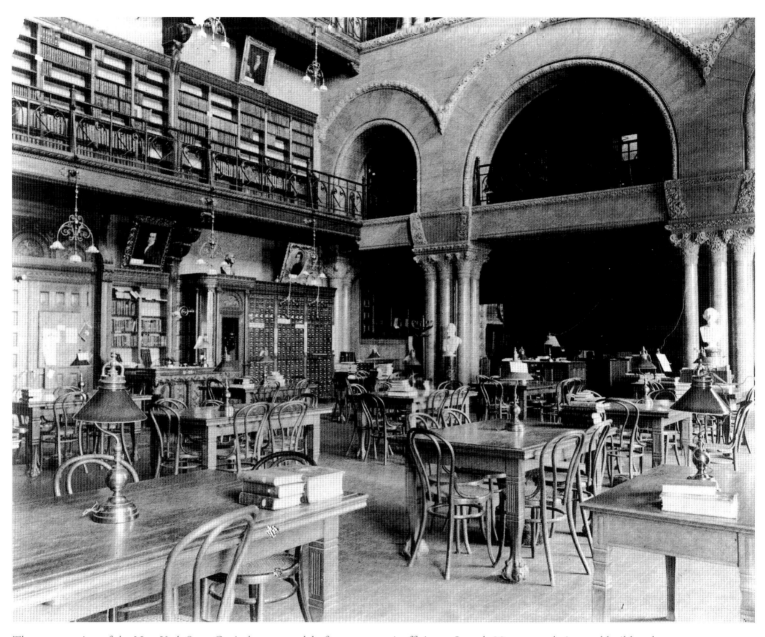

The construction of the New York State Capitol was a model of government inefficiency. It took 32 years to design and build and involved four separate architectural firms. Henry Hobson Richardson finally completed the project in 1899. Richardson's signature architectural style, Romanesque, dominates the building as shown here in the prevalent arches of the New York State Library. The Capitol is one of the last monumental, all-masonry buildings constructed in America, and it cost twice as much as the nation's capitol in Washington, D.C.

In 1892, the famous American photographer Alfred Stieglitz made this photograph of the streetcar terminal along Fifth Avenue in New York City. Stieglitz was a pioneering voice in the history of photography. It was in large measure through his efforts, culminating in the Armory Show of 1913 held in Manhattan, that photography gained acceptance as an art form.

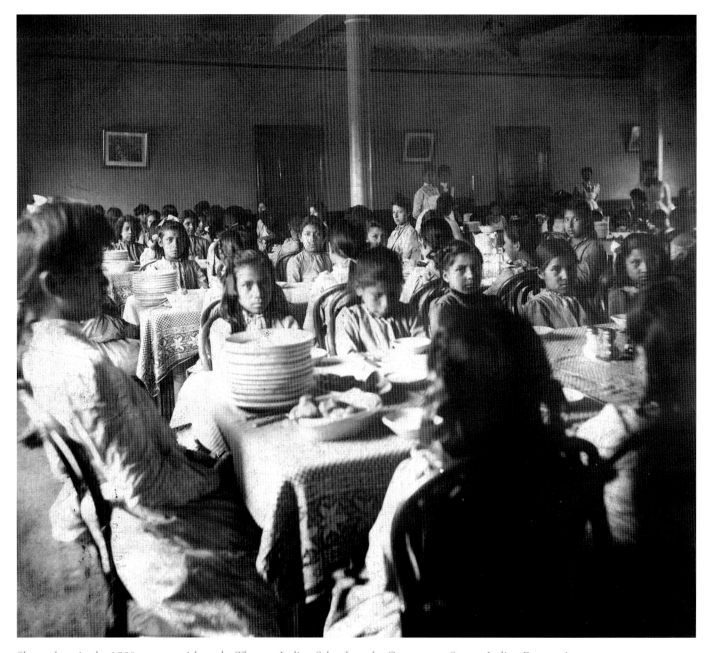

Shown here in the 1890s, young girls at the Thomas Indian School on the Cattaraugus Seneca Indian Reservation in western New York wait for a meal to be served. The plates will be filled at the head of each table and then passed around. Teachers and serving staff also wait at rear. The school was formed in 1855 to educate destitute and orphaned children from Indian reservations across the state.

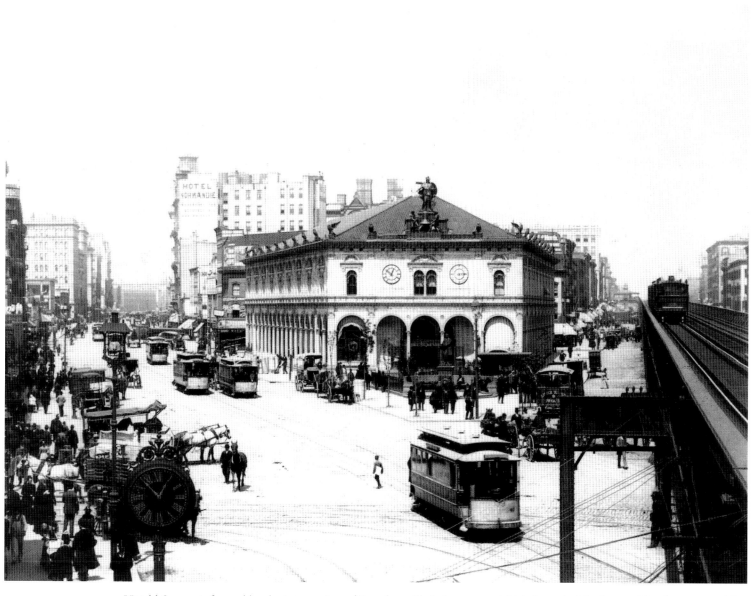

Herald Square is formed by the intersection of Broadway, Sixth Avenue, and 34th Street in Manhattan. The distinctive edifice with a five-arched entrance is the New York Herald newspaper building as it appeared in 1895. The Sixth Avenue elevated railroad runs at right. The most notable business at Herald Square today is Macy's flagship department store. The wooden escalator there still runs, and visitors still stop to shop.

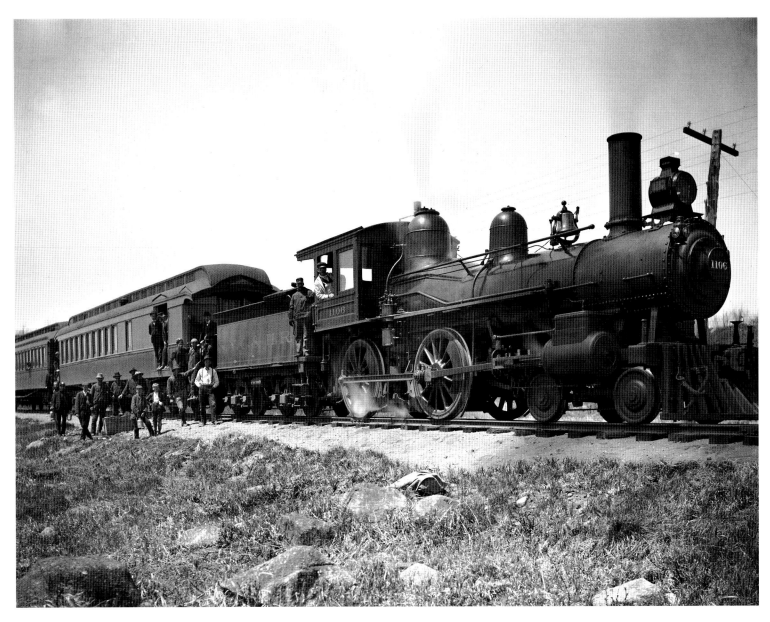

As part of a New York State reforestation project in the late 1890s, a New York Central train transported tree planters from Lake Clear Junction in the Adirondacks to nearby planting grounds each weekday for a period of two weeks. Men and boys are shown here debarking for their day of planting.

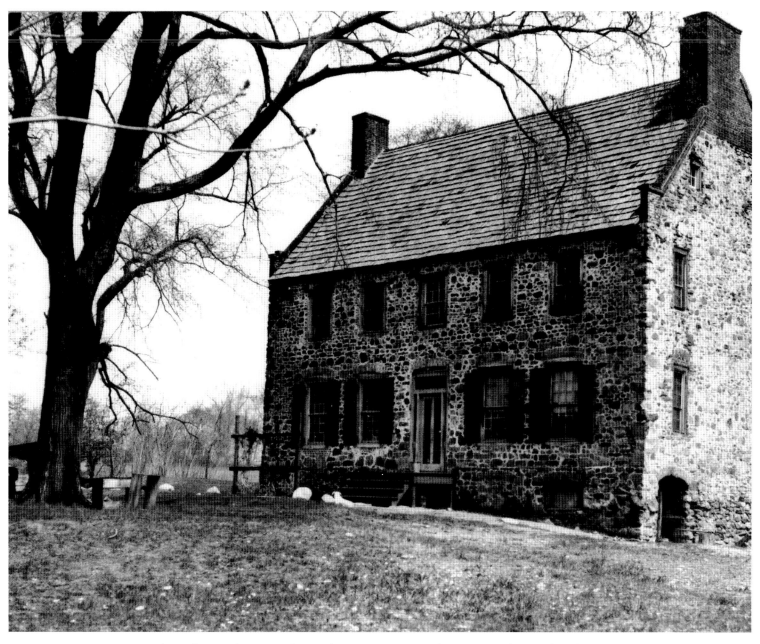

Shown here in the 1890s, the Conference House, as it is known, on Hylan Boulevard in Staten Island is a large Colonial vernacular stone residence built around 1680 by Christopher Billop and enlarged in 1720. It became the site of a conference on September 11, 1776, to achieve a peace agreement between England and the American colonies. The British were represented by Lord Richard Howe and the Americans by John Adams, Benjamin Franklin, and Edward Rutledge. Negotiations failed and the Revolutionary War proceeded.

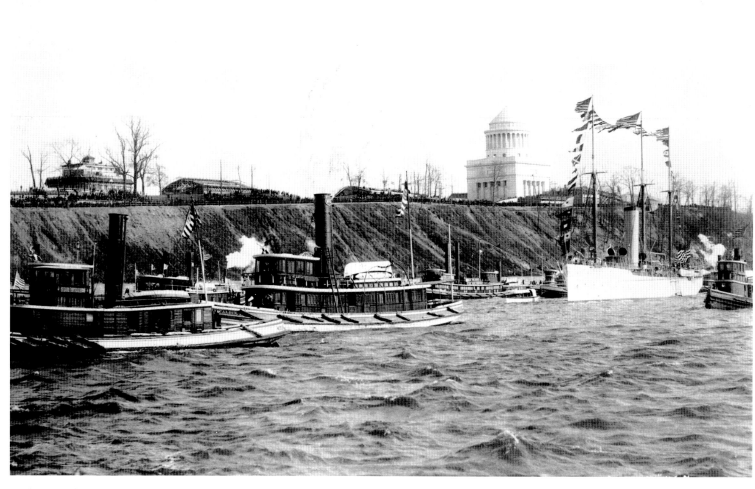

Tugboats and the USS *Dolphny* lie at anchor on the Hudson River in 1897, fronting the newly completed General Ulysses S. Grant National Memorial, on Riverside Drive at West 122nd Street, New York City. Designed by John H. Duncan, the monumental Classical Revival building is constructed of granite with Doric columns and a colonnaded drum. The marble interior holds the tombs of President Grant and his wife.

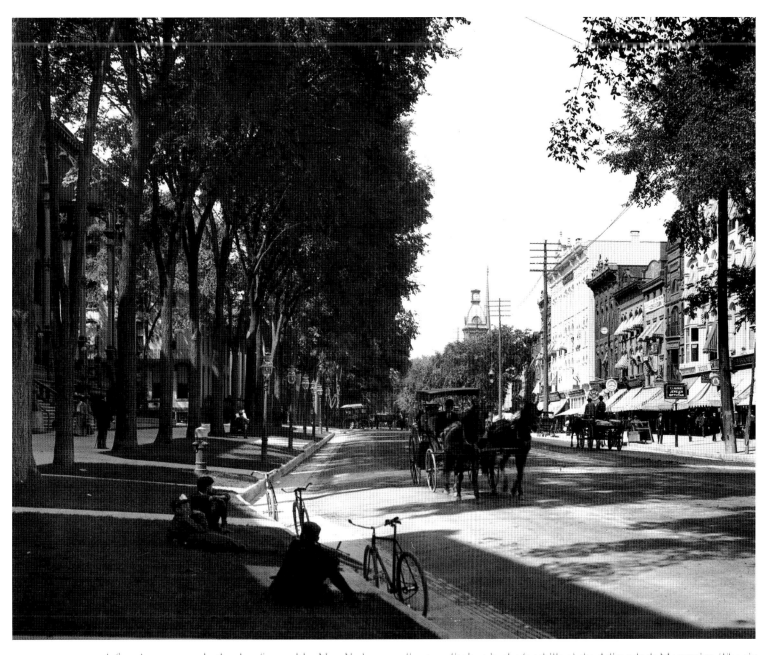

A favorite summer destination for wealthy New Yorkers was Saratoga Springs in the foothills of the Adirondack Mountains. The air was clean and cool, and there was much to occupy one's time in this attractive resort city: mineral baths, horse racing, casino gambling, and lavish parties. Shown here in the late 1890s, tree-lined Broadway featured grand hotels and elegant shops. Even the children enjoyed the ambiance—three boys have curbed their bicycles to take pleasure in the posh avenue.

About two miles from Kaaterskill Falls in the Catskill Mountains is Inspiration Point, with panoramic views of the surrounding mountains and the Hudson River. This and other places in the Catskills inspired artists of the Hudson River School, founded by the painter Thomas Cole. The preeminent painter in the group was Frederic Edwin Church, who wrote, "Nature has been very lavish here in the gifts of her beauty." Inspiration Point is a precipitous ledge that this couple respect at a safe distance.

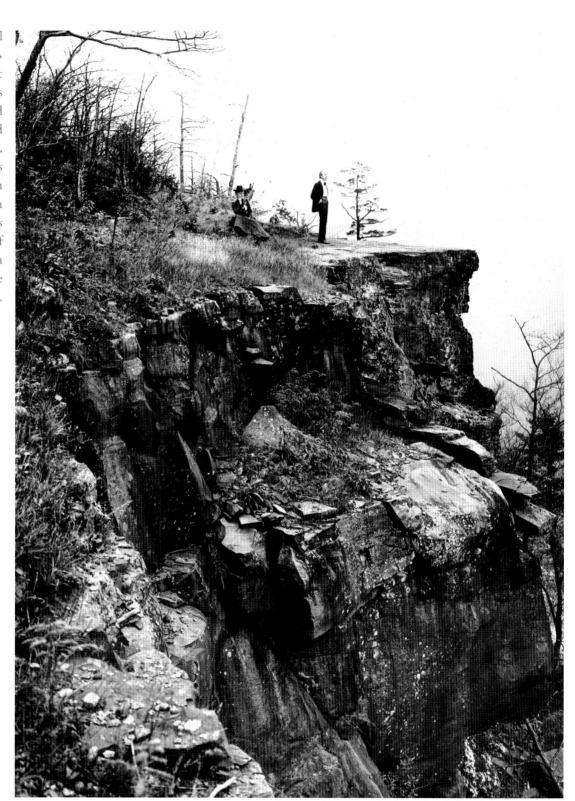

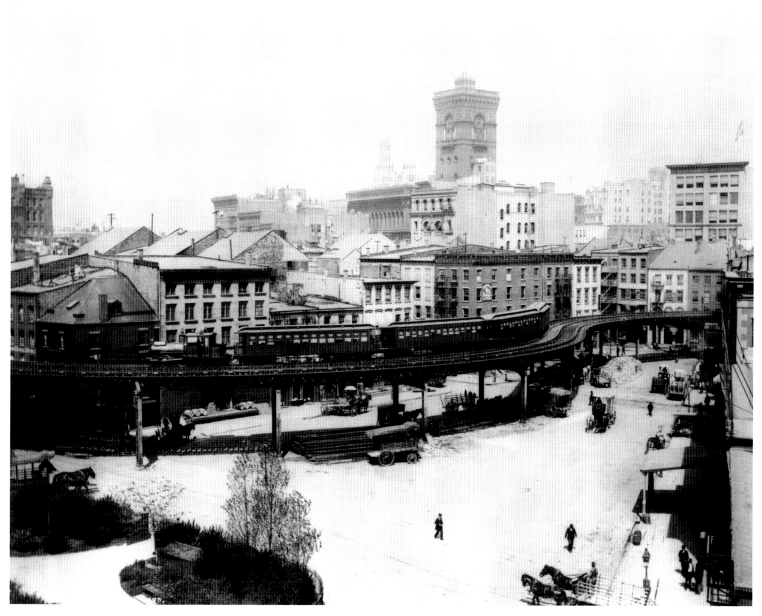

The first elevated railroad in New York City was constructed between 1867 and 1870 along Greenwich Street and Ninth Avenue. Here in 1895, the El winds through the Coentes Slip along the waterfront in lower Manhattan. The slip was a busy produce market area.

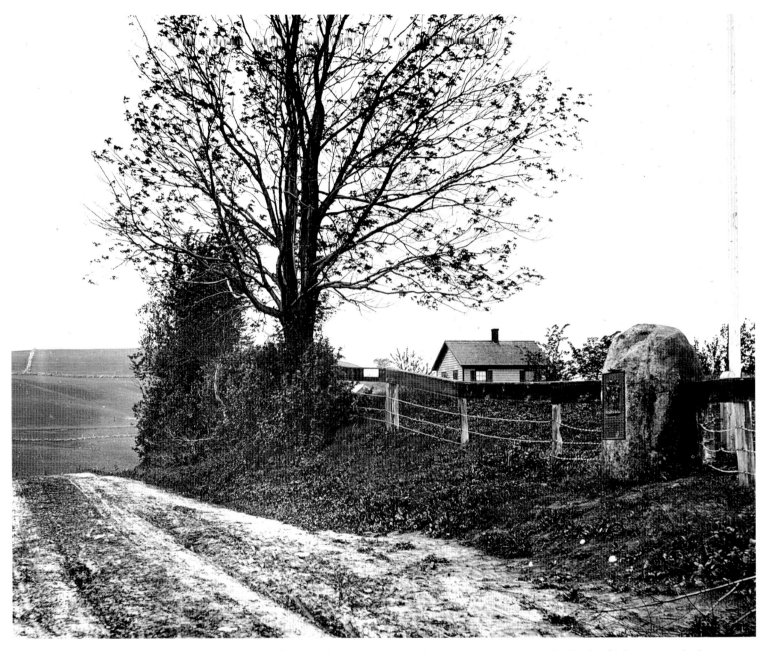

The historic marker (a bronze plaque on a stone boulder) on Johnson Avenue in Johnstown commemorates the Battle of Johnstown, which took place in the fields around Johnson Hall on October 25, 1781. British Loyalist forces were commanded by Major John Ross and Captain Walter Butler, and the Continentals were led by Colonel Marinus Willett. The battle ended with Loyalist forces retreating as night fell. It was one of the last battles of the Revolutionary War, taking place a week after the British surrender at Yorktown, Virginia.

John Brown (1800–1859) was a man with a moral vision and the courage and determination to pursue it. At a time when America was tolerant of slavery, he became one of its principal opponents. He was arrested for his attempt to launch a slave insurrection and was convicted and hanged. His martyrdom was commemorated with the song "John Brown's Body," rewritten by Julia Ward Howe to become "Battle Hymn of the Republic." Brown's body, as well as those of family members, is buried inside this picket fence next to his house at his Adirondack farm in North Elba, near Lake Placid.

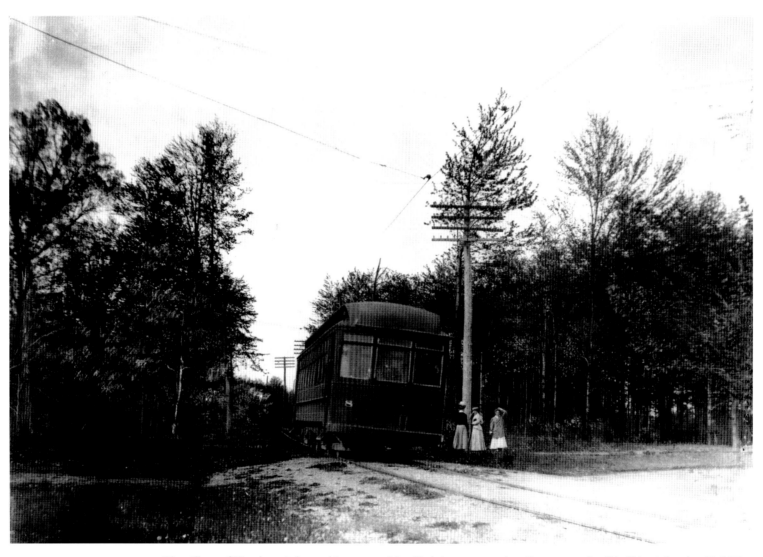

The village of Hamburg is located in western New York just commuting distance south of Buffalo. After the Civil War, Hamburg built a village streetcar system, eventually electrified. One of the electric trolley cars is pictured here in the late 1890s.

Onondaga Street in Syracuse was lined with stately elms in the late 1890s. Dutch elm disease would later decimate the landscape of many city streets like this one. Fine residential streets like Onondaga have deep front-lawn setbacks, and the houses, like the Italianate-style house in the foreground, often had broad front porches for relaxation and visiting with neighbors on summer evenings.

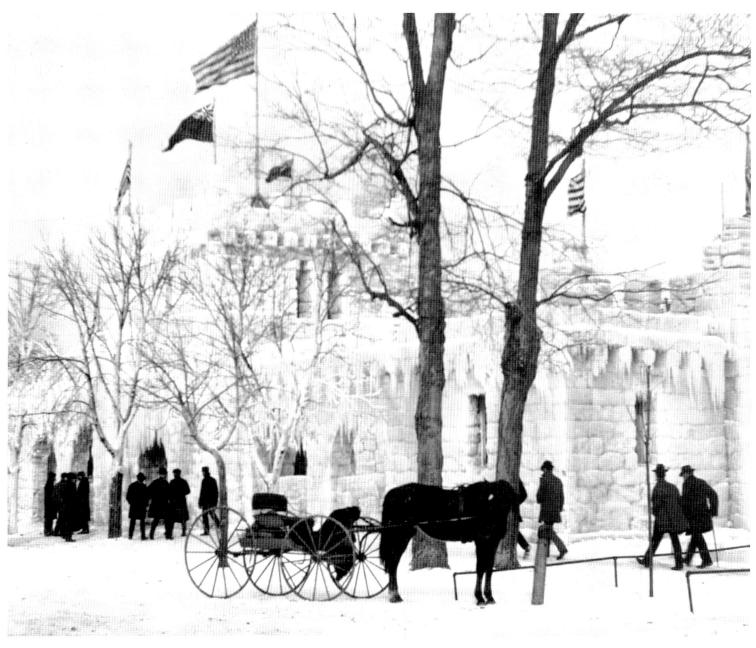

The "Great Ice Palace" was built near the American Falls for a winter festival held at Niagara Falls during 1898–1899. Constructed of large blocks of ice, the palace's walls were seven feet thick, and the structure supported three ice towers. At night, the ice palace was illuminated with colored lights.

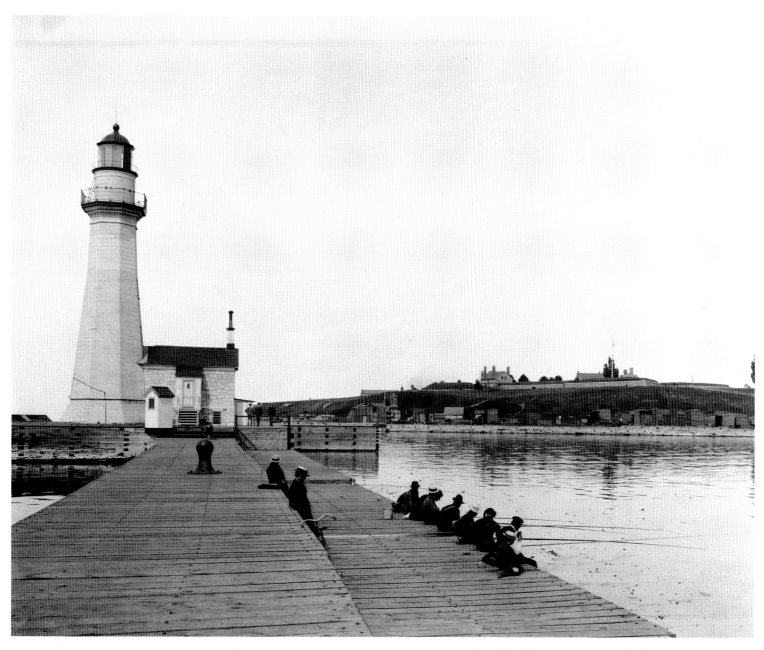

Oswego is a port city on the eastern shore of Lake Ontario. The Oswego Canal, built in 1828, connected Lake Ontario to the Erie Canal, making the city a prominent trading center. The lighthouse alerted ships to the Oswego port. In the distance is Fort Ontario, which dates to 1755. It was destroyed and rebuilt several times. The shape of the fort is pentagonal with five arrowhead-shaped bastions atop an earth embankment, which could repel attacks from any direction, by sea or by land.

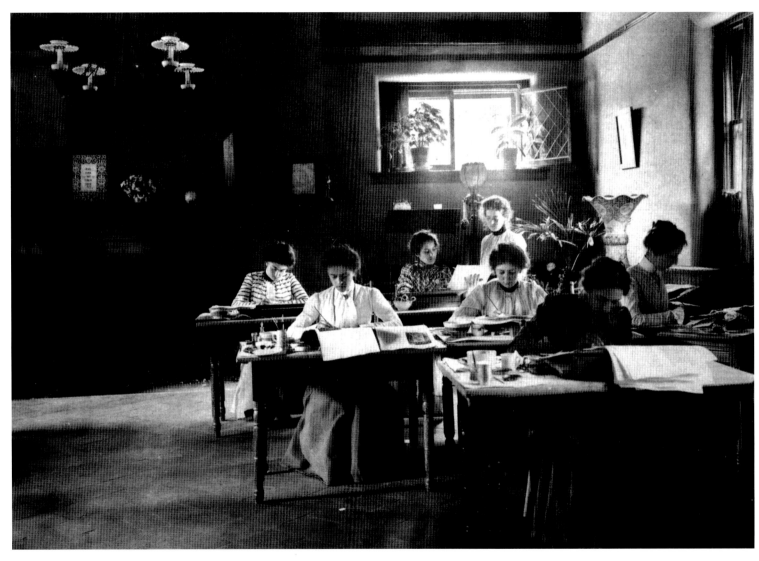

In 1900, seven women at the Roycroft colony in East Aurora, just outside Buffalo, are engaged in the crafts efforts for which Roycroft became internationally famous. On the walls are framed quotations urging industry and creativity.

In the foreground is one of several buildings on the Roycroft campus, photographed in 1900. The Roycroft was established in 1895 by Elbert Hubbard, a charismatic business entrepreneur and writer, as part of the Arts and Crafts movement in America. Roycrofters did expert printing, fine bookbinding, hand-fashioned glass and copperware, handsome leather goods, and Mission-style furniture. One of Hubbard's best-known essays, *A Message to Garcia,* on accepting responsibility and getting the job done, has sold more than 80 million copies. The Roycroft community began to decline following the deaths of Hubbard and his wife aboard the *Lusitania,* which was torpedoed by a German U-boat in 1915.

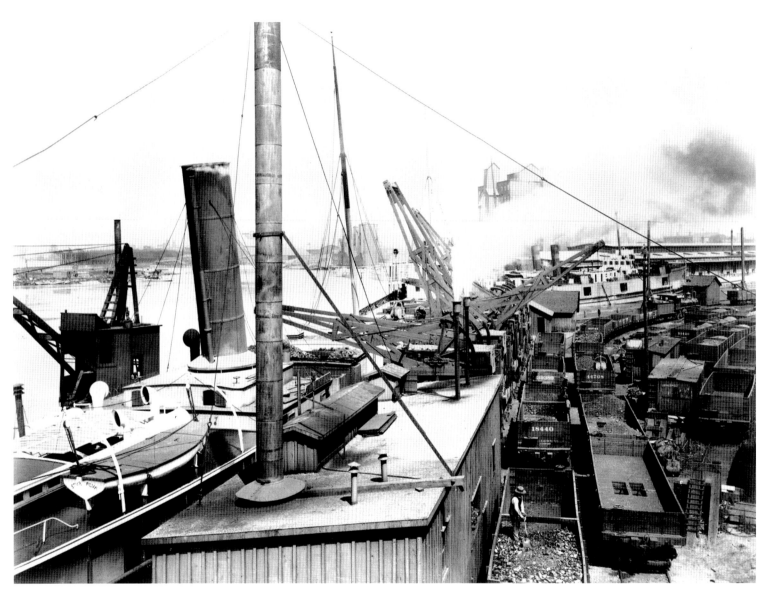

In 1900, Buffalo was a major steel town. Iron ore was shipped on the Great Lakes from the Midwest and unloaded at this Lake Erie dock in Lackawanna. Thornberger hoists were used to unload ore from the lake ships and deposit it in railroad cars that transported it to the steel mills. Coal to fire the blast furnaces came by train from Pennsylvania. Lackawanna Steel would be acquired by Bethlehem Steel, one of America's largest steel producers, in 1922.

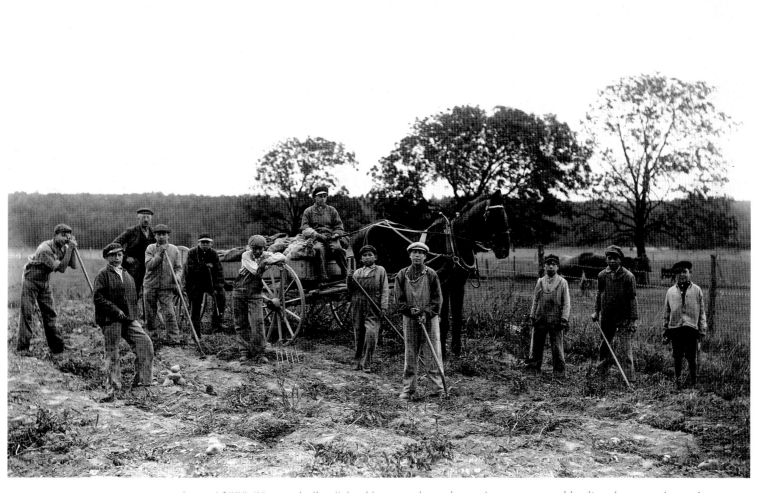

Around 1900, Thomas Indian School boys are shown harvesting potatoes and loading them on a horse-drawn cart.

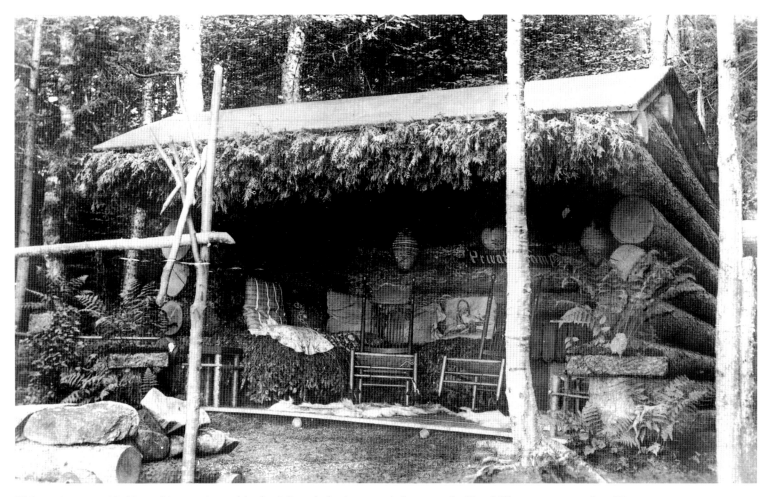

This rustic, open-sided log cabin was situated in the Adirondacks, in a wooded area on the Hotel Glennmore grounds at Big Moose Lake. It was fitted with animal-skin rugs, rocking chairs, cushions, potted ferns, and Japanese paper lanterns. The small sign on the back wall reads, "Private Camp."

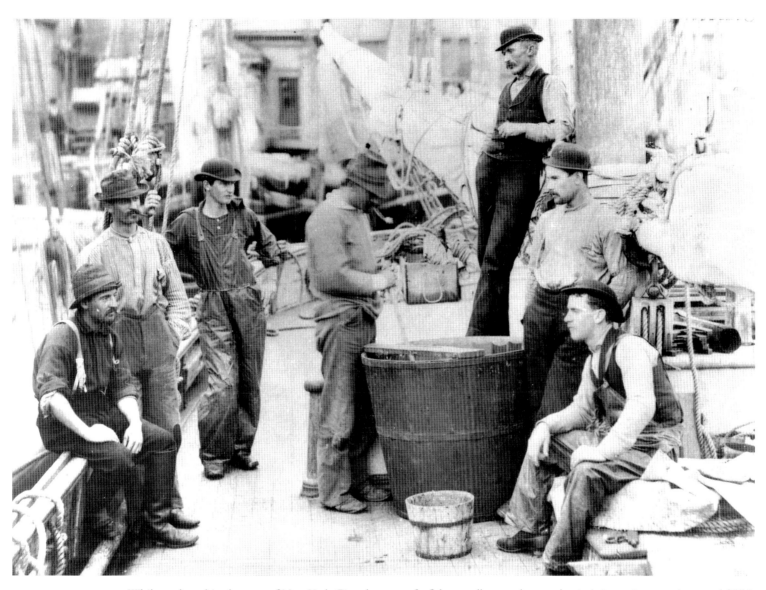

While anchored in the port of New York City, the crew of a fishing sailboat gather on the deck for a photograph around 1900. Ropes and rigging to manage sails and fishing nets, as well as wooden barrels and boxes, are visible on the deck.

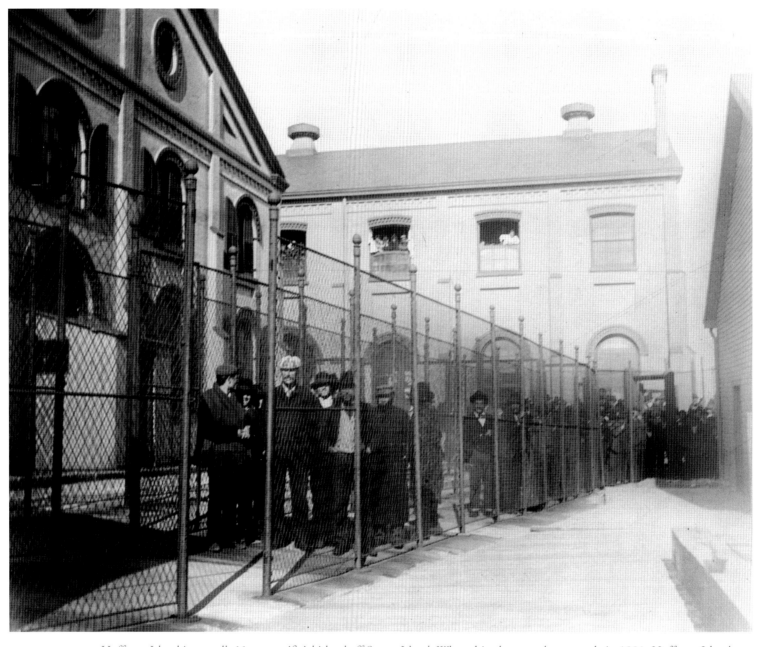

Hoffman Island is a small, 11-acre artificial island off Staten Island. When this photograph was made in 1901, Hoffman Island was used as a quarantine station to house immigrants believed to be carrying contagious diseases, principally smallpox. The picture shows immigrants from a smallpox ship being registered for their stay at housing facilities on the island.

In New York City, there were tenements that were built on a 25-foot-wide lot. A law required that every room have a window, but many of these windows looked out on extremely narrow shafts. Residents could reach out and shake hands with the neighbor across the airshaft. They were called dumbbell tenements for being pinched in the middle like a weight lifter's dumbbell. This photograph from around 1900 peers down into one of those narrow dumbbell tenement airshafts.

Featuring an imposing Greek Revival façade, the Ansley Wilcox House, at 641 Delaware Avenue, was built in 1838 in Buffalo. Vice-president Theodore Roosevelt was inaugurated as the 26th president of the United States here after President William McKinley was assassinated while attending the 1901 Pan-American Exposition in Buffalo. On vacation in the Adirondacks at the time, Roosevelt rushed to Buffalo and, with the Wilcox family and dignitaries in attendance, took the oath of office in the living room.

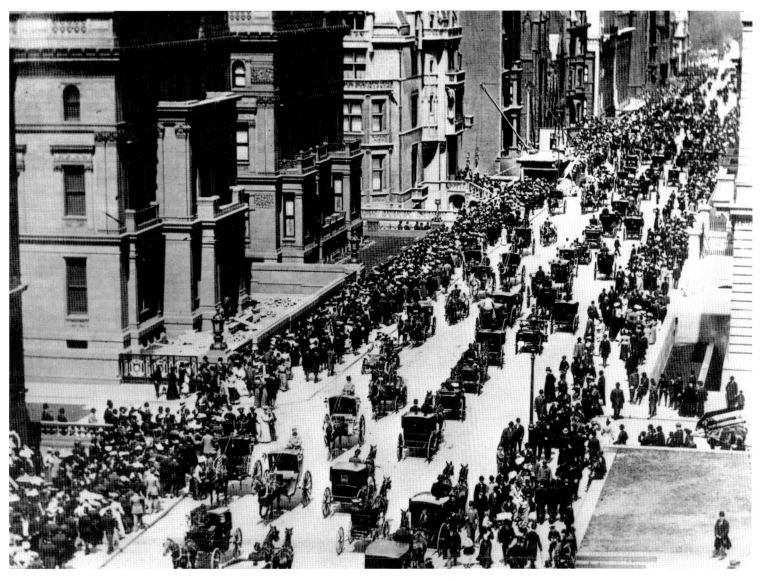

This is Easter Sunday morning in 1900 on Fifth Avenue in New York City. The sidewalks are jammed with churchgoers and other celebrants, and the street itself is bustling with two-way traffic. Most of the vehicles are horse-drawn carriages, but there are at least two motorcars, one driving uptown in the center of the photograph. The elegant mansions of the wealthy line the avenue at left.

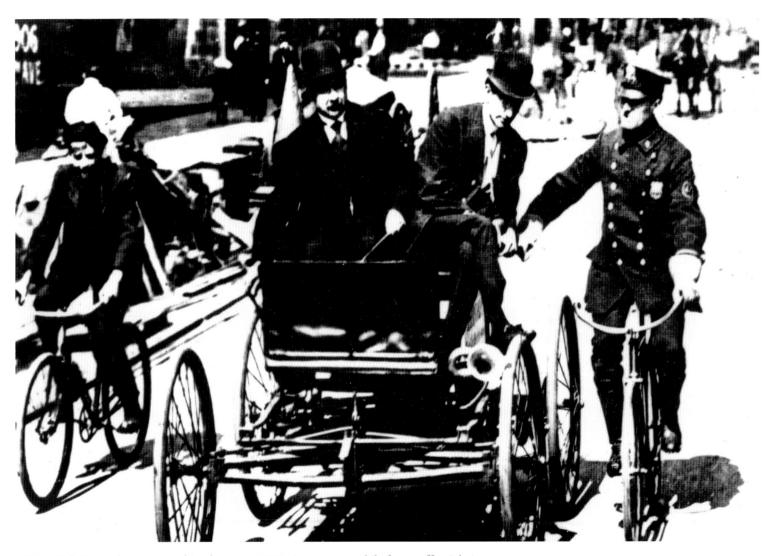

A New York City policeman on a bicycle stops a 1900-vintage automobile for a traffic violation.

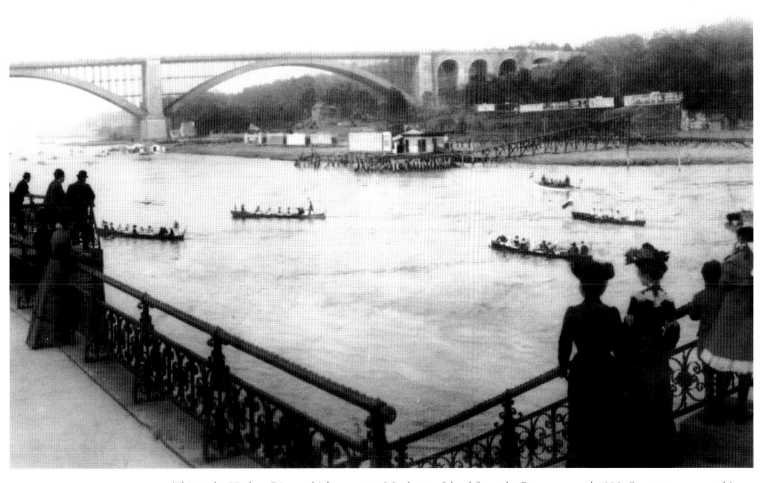

This is the Harlem River, which separates Manhattan Island from the Bronx, around 1902. Spectators are watching a regatta staged by a New York boat club. In this era, rowing was highly popular as a sport in the New York City area, which was home to dozens of rowing clubs. The Harlem River Regatta, attended by thousands, was an annual event in the spring of the year.

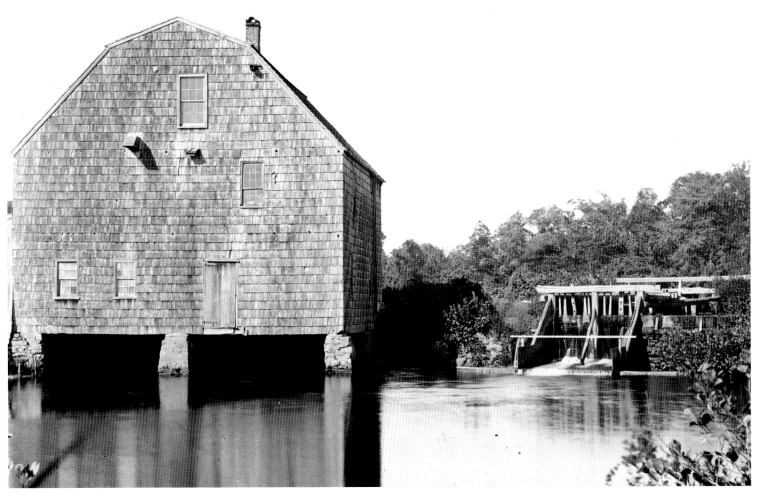

Shown here in 1900 is the watermill at Smithtown, Long Island, on the Nissequogue River. Mills like this one, which employed a waterwheel powered by falling water, were once relied on to grind wheat into flour and saw trees into lumber.

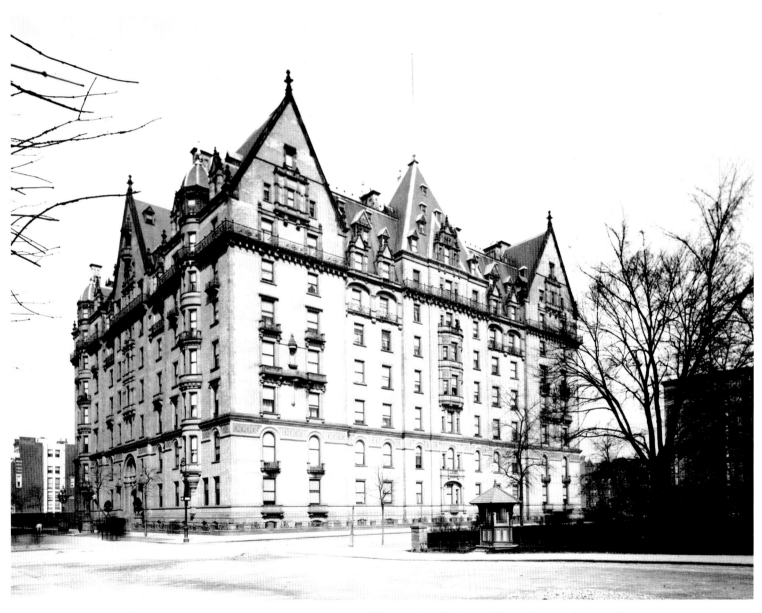

The Dakota is arguably the most famous apartment building in New York City. The architectural style is German Renaissance. It was built in the years 1880 to 1884 on Central Park West at 72nd Street, which was a remote address at that time, giving rise by some accounts to the name. The apartments were designed for wealthy New Yorkers who maintained a staff of servants. The Dakota's many famous residents have included Judy Garland, Carson McCullers, Leonard Bernstein, and singer-songwriter John Lennon of the Beatles. Lennon was shot and killed on the sidewalk outside the Dakota in December 1980.

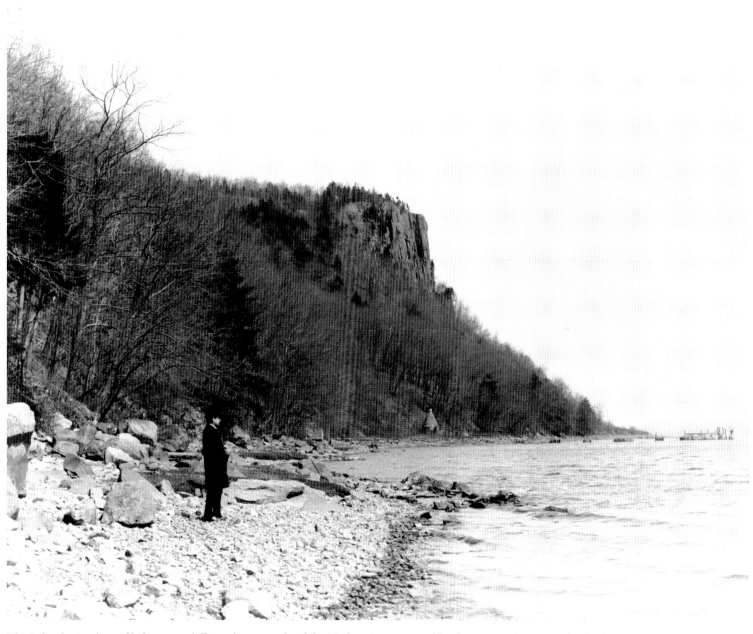

The Palisades is a line of lofty, steep cliffs on the west side of the Hudson River in Rockland County. The town of Palisades is a residential hamlet in the vicinity, and Columbia University operates an observatory in the area. In this 1903 image, a visitor looks east across the Hudson from a point below the cliffs.

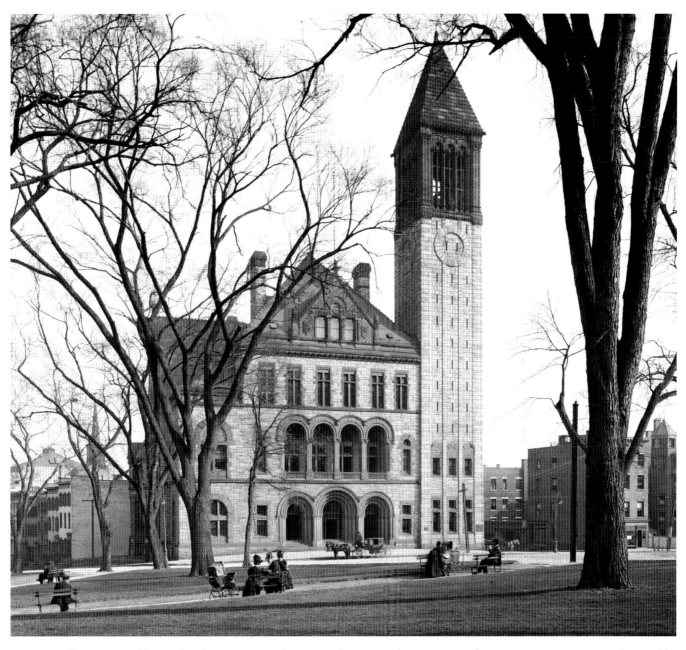

Albany City Hall, completed in 1883 at Eagle Street and Corning Place, is a magnificent Romanesque structure designed by Henry Hobson Richardson, America's preeminent architect of the period. The arch was Richardson's signature design motif, which is amply demonstrated in this building. City Hall features rusticated granite and brownstone trim to separate the stories and highlight fenestrations. There are 60 bells in the tower, which play music and ring the hours daily.

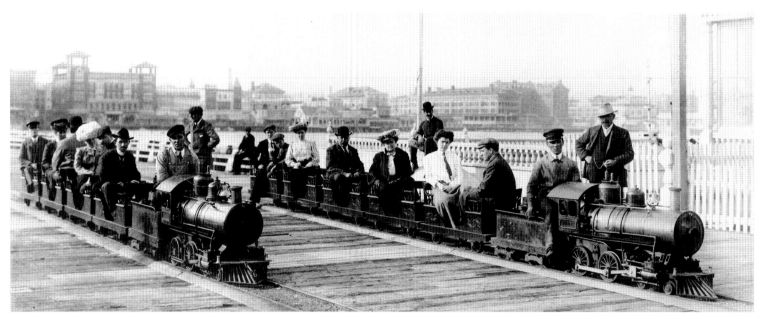

A miniature railway system transports visitors around Dreamland, an amusement park on Coney Island in south Brooklyn that operated for seven years beginning in 1904. It would appear that the rail cars were made for children, but in this image only adults are aboard. Reportedly, the trains could haul ten tons of weight, pulled by genuine 4-4-0 steam engines. Dreamland caught fire in 1911 and burned to the ground, leaving only fond memories of its spectacular rides and attractions.

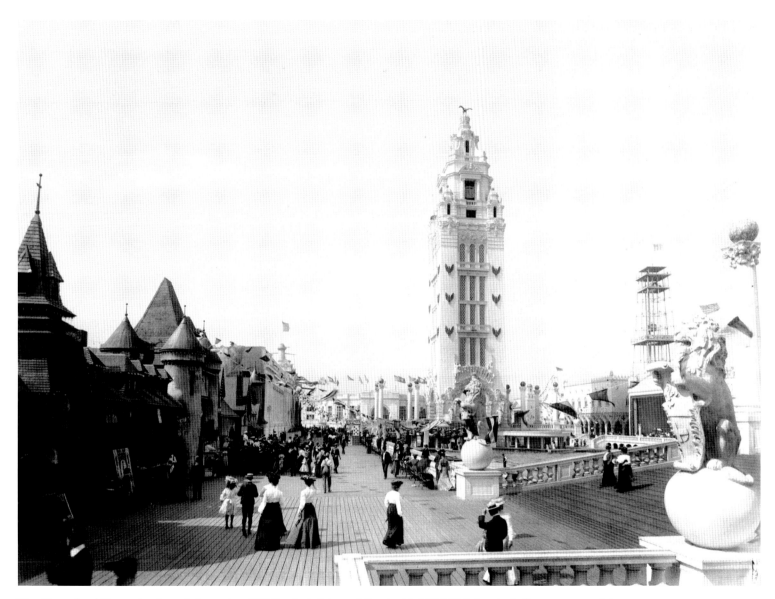

The Dreamland Tower dominated the park at 375 feet in height and fitted with 100,000 lights, including two powerful spotlights, which apparently disoriented ship captains who thought it was a lighthouse. The tower's architecture was based on the Giralda in Seville, Spain, and included a large metal falcon at its summit. Americans smartly attired, which was the norm in 1904 regardless of one's destination, wander the boardwalk taking it all in.

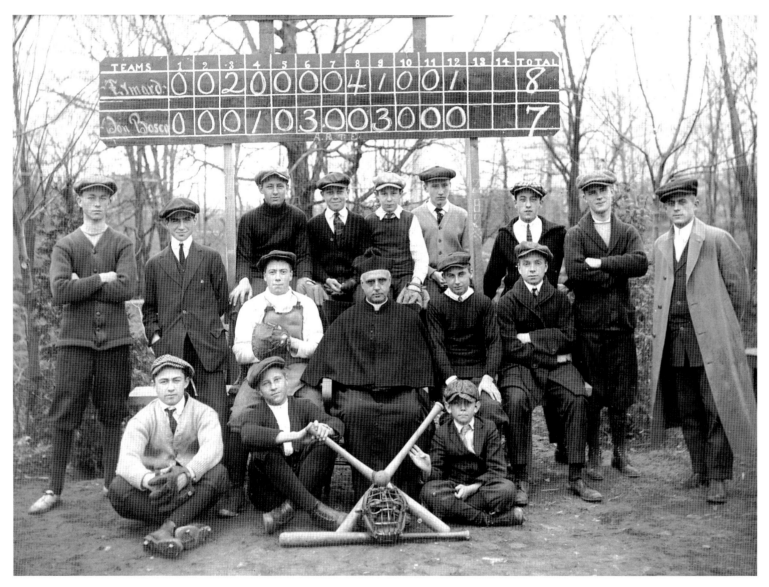

TEAMS	1	2	3	4	5	6	7	8	9	10	11	12	13	14	TOTAL
Eymard	0	0	2	0	0	0	0	4	1	0	0	1			8
Don Bosco	0	0	0	1	0	3	0	0	3	0	0	0			7

Posing for a group shot around 1890 is the baseball team of Eymard Seminary, a Catholic school in Suffern, located in southern New York near the New Jersey border. A Roman Catholic monsignor, wearing a cape and biretta, is seated at center. Team members are gathered around, with an adult in a long overcoat, perhaps the coach, standing at right. The scoreboard indicates that the Eymard team scored a run in the 12th inning to beat the Don Bosco team by a score of 8 to 7.

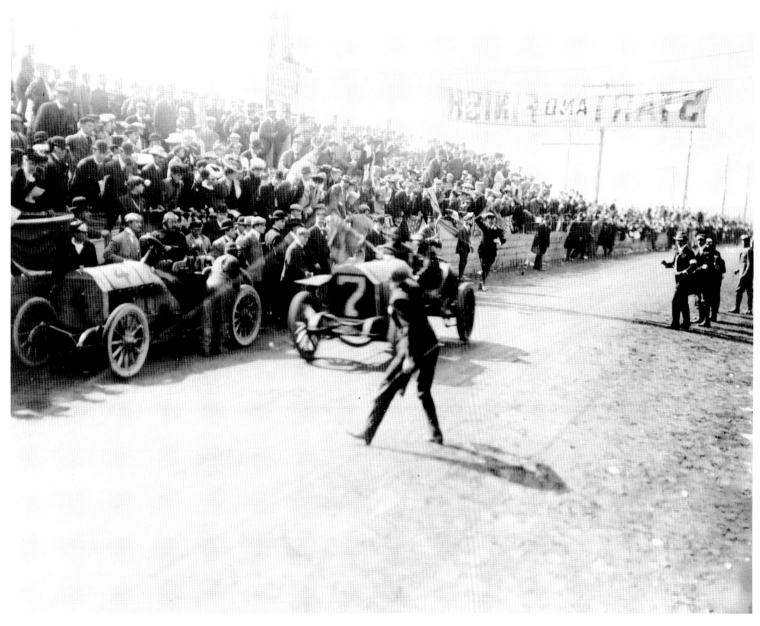

The William K. Vanderbilt, Jr., Cup Races were the first international motorcar cup races held in America. Vanderbilt, who lived nearby, and a few of his friends arranged to close off public roads near Hicksville on Long Island to create a triangular racetrack for the event. The first race was held October 8, 1904, and this image records the second race, in 1905. Car No. 7, driven by Joe Tracey, was flagged down as winner.

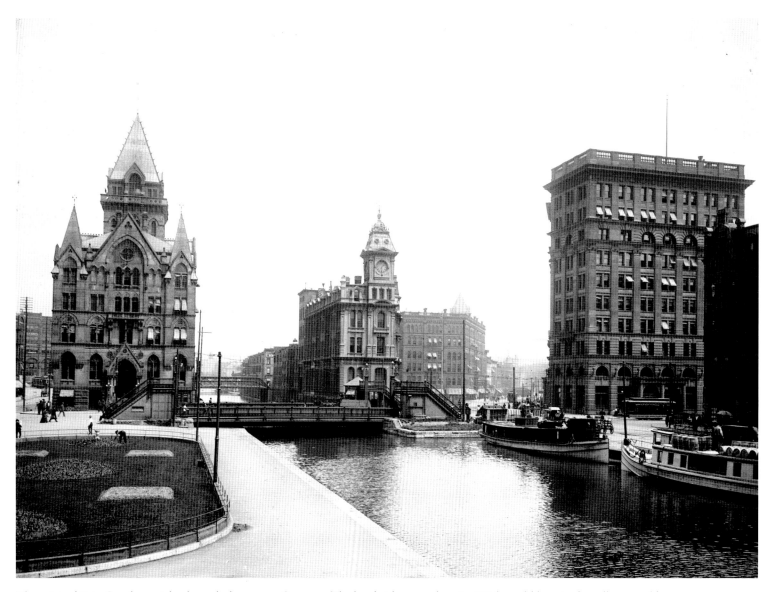

The original Erie Canal ran right through downtown Syracuse. The low bridge, seen here in 1904, could be raised to allow canal boat traffic to pass underneath. At left is the Syracuse Savings Bank, a monumental High Victorian Gothic sandstone building completed in 1876, and an impressive architectural statement to the success that the Erie Canal brought to the city. At center is the Gridley Building, a Second Empire–style edifice designed by the famous Syracuse architect Horatio Nelson White.

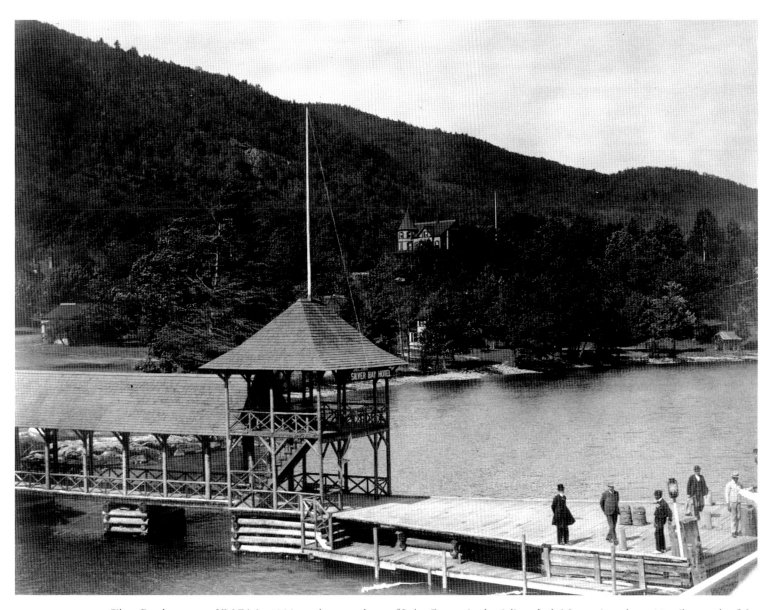

Silver Bay began as a YMCA in 1900 on the west shore of Lake George in the Adirondack Mountains, about 20 miles north of the village of Lake George at the south end of the long lake. Across the lake is Spruce Mountain, and Sugar Loaf and Black Mountain are a little farther to the south. The spectacular scenery at Silver Bay is suggested in this 1904 photograph of the boat dock. Lake George figured importantly in the Revolutionary War and much later as a destination for the nation's rich and famous. James Fenimore Cooper alludes to the lake in his classic Leatherstocking tale *Last of the Mohicans.*

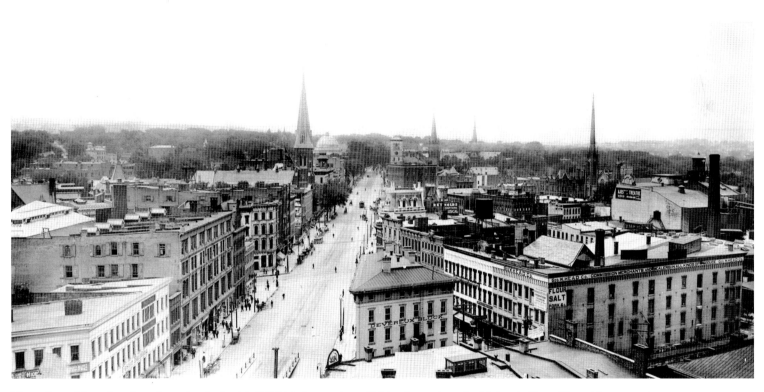

The spires of four churches pierce the sky in this 1905 bird's-eye view of Utica, located on the Mohawk River. The wide avenue is Genesee Street, and on the left beyond the first church steeple is the gold dome of the Savings Bank of Utica, built in 1898 in the Beaux-Arts style. On Saturday, October 23, 1819, the very first trip on the first-completed section of the new Erie Canal between Utica and Rome took place after the canal bed was flooded, a sight that awed many.

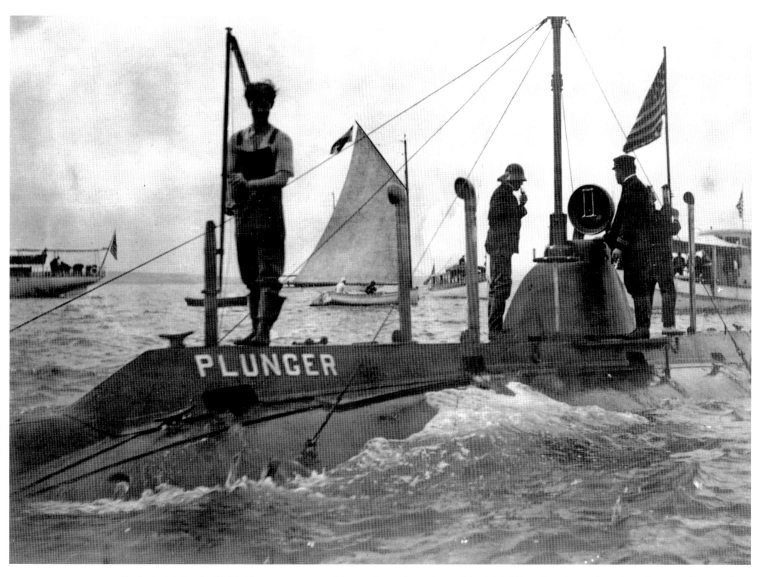

Built in 1902, the USS *Plunger* was one of the earliest submarines of the U.S. Navy. In 1905, when this photograph was taken, it was towed to Oyster Bay on Long Island to conduct trials. Four members of the crew stand on deck while sailboats and yachts move by in the distance. On the afternoon of August 22, 1905, President Theodore Roosevelt, who lived nearby, paid a visit to *Plunger* and boarded the submarine for a series of dives spanning three hours.

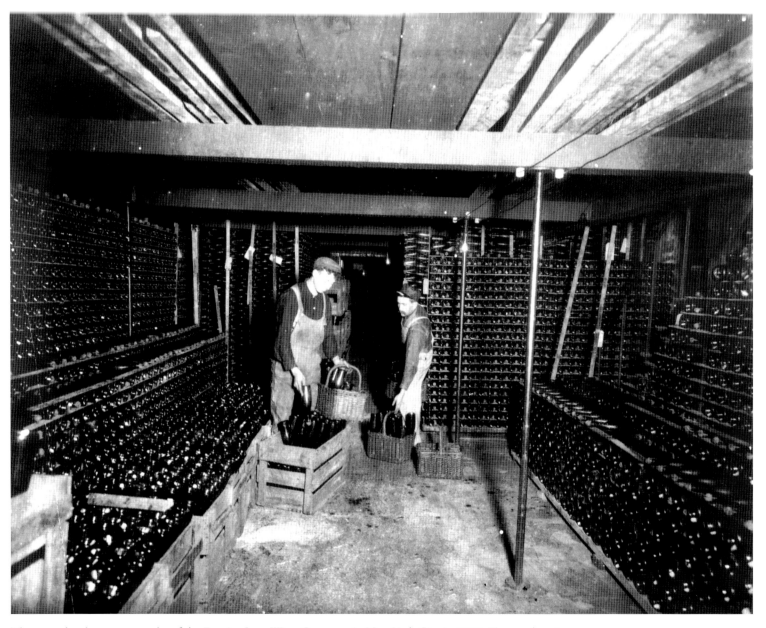

These are the champagne vaults of the Empire State Wine Company in New York City in 1905. Two workers in aprons fill baskets with bottles of champagne to make a delivery.

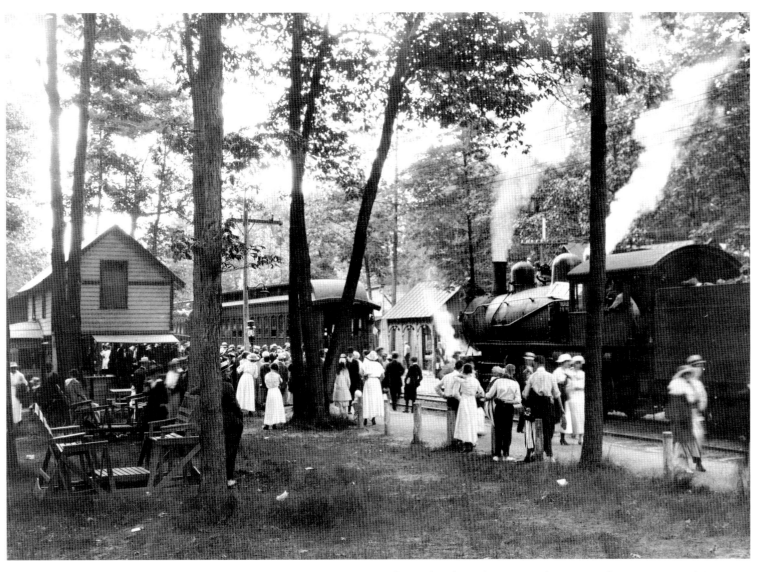

The village of Sylvan Beach on the eastern shore of Oneida Lake in the Finger Lakes region of upstate New York is a resort community offering fishing, swimming, boating, and the Sylvan Beach Amusement Park. In the late nineteenth century, before the advent of the automobile, such resorts succeeded only if they could be reached by train.

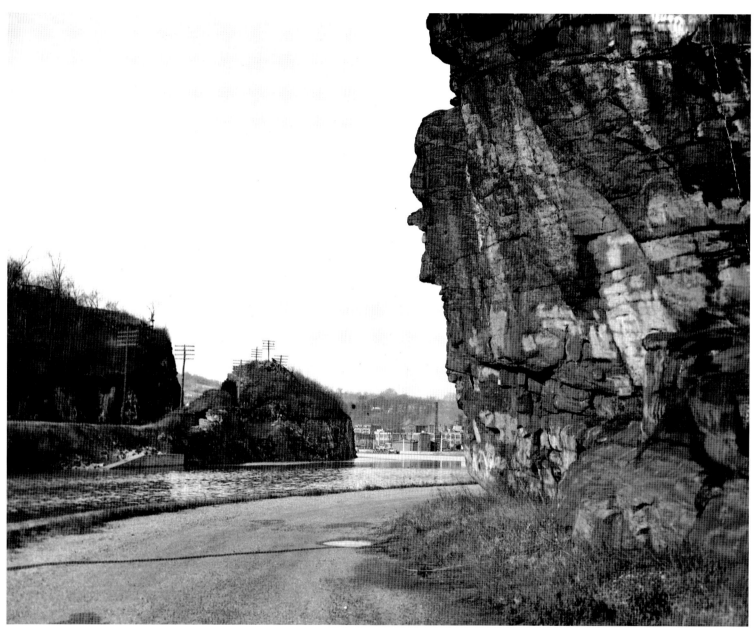

Shown here alongside the Erie Canal in Little Falls is the curious and massive Profile Rock, aptly named for its natural anthropomorphic attributes. Little Falls is also home to the world's highest canal lift lock. In seven minutes, the lock can raise or lower boats 40.5 feet.

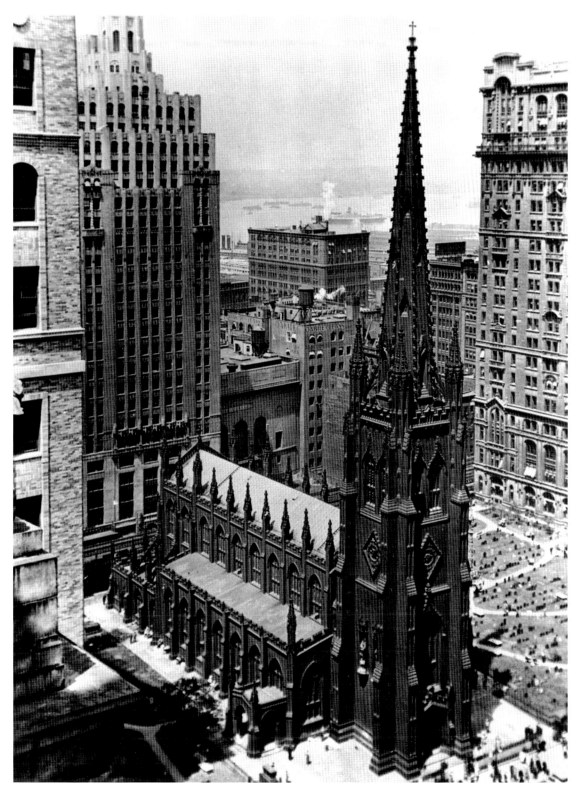

Trinity Church, which faces Wall Street from Broadway in lower Manhattan, was designed by the famous architect Richard Upjohn, whose specialty was Gothic Revival architecture. This church, the second on the site (the first one was built in 1698), was consecrated in 1846. At that time, the soaring neo-Gothic spire was the tallest structure in Manhattan. Trinity Church was designated a National Historic Landmark in 1976.

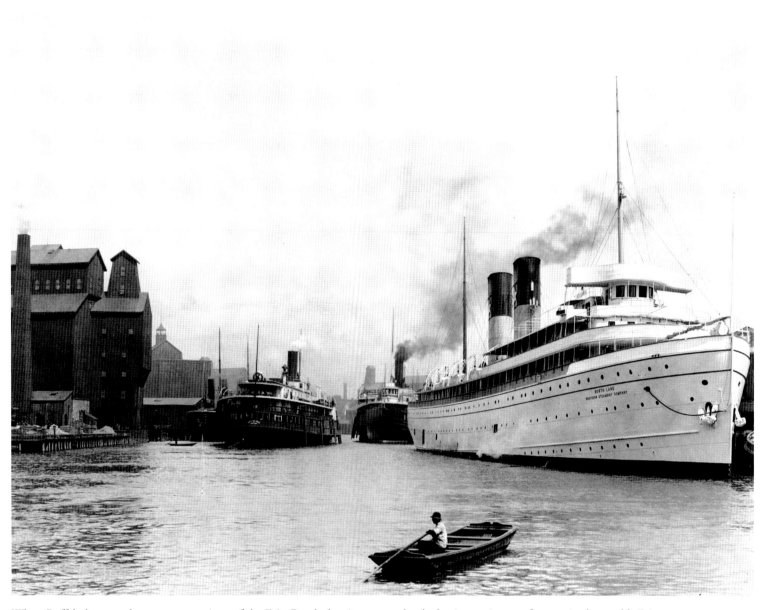

When Buffalo became the western terminus of the Erie Canal, the city grew to be the busiest grain-transfer port in the world. Erie Canal boats had no sails or keels to navigate the Great Lakes, and lake ships were too large for the canal. As a result, cargo had to be unloaded and reloaded at Buffalo. Grain elevators, like those at left, were invented in Buffalo to store grain during the transfer, and steamships like the *North Land* at right, shown here in port, navigated the Great Lakes.

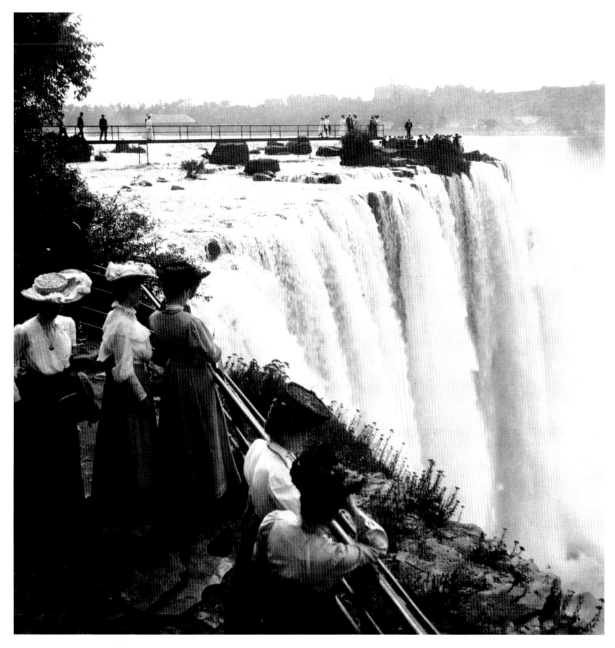

A group of spectators view Niagara Falls from Goat Island, which separates the American from the Canadian Horseshoe Falls. In the distance, a pedestrian bridge leads to rock outcroppings in the rapids. Goat Island gets its name from an early settler, John Stedman, who kept his goats on the island to protect them from wolves. The flank-to-flank width of Niagara Falls is 1,000 feet, and the height varies from 120 to 170 feet.

Stony Brook is a village on the North Shore of Long Island. The buildings in this 1906 photograph face Stony Brook Harbor, and the low-lying landmass in the distance is Long Beach. Today the village is primarily a residential community and home to the State University of New York at Stony Brook.

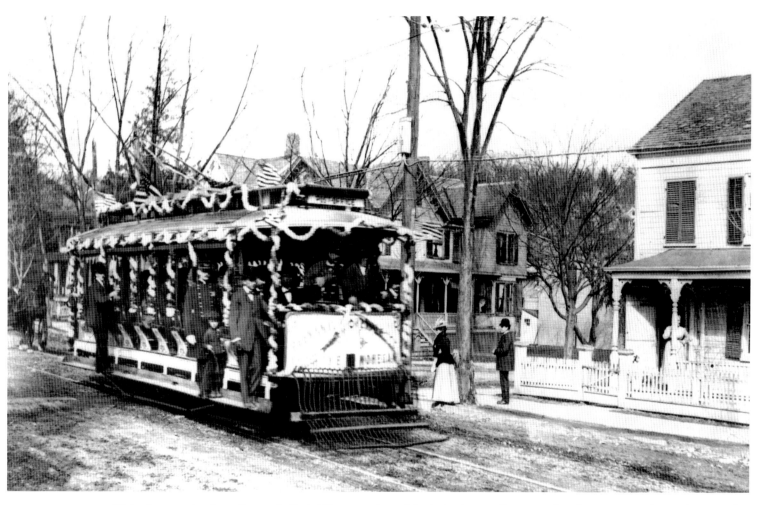

This photograph of a trolley car in Peekskill was made on March 23, 1907, a few years after the Putnam and Westchester trolley road was extended to Peekskill in northern Westchester County. It replaced the stage lines that for many decades had provided transportation along the east side of the Hudson River. People were thrilled to be rid of the antiquated stagecoaches and certainly didn't complain about the 5-cent fare to New York City.

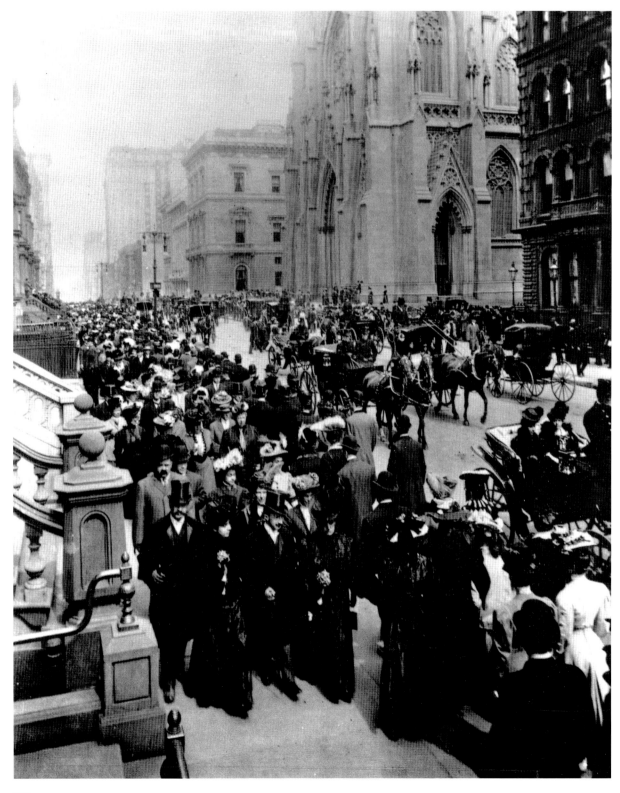

Easter Sunday 1906 finds New Yorkers thronging Fifth Avenue in their finest apparel—men with their top hats and women in long gowns and elaborate bonnets. In the background, between 50th and 51st streets, rises the magnificent neo-Gothic St. Patrick's Cathedral, where as many as 2,400 New Yorkers could have worshiped this morning. St. Patrick's was completed in 1878 on the designs of architect James Renwick, Jr.

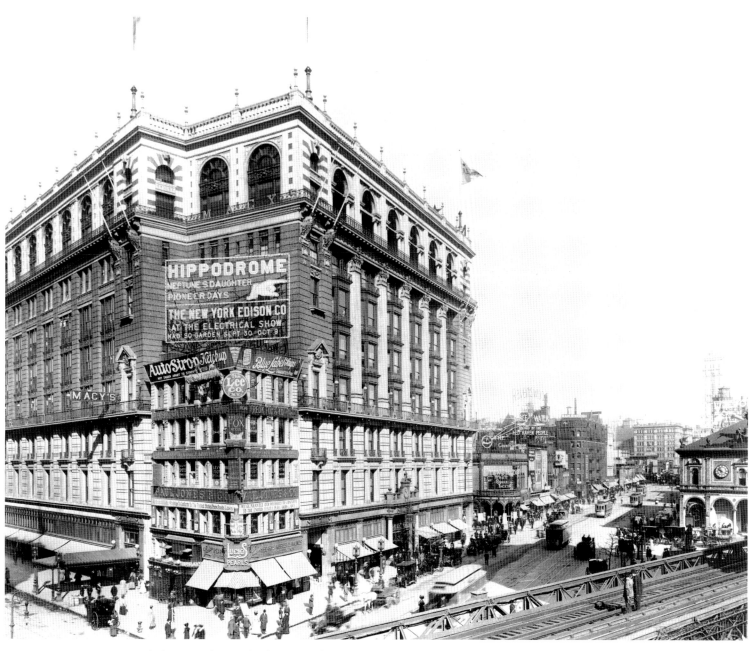

Founded in 1858 by Rowland Macy and touted as the world's largest department store, Macy's at Broadway and 34th Street in Manhattan covers an entire city block. Built in 1902, the stone building in two contrasting colors is nine stories tall, but there are ten shopping floors, including the basement. On the Beaux-Arts exterior, two early twentieth century white marble caryatids carved by J. Massey Rhind support an entablature. Huge arched windows adorn the top floor, and four-story-tall columns separate bays on the Broadway façade.

Troy, opposite Albany on the Hudson River, became well known for manufacturing collars, cuffs, and shirts. Cluett, Peabody and Company, the makers of Arrow shirts and collars, became the premier and longest-lasting operation of the kind in the world, manufacturing products into the 1980s. Employees shown here sit at long tables sewing Arrow shirts early in the twentieth century.

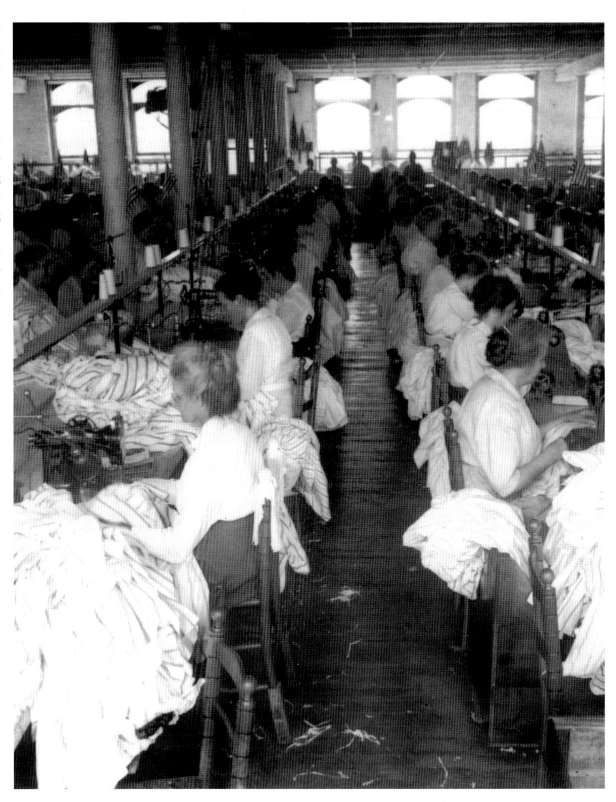

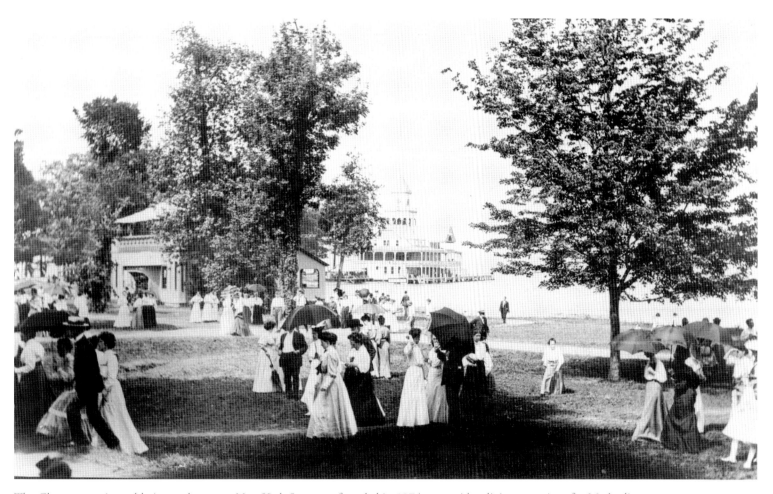

The Chautauqua Assembly in southwestern New York State was founded in 1874 to provide religious meetings for Methodists for two weeks in the summer. It soon expanded to include secular subjects and became nondenominational. Today, Chautauqua Institution offers programs in music, art, politics, religion, education, and science through the entire summer and fall. The 750-acre Victorian village is a designated National Historic Landmark and a remarkable architectural phenomenon. Here in 1908, institution guests socialize on the Promenade next to Chautauqua Lake.

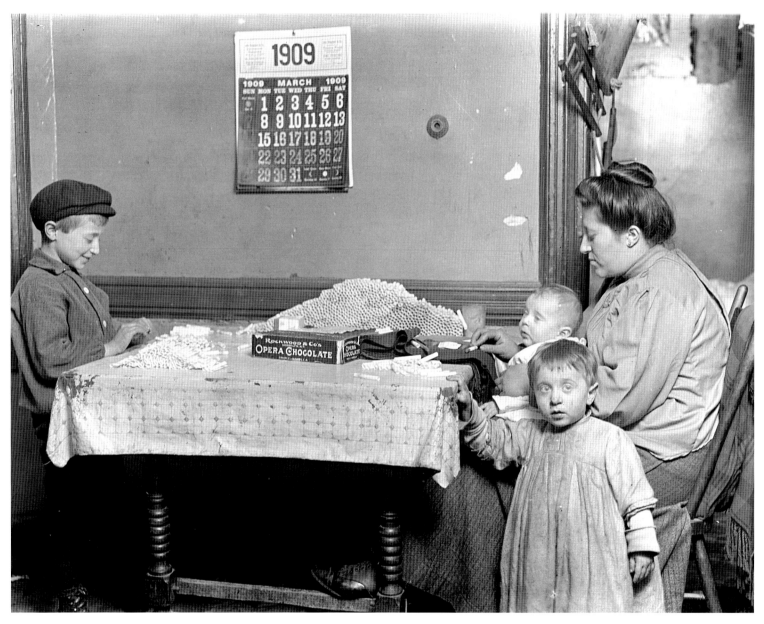

An immigrant widow and her son roll papers for cigarettes on a kitchen table in a dilapidated New York City tenement apartment in March 1909. A pile of completed rolls sits on the table. Well-known photographer Lewis Wickes Hine traveled the nation for ten years beginning in 1907 documenting child labor. His work for the National Child Labor Committee contributed to the effort to end the practice.

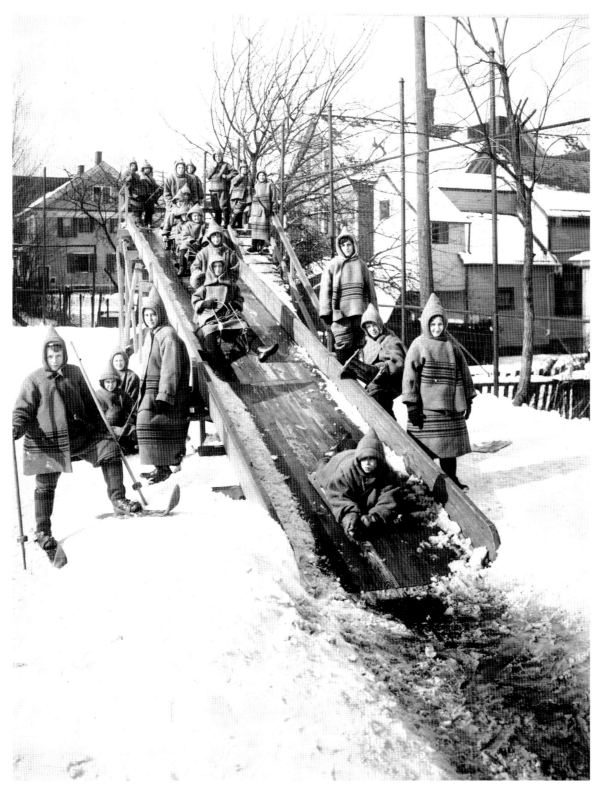

On a wintry day in the 1910s, schoolchildren ride sleds down a chute constructed of wood in the playground of a Rochester elementary school. The incline was kept slippery with repeated applications of snow. The children all wear identical hooded winter coats, suggesting that they were enrolled in a private school.

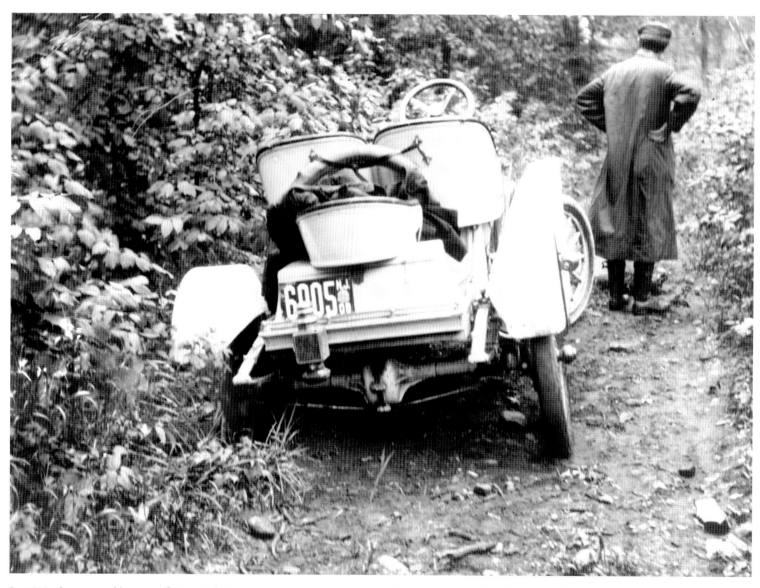

In 1909, the unpaved byways of New York State seem to be dualing with this New Jersey motorist. Unclear is whether the motorist or the roadster betrays the greater frustration.

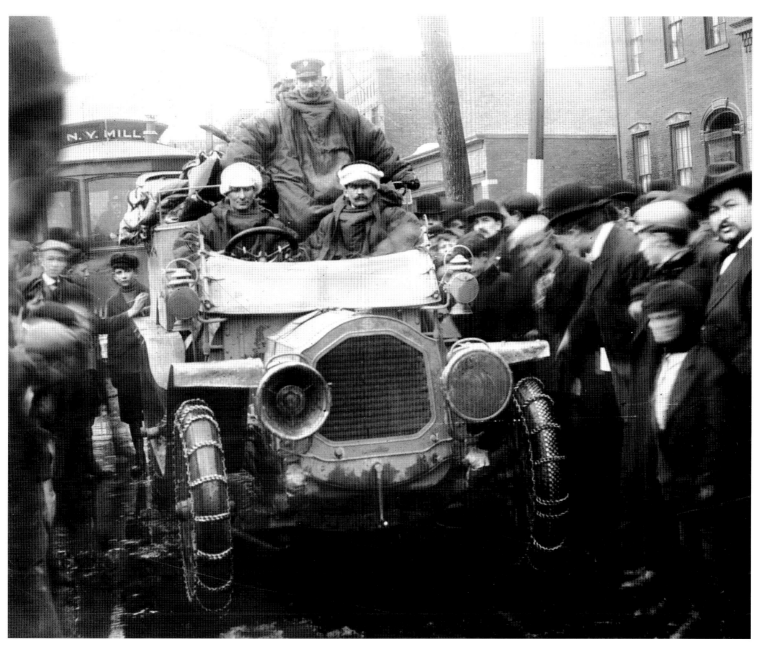

The New York to Paris Auto Race of 1908 is legendary, with teams from France, Germany, Italy, and the United States competing. The race was a grueling around-the-world contest, beginning in Manhattan's Times Square on February 12, then to Chicago, San Francisco, Seattle, north to Alaska, thence by ship to Japan, and on to Asia and Europe through Vladivostok, Berlin, and ending at the Eiffel Tower in Paris. Americans won the event in the Thomas Flyer, built in Buffalo and driven by George Schuster of Buffalo. Here is the De Dion car, competing for France, making its way through Utica near the beginning of the race. The De Dion would fall out of the race in Siberia, where the drivers' nerve was overcome by frigid temperatures and fear of banditry.

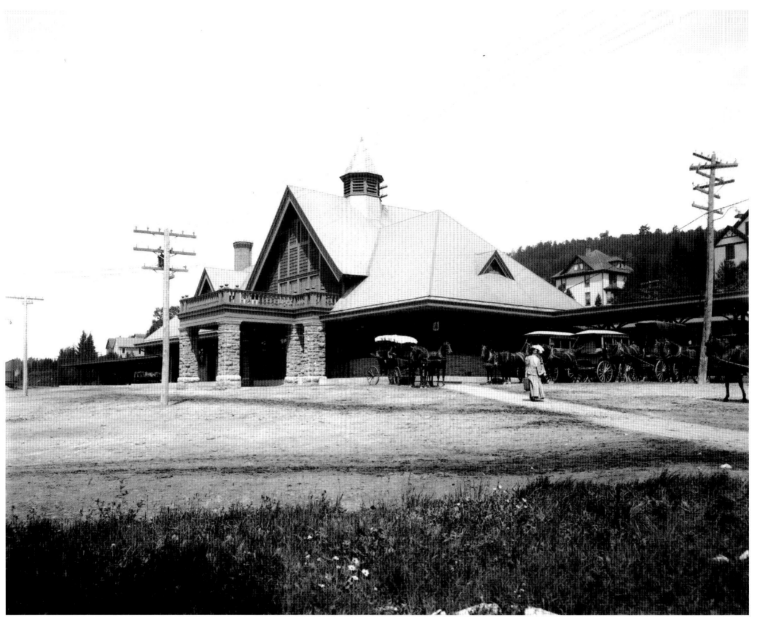

Union Depot in Saranac Lake, in the Adirondack Mountains, was built in 1904 by the Delaware and Hudson Railroad, which consolidated New York Central service from the west and the Chateaugay Railroad from the east. Between 1904 and 1940, railroads were the principal means for visits to the Adirondacks, and the D&H ran 18 to 20 scheduled passenger trains to and from Saranac every day in summer months. The picturesque station now houses historic exhibits, and the ticket office also serves the Adirondack Scenic Railroad, which offers scenic excursions between Saranac Lake and Lake Placid.

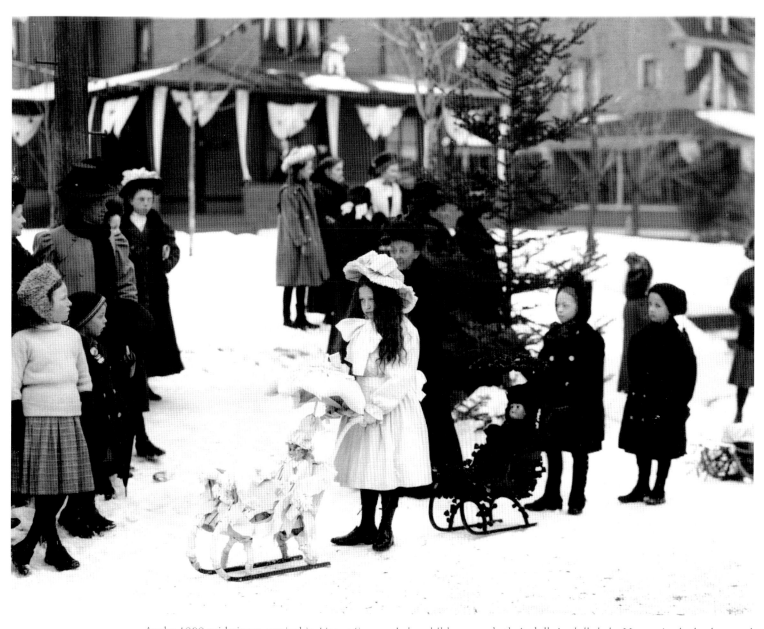

At the 1909 midwinter carnival in Upper Saranac Lake, children parade their dolls in doll sleds. Houses in the background are decorated with bunting. The carnival was first held in 1898 and still flourishes today as a popular annual event.

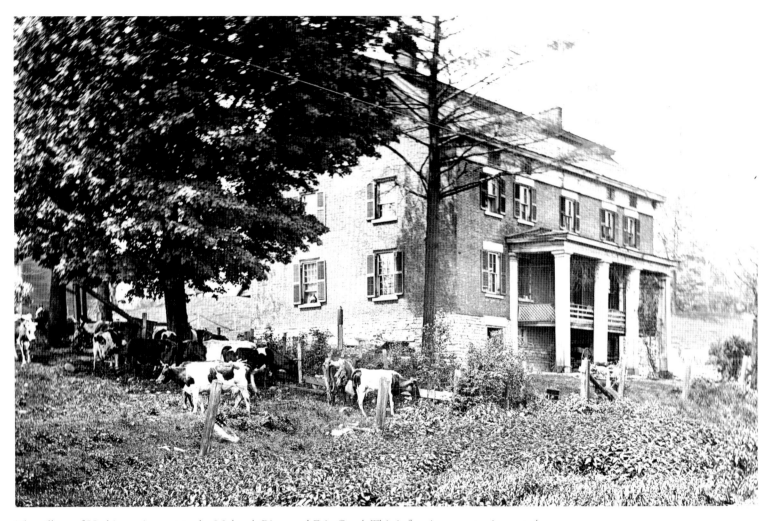

The village of Herkimer sits next to the Mohawk River and Erie Canal. This is farming country in central New York State. Shown with cattle grazing around a large tree, this nineteenth-century farmhouse near Herkimer featured a gambrel roof with chimneys at both end gables and a five-bay façade with a two-story portico and Doric columns supporting the porch roof.

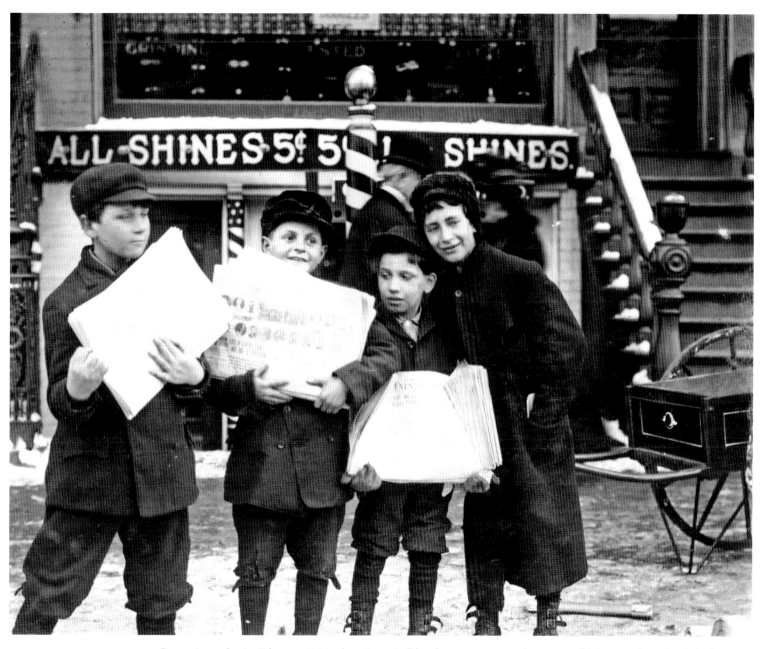

On a wintry day in February 1910, three "newsies" hawk newspapers on the streets of Schenectady. Behind the boys is a barbershop advertising shoe shines for a nickel. Newsies were among the subjects of special focus by photographer Lewis Hine in his work for the National Child Labor Committee.

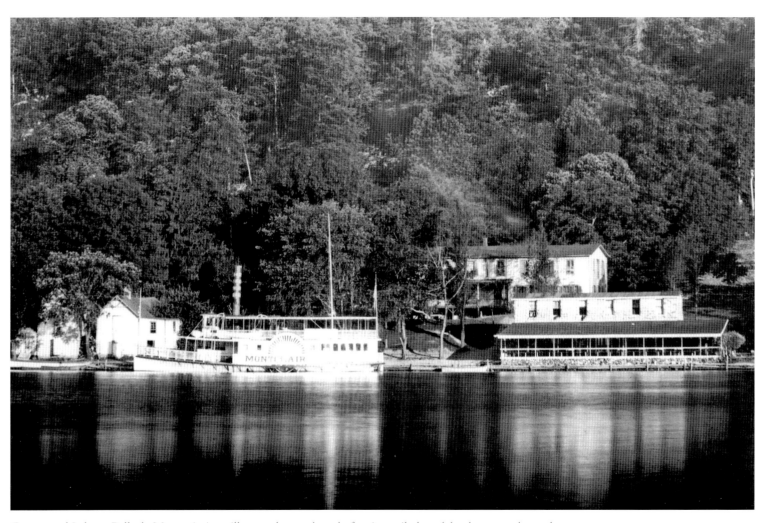

Greenwood Lake at Bellvale Mountain is a village at the north end of a nine-mile-long lake that extends south across the state line. Here in 1910, the village boasted a paddle-wheel tourist boat, the *Montclair,* which provided scenic excursions along the lake. Just 50 miles from New York City, Greenwood Lake remains a resort destination today, with the Appalachian Trail traversing Bellvale Mountain.

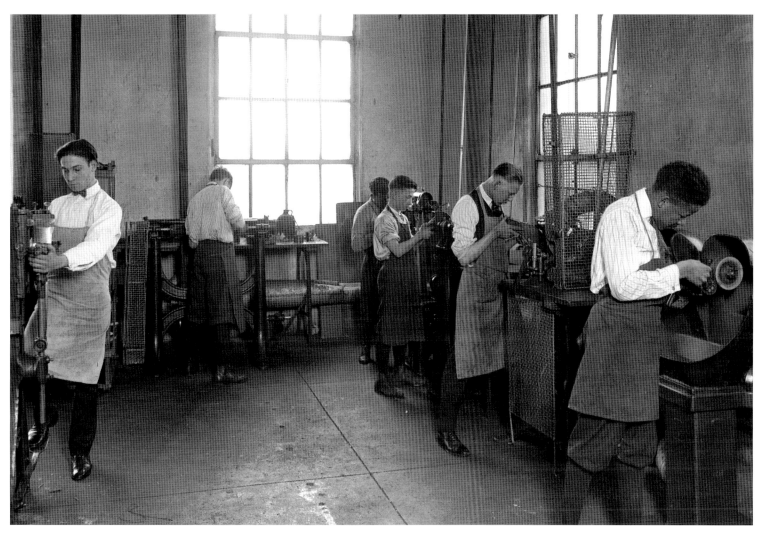

Shown here is a high school industrial arts class in 1910 at the Seneca Day Vocational School in Buffalo. The young men are working at grinders and other machinery.

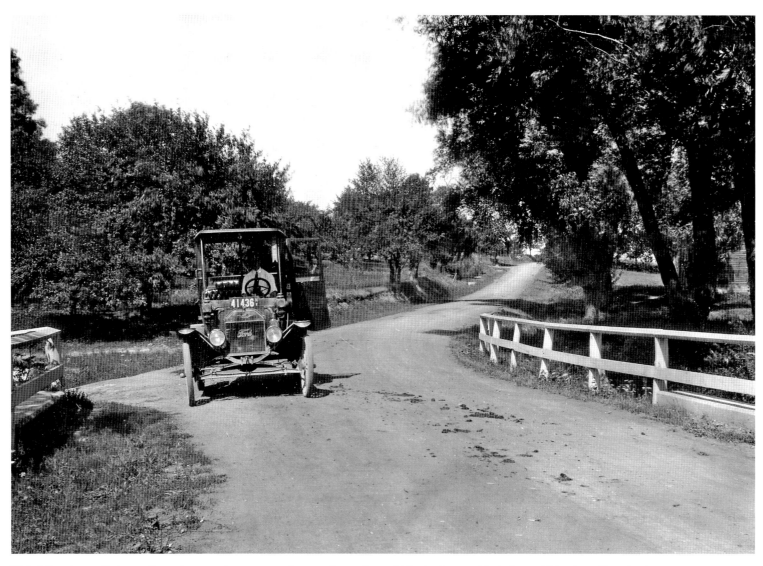

This fellow has pulled over for a photograph on a secondary road near Stone Ridge in August 1911. Stone Ridge is a village in the Shawangunk Mountains south of the Catskills. The automobile is an early Ford sedan.

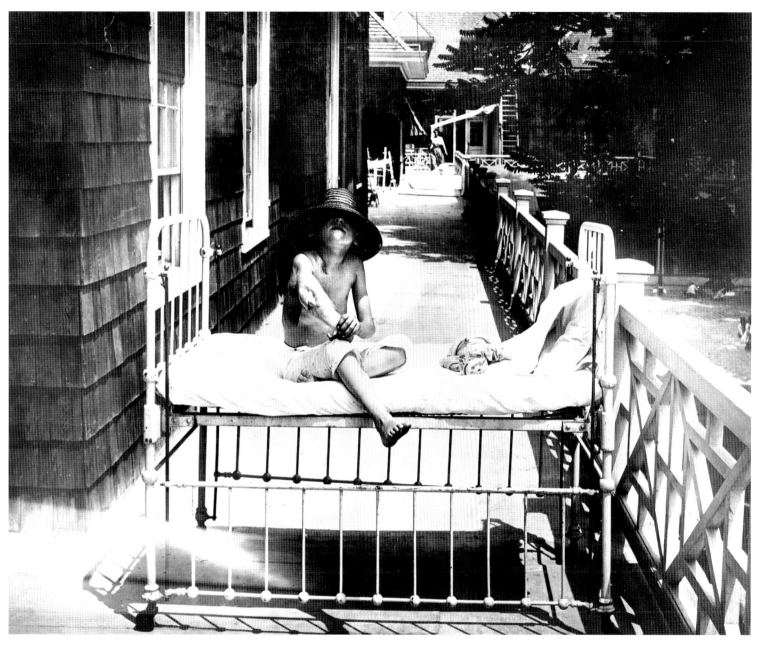

The Sea Breeze Hospital on Coney Island in Brooklyn treated children with surgical tuberculosis, considered incurable at the time. The open-air treatment at Sea Breeze, however, had remarkable success. Sea air, good food (lots of eggs and milk), and salt-water bathing were the formula for conquering the disease. The hospital could hold only 43 patients at a time, so there was a long waiting list. In this image from the early 1900s, a tubercular child displays a seriously infected arm from his hospital bed in the fresh air.

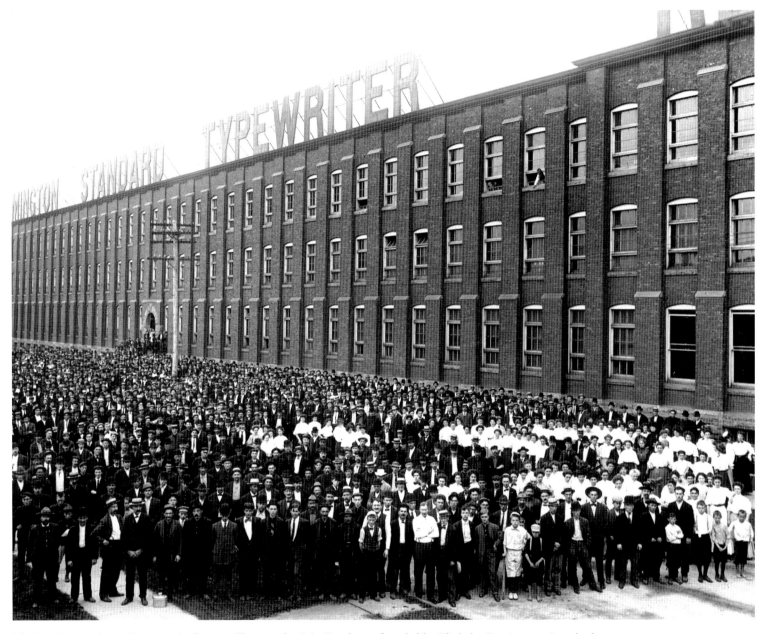

The Remington Arms Company in Ilion, a village on the Erie Canal, was founded by Eliphalet Remington, Jr., who became enormously successful after inventing a superior rifle. He purchased the patent for the first typewriter and began manufacturing Remington typewriters in 1873. By 1911, when this image was recorded, the Remington Standard Typewriter plant was huge, and the employees numbered in the hundreds when they gathered for this picture. Not to be confused with Eliphalet, Frederic Remington of Canton, New York, grew famous as a sculptor and painter of scenes of the American West.

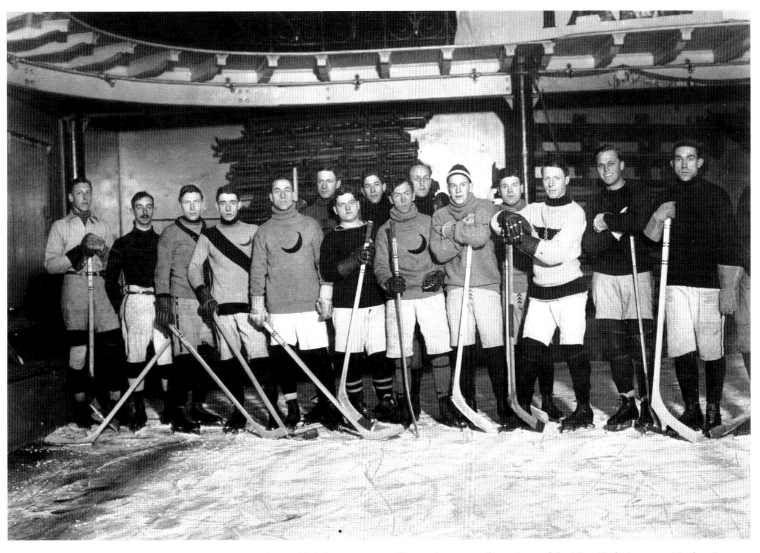

The Crescent Athletic Club of Brooklyn (called "New Mooners") were longtime champions of the New York Amateur Hockey League. They won first place in the league in 1900, 1901, 1902, 1903, 1905, 1906, 1908, and 1911. Their chief competitor was the New York Hockey Club. A couple of their historic games were particularly exciting, including those played on March 9, 1902, and January 20, 1905, at the St. Nicholas Rink. Members of the Crescent Athletic Club pose for a group shot here in 1911.

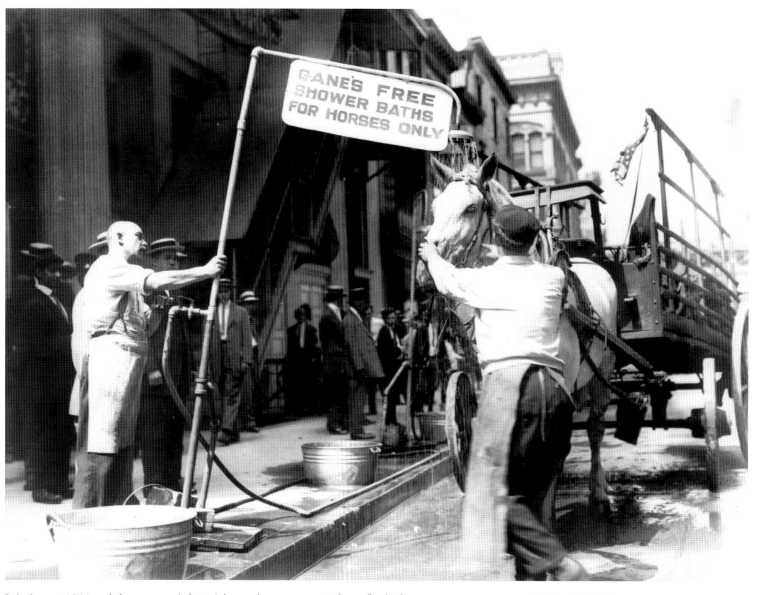

It is August 1911 and the summer is hot. A horse shower connected to a fire hydrant was set up on a street in New York City to provide a cooling shower bath to hard-working horses.

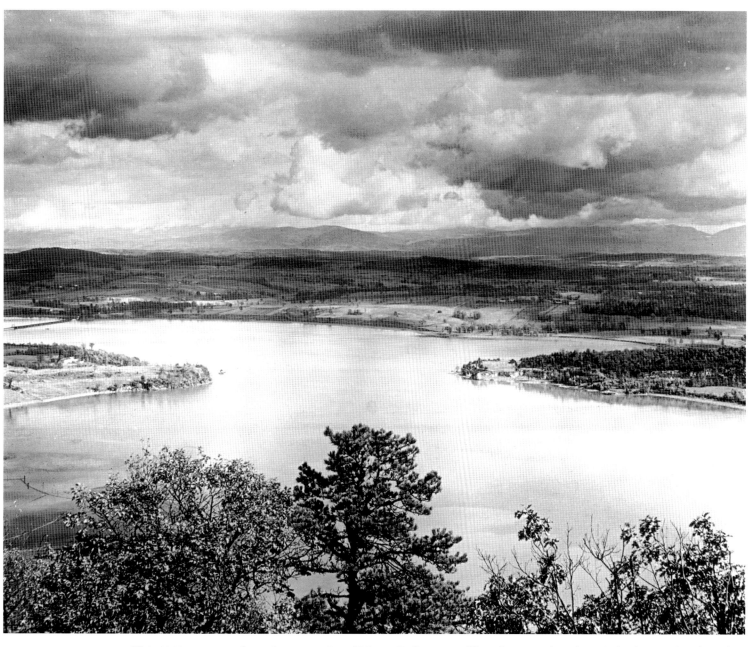

This 1911 panorama from the perspective of Mount Defiance near Ticonderoga in the Adirondacks shows Lake Champlain at one of its narrowest points. The vista faces east toward Vermont. At left is the location of Fort Ticonderoga, and on the peninsula at right stood Fort Independence in Vermont.

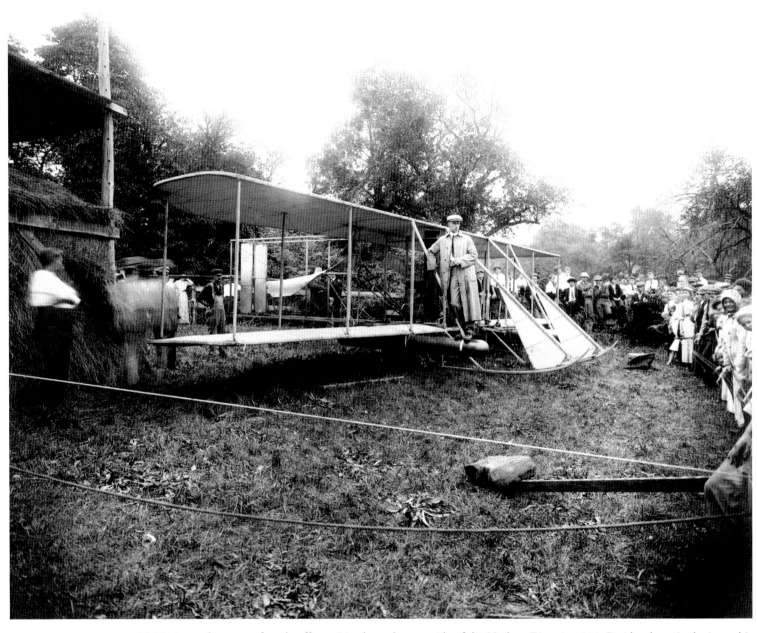

H. N. Atwood prepares for takeoff near Nyack on the west side of the Hudson River in 1911. Besides the paired wings, this early airplane has runners rather than wheels. The design seems to be based on the original Wright brothers Flyer of 1903, with modifications that include the triangular sails above the front runners. A large crowd has gathered to witness the event.

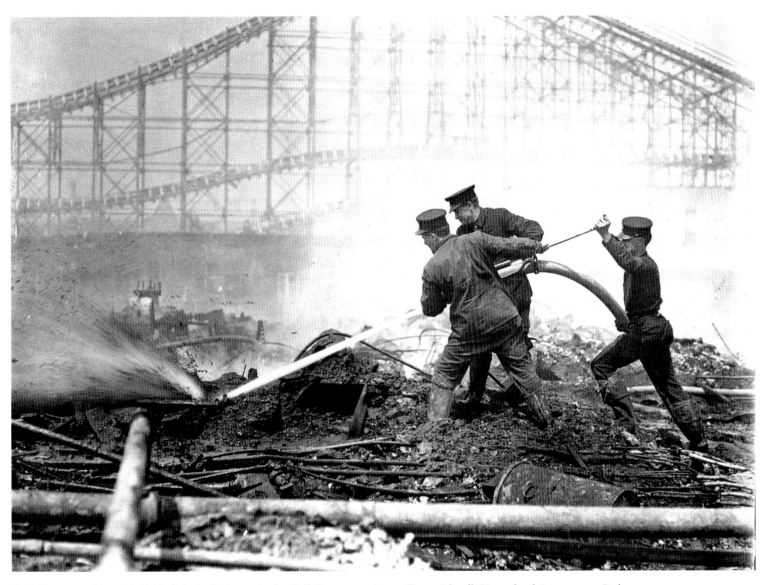

At 2:00 A.M. on May 27, 1911, light bulbs burst in the Hell Gate attraction at Coney Island's Dreamland Amusement Park. The burst bulbs ignited buckets of tar, creating a fire that quickly engulfed the park. Burning for 18 hours, the fire destroyed all of Dreamland except for the roller coaster in the background, which was untouched. Three firemen are shown here extinguishing the final remnants of the historic blaze.

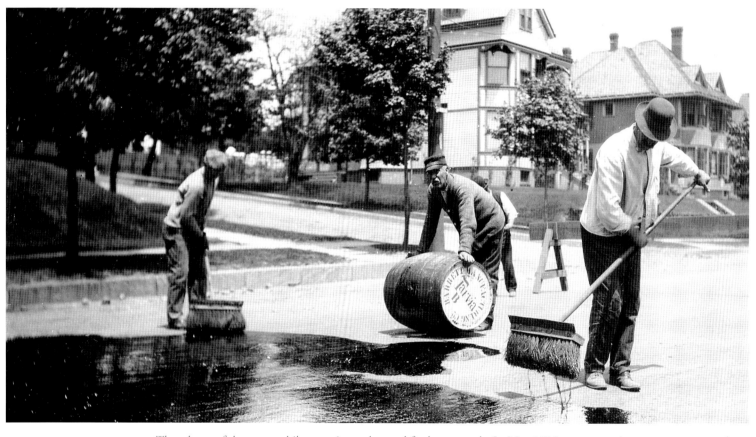

The advent of the automobile gave rise to the need for better roads. In May 1912, a street maintenance crew spreads an experimental material as a sealant on a road in Jamaica, Queens, Long Island. Created by the Barrett Manufacturing Company, Tarvia B did not require heating prior to application, yielding significant cost savings, according to a promotional pamphlet.

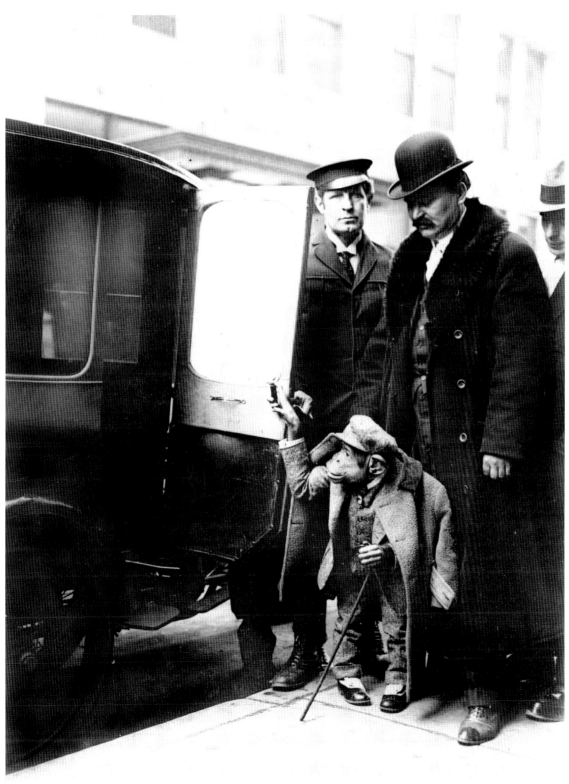

This well-dressed chimpanzee carries a cane and rides in a car. He is attended by a liveried driver and a distinguished gentleman in bowler hat and fur-collared winter coat. The sophisticated primate was spotted around 1910 in New York City near the Hippodrome Theatre at 756 Sixth Avenue, Manhattan, which featured circus acts.

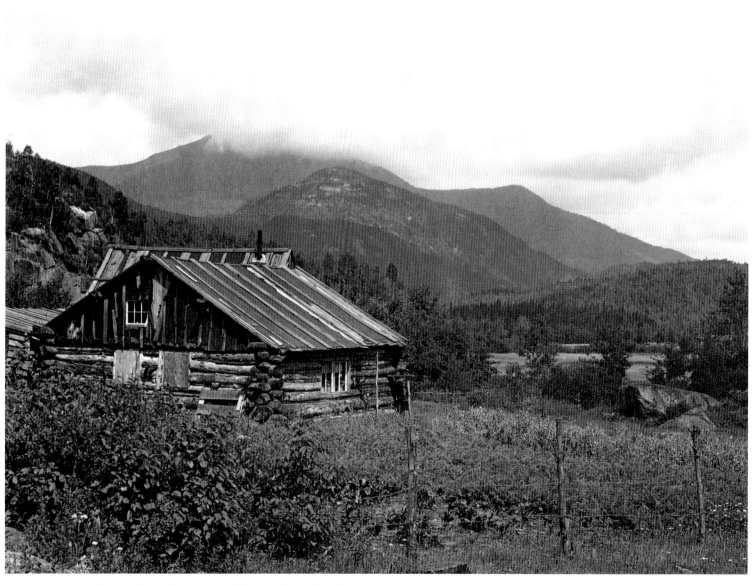

Mighty Whiteface Mountain in the northern Adirondacks is shrouded in clouds in this 1912 image, which faces north from Wilmington Notch in Essex County. In the foreground is an Adirondack-style log cabin. The Adirondack architectural style borrowed from the Swiss chalet style. In the construction of this cabin, whole logs rather than half logs were used.

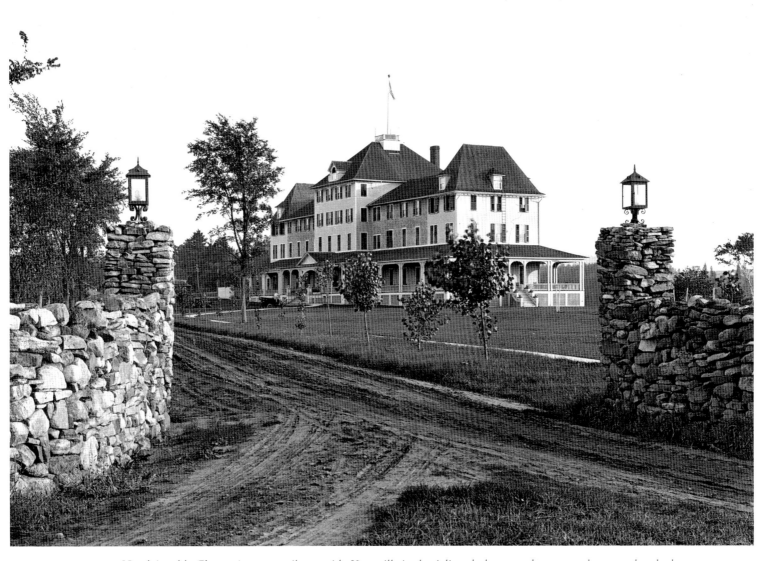

Hotel Ausable Chasm, just two miles outside Keeseville in the Adirondacks, was a large, popular resort hotel where guests came to explore the dramatic Ausable Chasm gorge created 500 million years ago by the Ausable River, whose headwaters start at Mount Marcy. The breathtaking natural phenomenon has been a favorite destination since 1870. And the grand Hotel Ausable Chasm, with its stone entrance wall, its wraparound porch, fine accommodations, and scenic outlook over the chasm was the place to stay until 1954, when it burned to the ground.

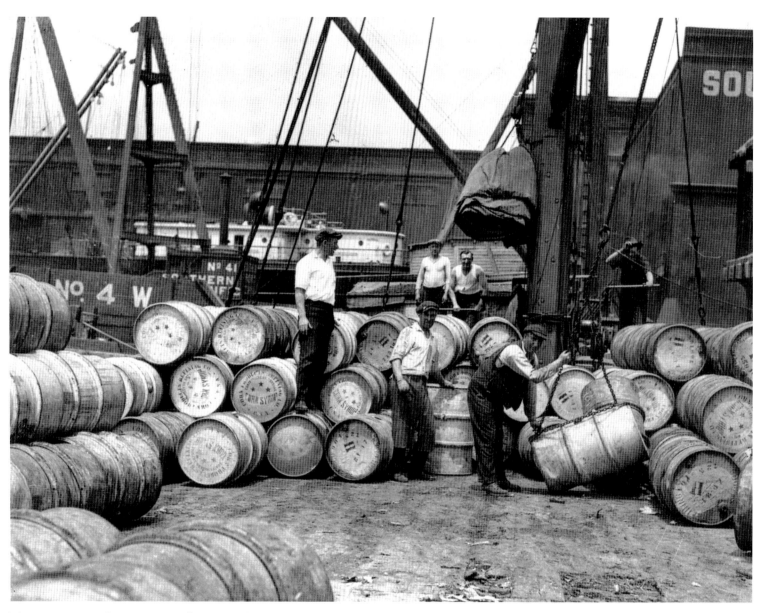

This is a Lewis Wickes Hine image from 1912 depicting stevedores on a New York City dock loading barrels of corn syrup onto a barge on the Hudson River. Raised in Wisconsin, Hine moved to New York City in 1901, rising to become an accomplished member of his profession. His subjects include Ellis Island immigrants, Red Cross relief efforts during World War I, construction of the Empire State Building, and his work for the National Child Labor Committee, examples of which also appear in this section. No longer patronized by the government late in life, Hine died at Dobbs Ferry, New York, in 1940, succumbing to the penury he had spent his life documenting.

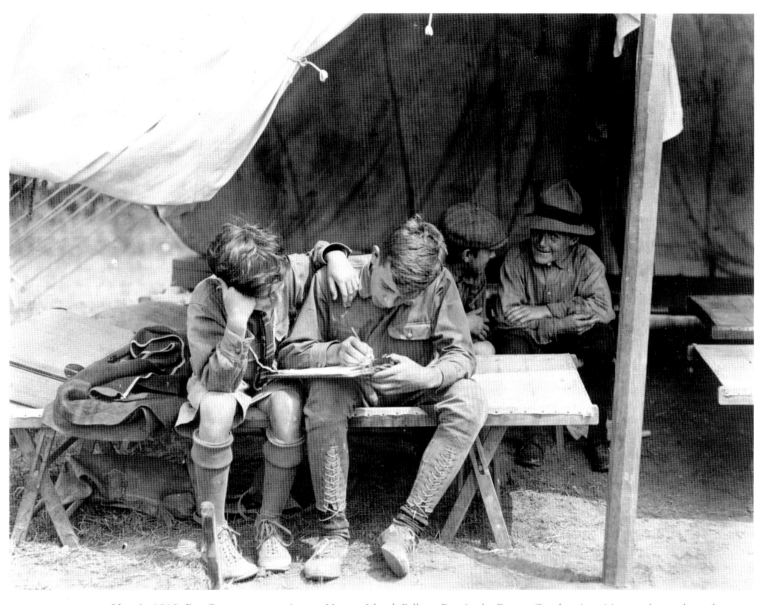

Here in 1912, Boy Scouts are camping on Hunter Island, Pelham Bay, in the Bronx. One boy is writing, perhaps a letter home to his folks. Hunter Island got its name from John Hunter, a wealthy auctioneer and farmer who once owned the island before the city of Bronx bought it. The Boy Scouts of America was founded only two years before this image was recorded.

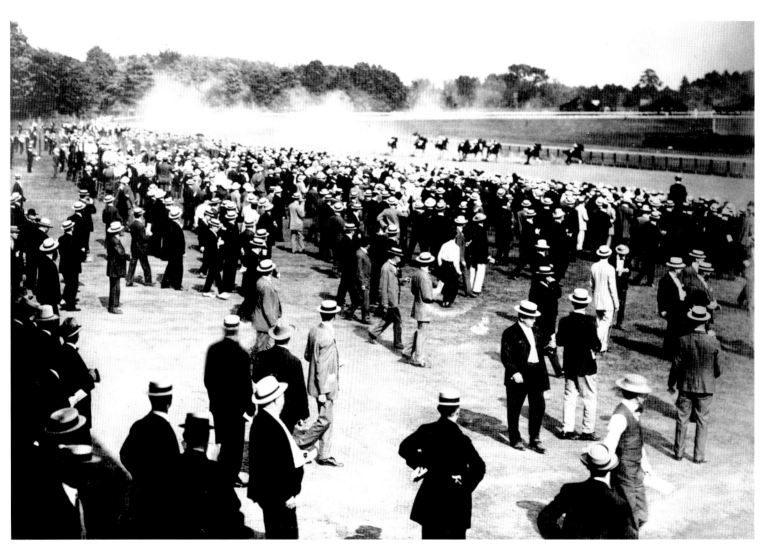

July and August are horse-racing months at the Saratoga Springs Race Course. Here in July 1913, crowds gather at the track as horses race by, raising dust as they pass. Saratoga's racetrack is the oldest continuously operating course in the United States, dating to 1863. The town of Saratoga Springs grew up around the mineral springs abundant here and once featured the Grand Union Hotel, in its heyday the largest hotel in the world. It was razed in 1953 to make way for a supermarket.

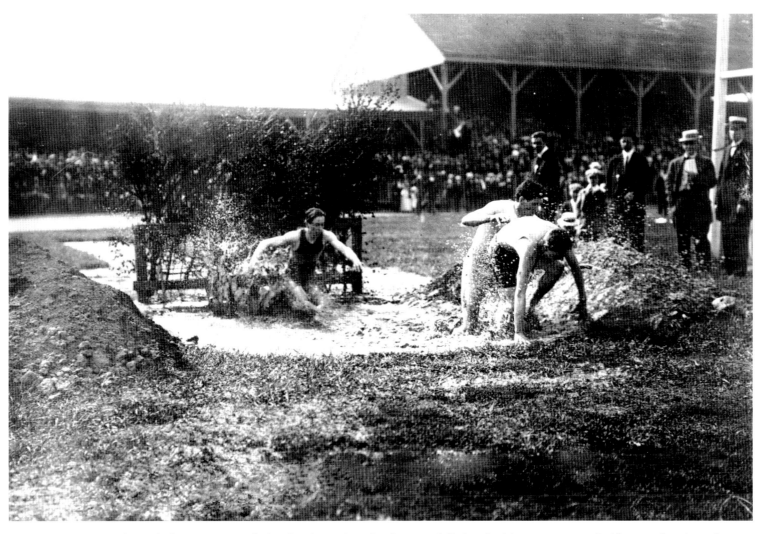

A steeplechase race normally involves horses jumping fences and ditches. In this case, a group of athletes perform in such a race using a fence in a ditch filled with water. This steeplechase in Celtic Park was held May 27, 1912. In the early twentieth century, the Association of Irish Athletics of America sponsored many athletic events in Celtic Park, located in Long Island City, Queens.

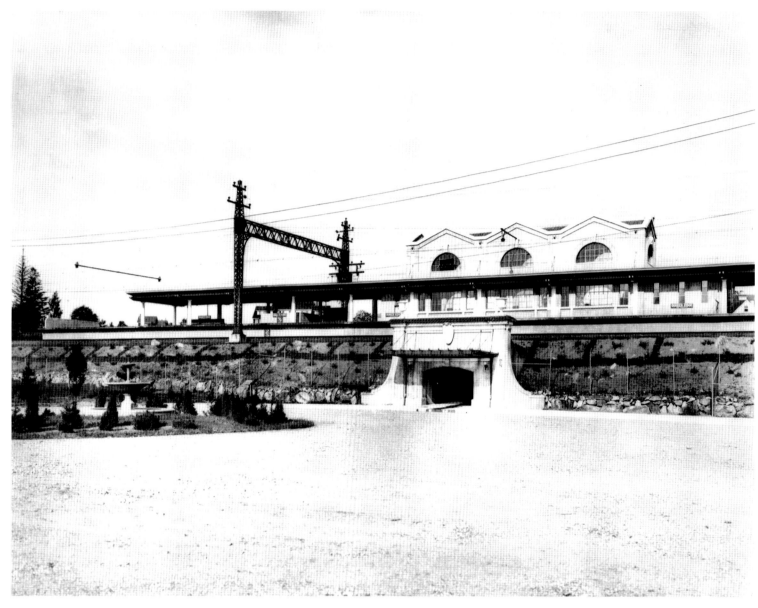

Here in 1913 is the Quaker Ridge railroad station in New Rochelle on the Long Island Sound in Westchester County. When the New York and New Haven Railroad opened a line with a stop in New Rochelle, it became famous as a summer resort and also as a residential community for New Yorkers who could afford to live there. The Quaker Ridge station is a stop on the New York, Westchester, and Boston Railroad line.

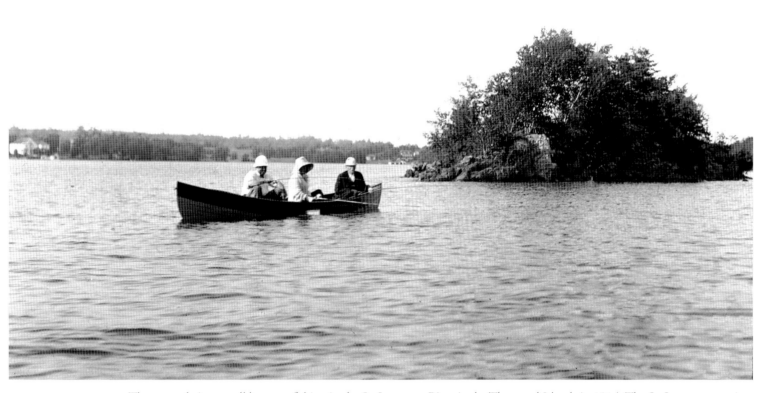

Three people in a small boat are fishing in the St. Lawrence River in the Thousand Islands in 1914. The St. Lawrence receives fresh water from Lake Ontario, which collects overflow from the other Great Lakes and carries it to the Atlantic Ocean. The U.S.-Canadian boundary runs roughly down the middle of the river, dividing the islands somewhat equally between the United States and Canada. At the turn of the century, one of the islands became home to Singer Castle, owned by Singer sewing machine company president Frederick Bourne.

In 1914, Harry Houdini (1874–1926), world-famous escapologist, was tied up and put into a packing crate along with 600 pounds of iron weights and lowered into New York Harbor. He escaped in 2 minutes and 55 seconds. In 1918, he became the sensation at New York City's Hippodrome when he made a ten-thousand-pound elephant disappear from a brightly lit stage. Houdini also owned a brownstone in Harlem. The well-known photographer Carl Dietz recorded this image.

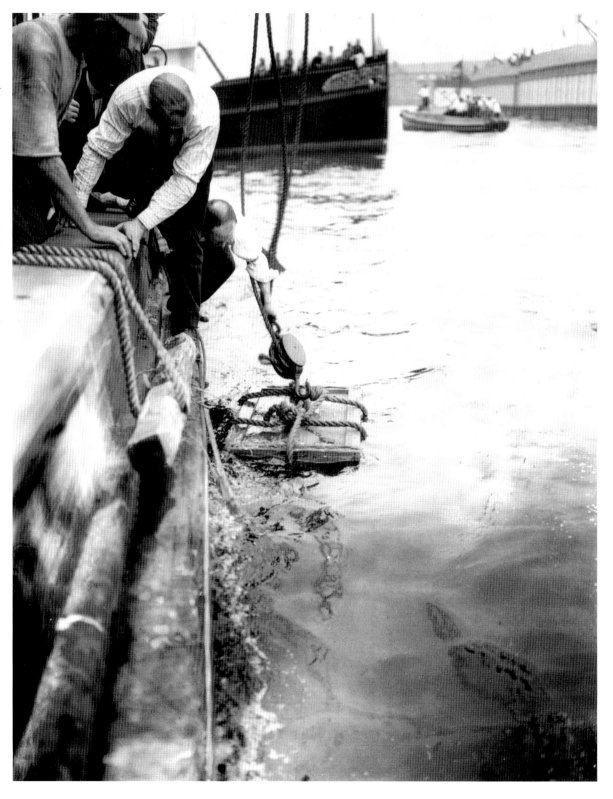

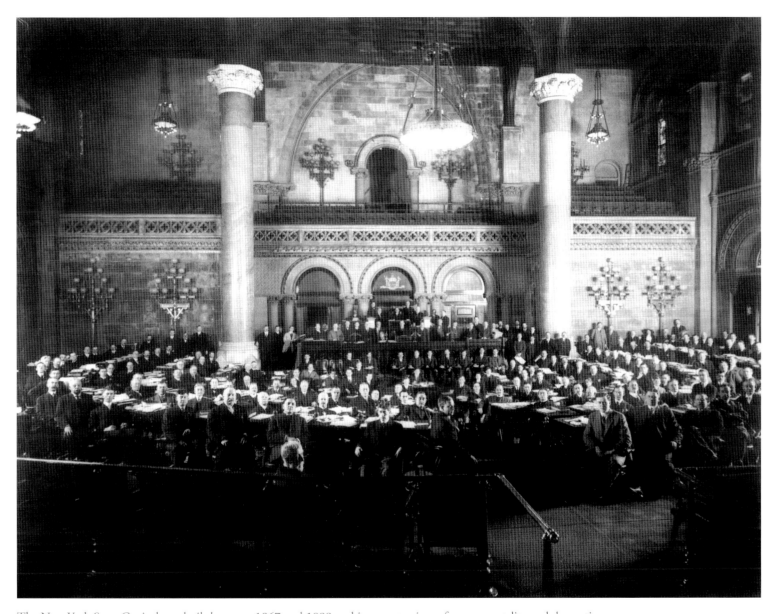

The New York State Capitol was built between 1867 and 1899 and is a masterpiece of monumentality and decorative design. One of America's greatest architects, Henry Hobson Richardson, is principally responsible for its finished grand appearance. Here is the Assembly Hall in 1913, with its immense two-story marble columns and Romanesque arches. Albany has been capital of the state of New York since 1797.

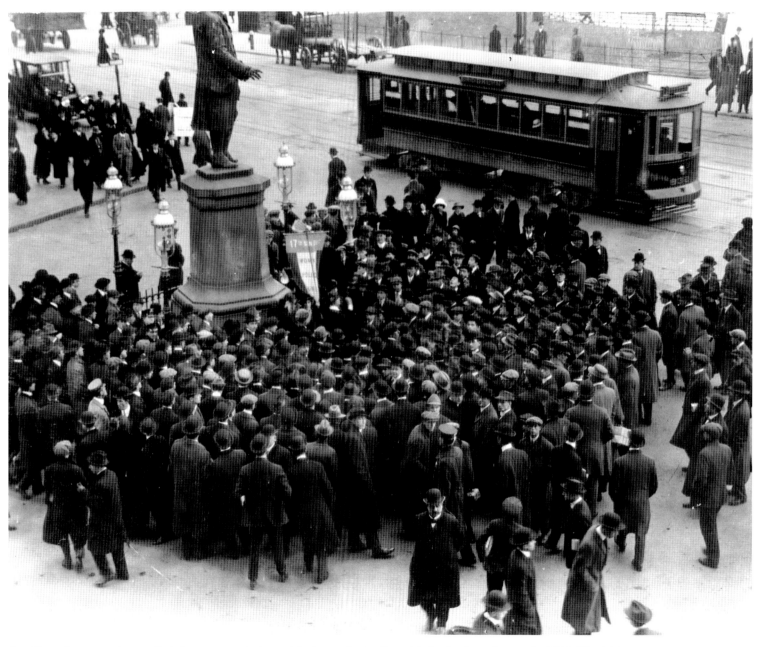

A suffrage demonstration on Park Row, a street in lower Manhattan in the financial district, is under way in 1913. The 19th amendment to the U.S. Constitution, giving women the right to vote, would not become law until 1920.

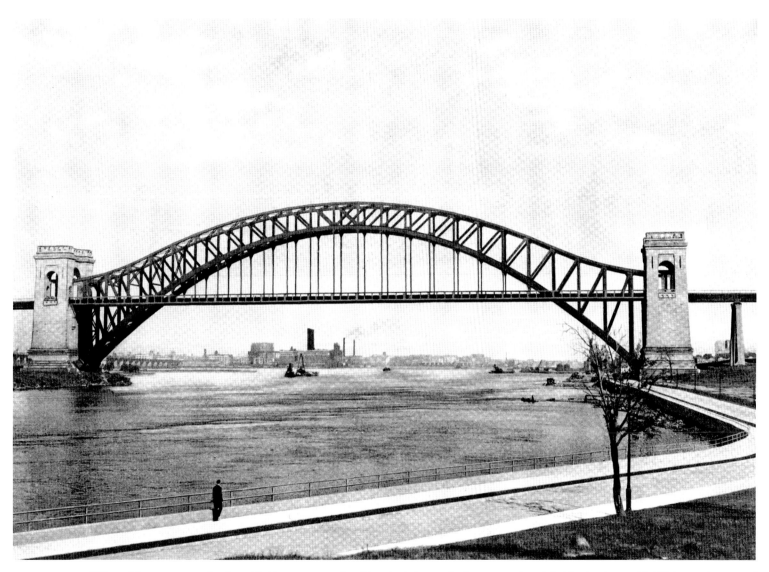

When this monumental railroad bridge was completed in 1916, it was the longest steel-arch bridge in the world. With a main span of 977 feet, the Hell Gate Arch Bridge spans the East River at Hell Gate, New York City, and at one time could accommodate four New York–to–Boston trains side-by-side. Gustav Lindenthal, an Austrian-born American civil engineer, designed the structure. The stone towers at each end of the bridge do not provide support; they are there for aesthetic reasons to give the bridge a solid appearance.

Shown here in June 1914, the anarchist Alexander Berkman, accompanied by Helen Harris and other anarchists, arrives in Tarrytown in an organized attempt to speak against the actions of John D. Rockefeller, who lived in the area. A Russian emigrant, Berkman had arrived in the U.S. in 1888, becoming a writer and leading member of the anarchist movement here. When he attempted to assassinate Henry Clay Frick, industrialist and philanthropist, Frick survived but Berkman spent 14 years in prison. After serving time for conspiracy to oppose the draft in 1917, Berkman and co-anarchist Emma Goldman were deported to Russia, where Berkman supported the Bolshevik Revolution, until the Soviet use of violence and the repression of independent voices gave him second thoughts. Berkman committed suicide in 1936.

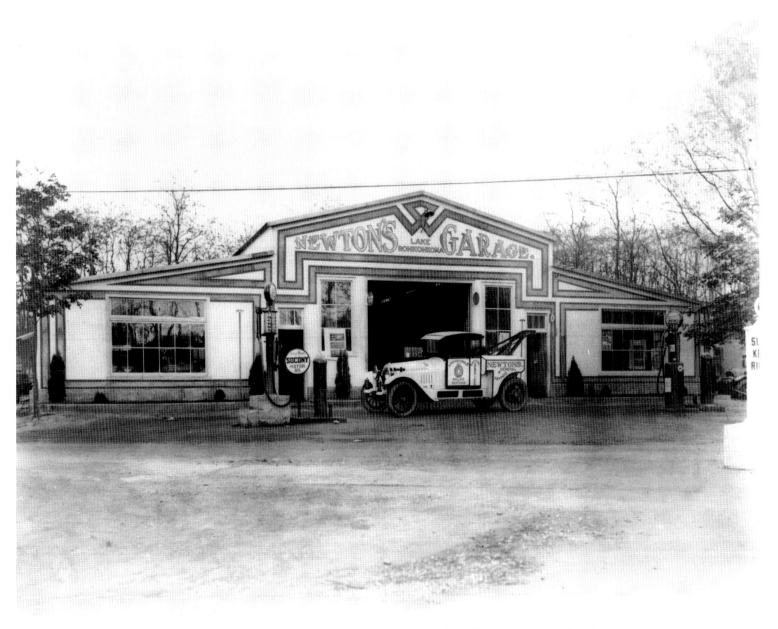

Newton's Garage did business in the village beside Lake Ronkonkoma—a large, oval-shaped lake one hundred feet deep in places, the largest on Long Island. The area was a well-known and fashionable summer resort during the era. Early filling stations typically featured whimsical architecture, and this garage is no exception. Columns flank the center entrance, large windows fill the façades of the side wings, and fancy geometric trimwork covers the face of the structure. Newton's "Locomobile" is parked proudly in front, ready for the next service call.

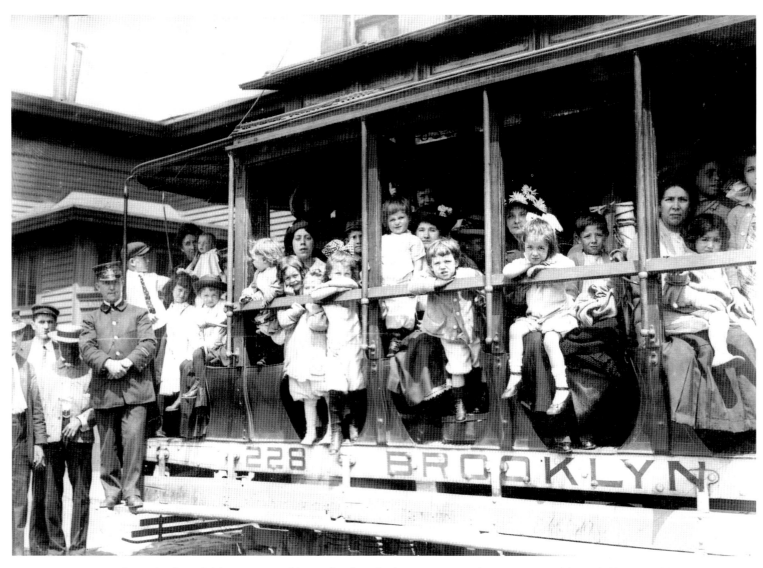

On June 2, 1913, mothers take their children on a Brooklyn trolley for a fresh-air outing. Fresh sea air was readily available—Brooklyn is located at the western end of Long Island and is surrounded by water on three sides. Early on a city in its own right, Brooklyn was joined with Queens, the Bronx, Staten Island, and Manhattan to become one of the five boroughs of New York City in 1898.

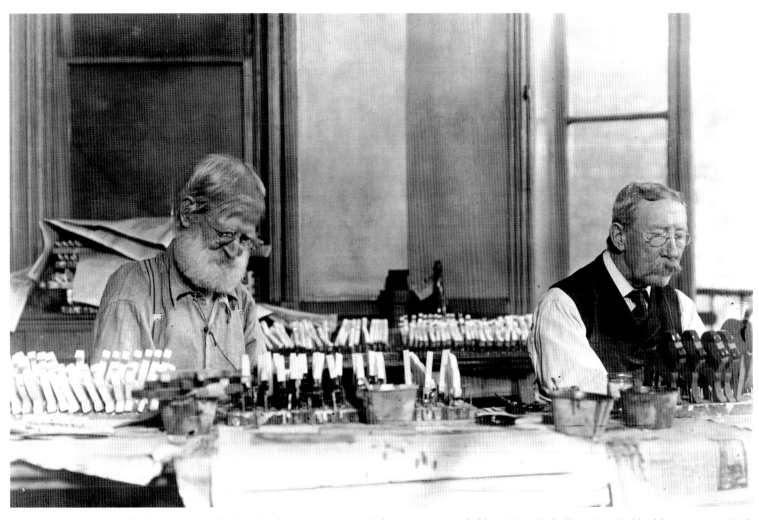

Two elderly men assemble handmade toys in a toy workshop in 1915, probably in New York City. New York's oldest toy store, FAO Schwarz, opened its doors in the city in 1870, its fame renewed in recent times in the movie *Home Alone 2*.

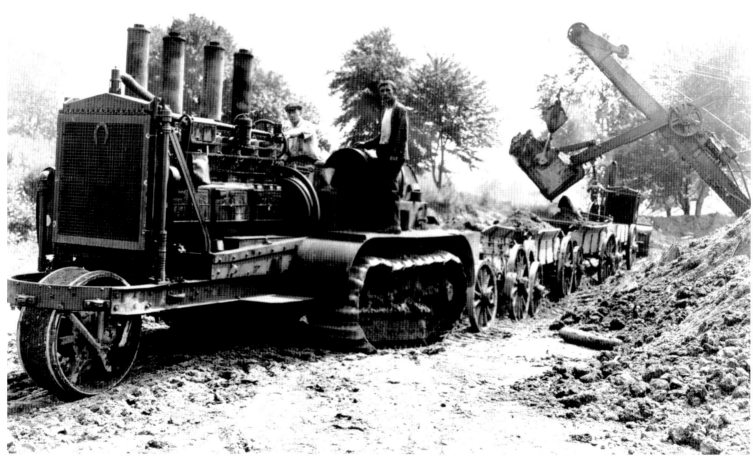

This is the kind of earth-moving equipment used in the early years of the twentieth century. Those familiar with mechanical apparatuses will have little difficulty decoding the purpose of the horseshoe nailed to the radiator at left. Here the machine is being employed to construct one of the earliest limited-access highways in America, the Bronx River Parkway, which parallels the Bronx River. Construction began in 1907.

The Turtle Bay neighborhood in Manhattan extends from 43rd to 53rd Street and from Lexington Avenue to the East River. At least it did when this photograph was taken early in the twentieth century. Today, the United Nations building stands where the bay itself once existed. A 40-acre tract that was once Turtle Bay Farm has evolved into an urban neighborhood of tree-lined streets and small-town sensations.

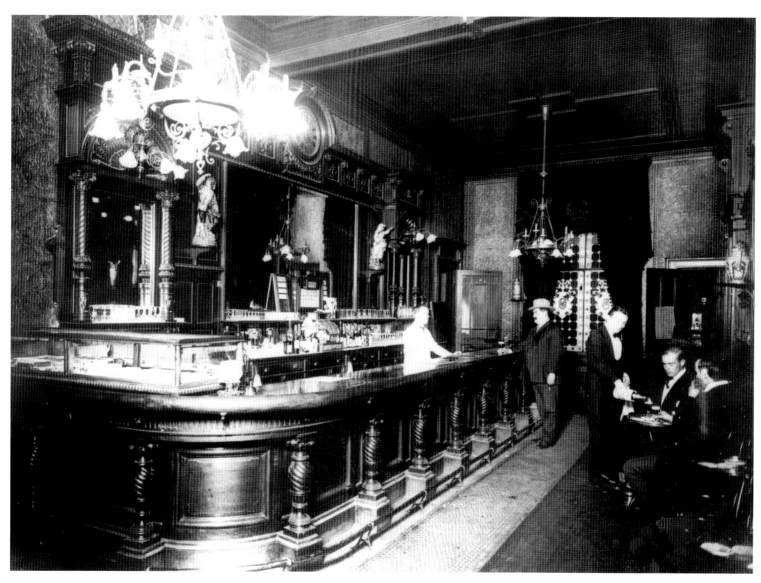

Here is the elegant barroom of the Arion Society Club, located on Park Avenue at 59th Street in Manhattan and photographed in 1915. Arion was organized in 1854 as a professional music and poetry club, named for the Greek poet and musician who lived and performed around 700 B.C. A long, heavy, carved-wood bar is shown, partly supported by wood columns incorporating a spiral motif, which is repeated in the mirrored back bar. Enormous Victorian chandeliers illuminate the space. Manhattan is home to more than a few bars dating to the nineteenth century, including the Ear on Spring Street, New Town on 18th, and McSorley's on East 7th.

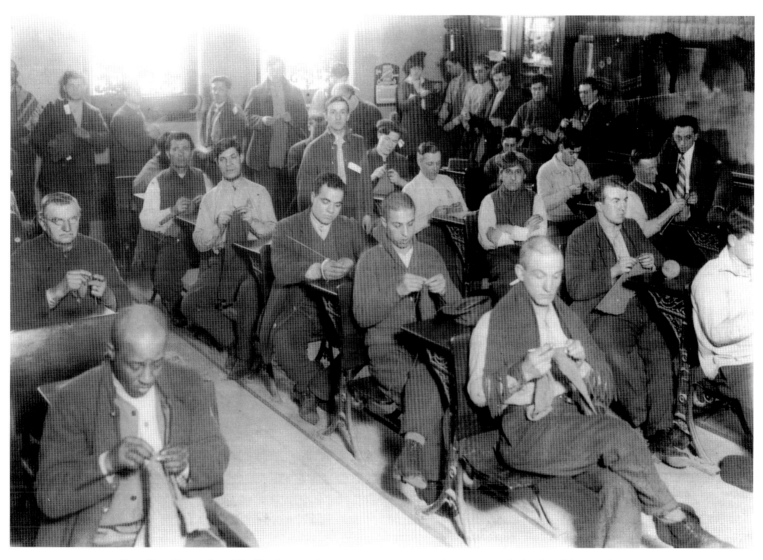

Sing Sing Correctional Facility is a maximum-security prison in Ossining on the banks of the Hudson River. The prison started in 1825 and today holds 1,700 inmates. In this 1915 image, prisoners sit in a classroom learning how to knit. The name "Sing Sing" comes from the Indian tribe Sinck Sinck, from whom the land was purchased. The words mean "stone upon stone," an appropriate appellation for the prison, which was built with marble excavated by prisoners from a nearby quarry.

The most iconic building on the Cornell University campus in Ithaca is the Jennie McGraw Tower, built in 1891 and shown here on June 4, 1915. The 173-foot-tall tower was designed by architect William Henry Miller, a Cornell alumnus. It stands adjacent Uris Library. Inside are the 1875 Seth Thomas clock with a 14-foot pendulum and 21 bells that not only mark the hours but also are played three times a day during the school year.

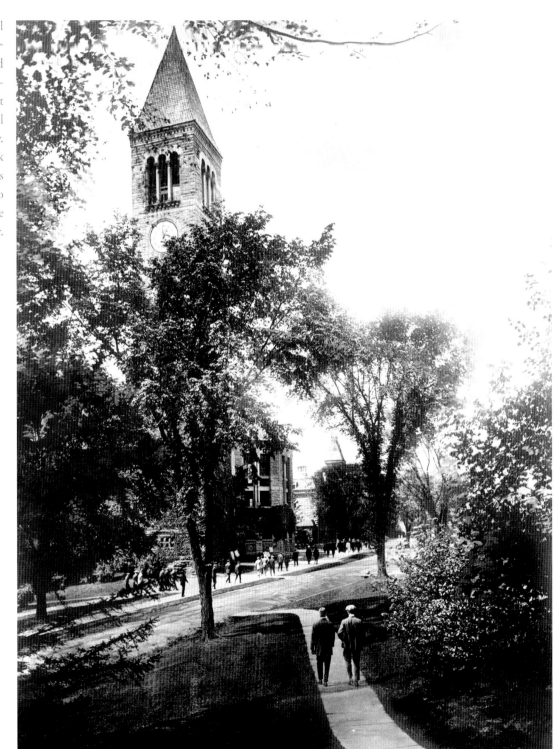

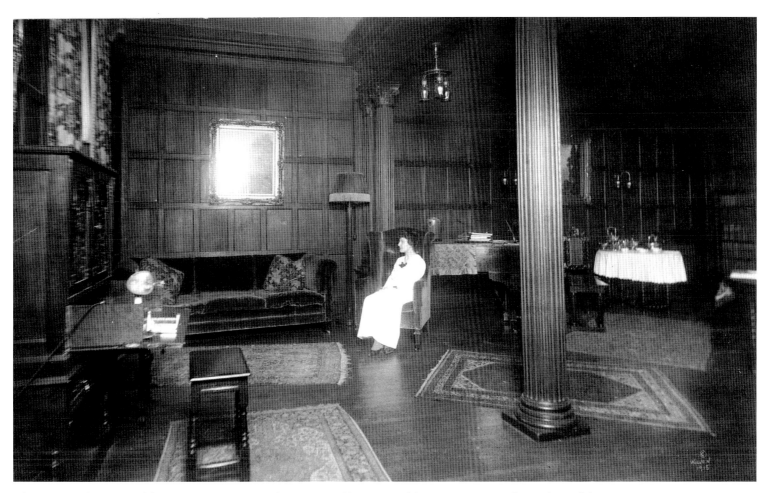

The senior parlor, pictured here in 1915, was opened at Vassar College in Poughkeepsie in 1895, with members of the senior class of 1895 contributing many articles of value and unique interest to their room. The parlor was designed in Colonial style with draperies in green and yellow, mahogany furniture, and Bocara rugs. On the walls are paintings by Corot and Millet, and in the background is a tearoom. Sitting for her photograph, one of the seniors relaxes in an easy chair.

A view down South Broadway in Nyack as it appeared in 1917. The image was recorded from the Burke Building, part of its Second Empire–style mansard roof appearing at right. The Hudson River flows at left, and on a clear day, New York City would be visible in the distance.

Wine, Women, Want, and War

(1917–1945)

In 1917, America began sending troops to Europe to fight in the First World War, which had begun in 1914. In August 1945, the Second World War ended. Between the end of the first war in 1918 and the beginning of the second in 1939, the United States experienced two contrasting periods. The first was the Roaring Twenties, a period of optimism and unconstrained lifestyles. The second was the Great Depression, a decade of extreme economic hardship that did not end until the nation mobilized for the Second World War. The contrast was vivid.

Prohibition of the manufacture, sale, and distribution of alcohol was mandated by the 18th Amendment to the U.S. Constitution in 1920 and continued until 1933, but it didn't stop all Americans from drinking. The long border between New York State and Canada offered plenty of opportunities to smuggle illegal liquor across Lake Ontario and the Thousand Islands. In fact, bootlegging was so prevalent that customs officials could do little to stop it. At least one officer was shot near Sackets Harbor while attempting to curtail the enormous inflow. Alcohol also entered easily at the other end of the state through the ports of Long Island and New York City, not to mention the many illegal distilleries operating inside New York and neighboring states. As a result, alcohol flowed freely in the many speakeasies and private clubs of New York's cities.

In the 1920s, a break with tradition arose and modernity prevailed. Art Deco as a style for everything from buildings to dinnerware dominated the arts and architecture with its zigzags, chevrons, and other geometric motifs. Jazz music blossomed, the lively Charleston became the most popular dance, and the young women who took to cigarettes were dubbed flappers, for their disdain for traditional norms and etiquette. Optimism about the future and enthusiasm for big profits in the stock market swelled stock prices to dizzying heights.

The New York stock market crash of October 29, 1929, put an abrupt end to the Roaring Twenties. The Great Depression that followed was a dismal contrast to the freewheeling decade. Personal incomes in New York State plunged by half to two-thirds. More than 60 percent of New Yorkers were classified as poor, and on average 25 percent of the American workforce was unemployed. Into this morass stepped Franklin Delano Roosevelt, a New Yorker from the Hudson River Valley, who became the 32nd president of the United States and who led the country through the depression and the Second World War during four terms in office. His ancestral home in Hyde Park on the shore of the Hudson River would be designated a National Historic Landmark by President Harry Truman.

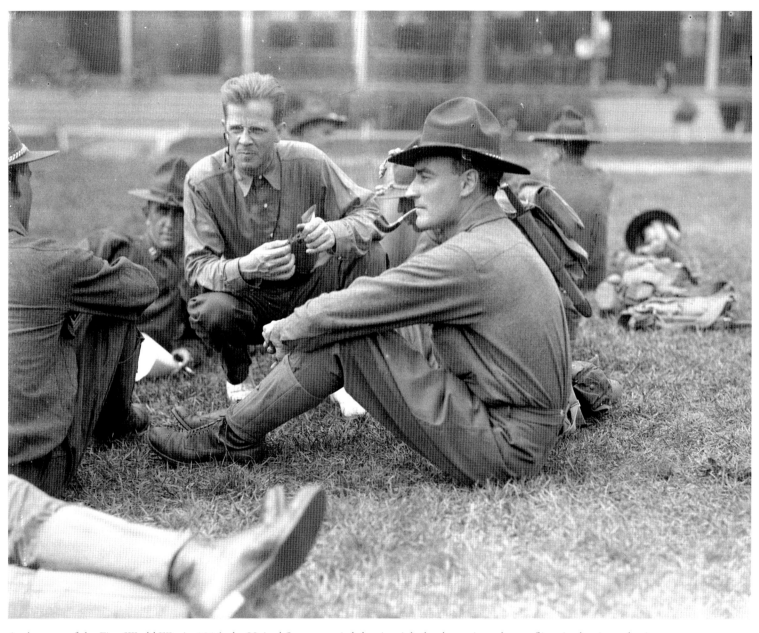

At the start of the First World War in 1914, the United States worried that it might be drawn into the conflict. At the time, the Army was small and the National Guard was insufficient for the prospects of fighting in Europe. To swell the ranks and the number of officers able to lead men into battle, conscription was instituted and a National Army Officer Candidate School was established in 1917 in Plattsburgh on Lake Champlain. In this image, officers-in-training relax on the school grounds.

A pageant promoting efforts of the American Red Cross in World War I was held on October 5, 1917, at Rosemary Open Air Amphitheatre in Huntington, Long Island. About 500 people were invited. Preceding the pageant was a concert by Lieutenant John Philip Sousa and his band of 230 enlisted men, and a dramatic masque was presented by a large contingent of famous stage actors from New York City, including Ethel Barrymore. The photograph shows the presentation group (at center) at a dress rehearsal.

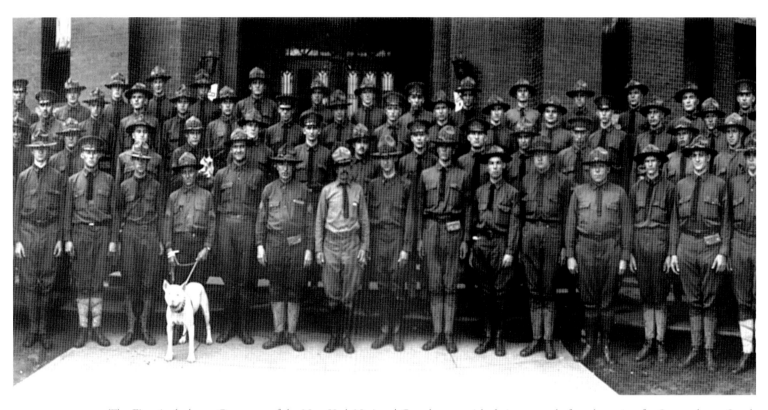

The First Ambulance Company of the New York National Guard poses with their mascot before departing for Spartanburg, South Carolina, in August 1917. There they will attend a training camp before being sent overseas. When the U.S. Congress declared war against Germany on April 6, 1917, the country was able to mobilize quickly.

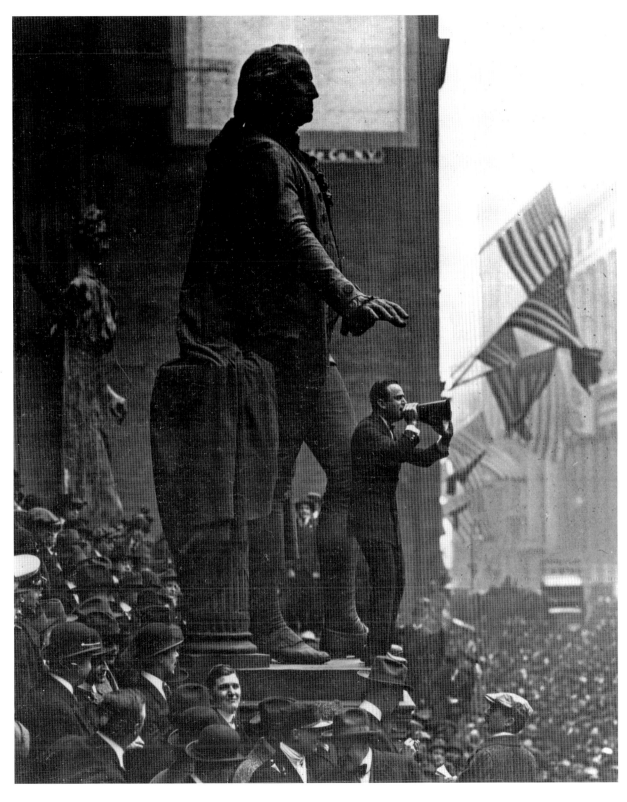

In April 1918, renowned Hollywood motion-picture actor Douglas Fairbanks, from the base of George Washington's bronze statue, exhorts the crowd at Wall Street in lower Manhattan to buy war bonds. The monumental statue stands at the top of the steps to Federal Hall National Memorial, an imposing marble building in Greek Doric style completed in 1842. It was here in 1789, in the original Federal Hall, that George Washington took the oath of office as the first president of the new republic.

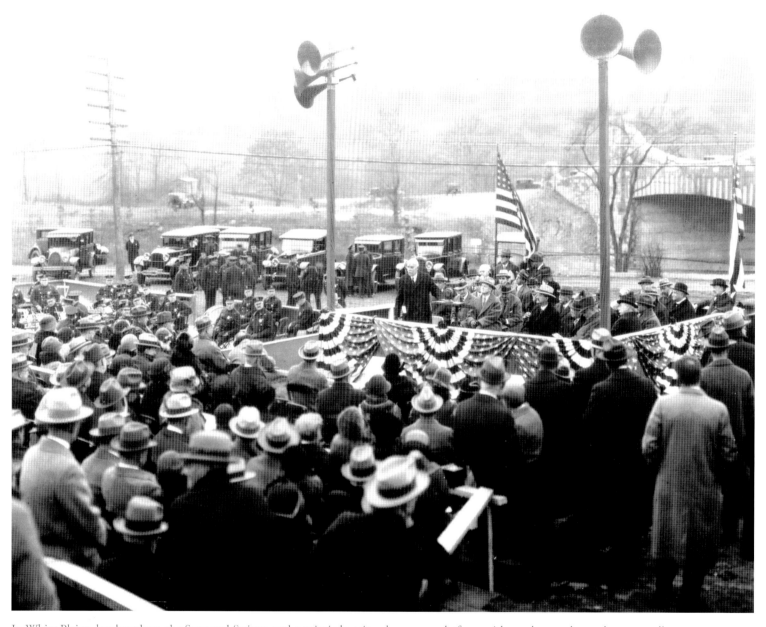

In White Plains, loudspeakers, the Stars and Stripes, and patriotic bunting showcase a platform with speakers and seated guests—all of whom are facing a crowd of onlookers, suggesting a political rally sometime around the 1920s. The United States Post Office issued a stamp in 1926 to commemorate the sesquicentennial of the Battle of White Plains on October 28, 1776. Today the souvenir sheet is a prized collector's item.

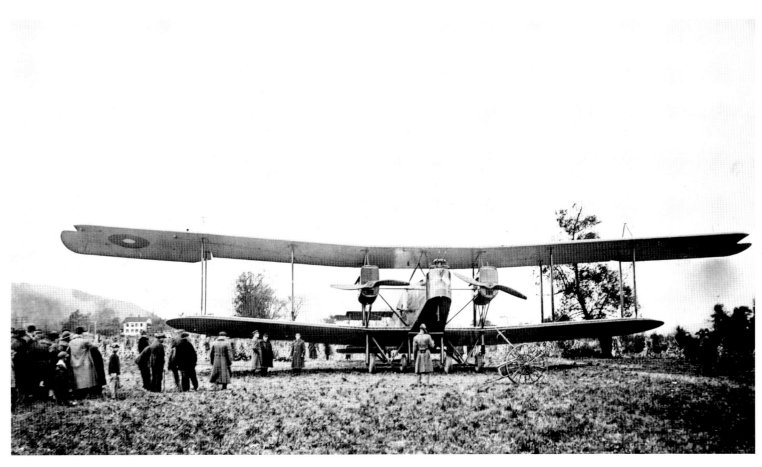

During the First World War, aircraft were first used as fighter planes and bombers. American bombers of the time were too vulnerable to interception by fighter planes in daylight, so night-bombing planes were developed. The Langley Night Bombing Airplane utilized concepts devised by the aviation pioneer Samuel Pierpont Langley (1834–1906). It was a two-engine biplane as shown in this October 15, 1918, photograph made in Frankfort, New York, a town on the Mohawk River east of Utica.

In the early 1920s, tugboats escort a United States Navy battleship up the East River. The war had ended a few years earlier, on November 11, 1918. In the background are the Brooklyn Bridge and the Manhattan skyline.

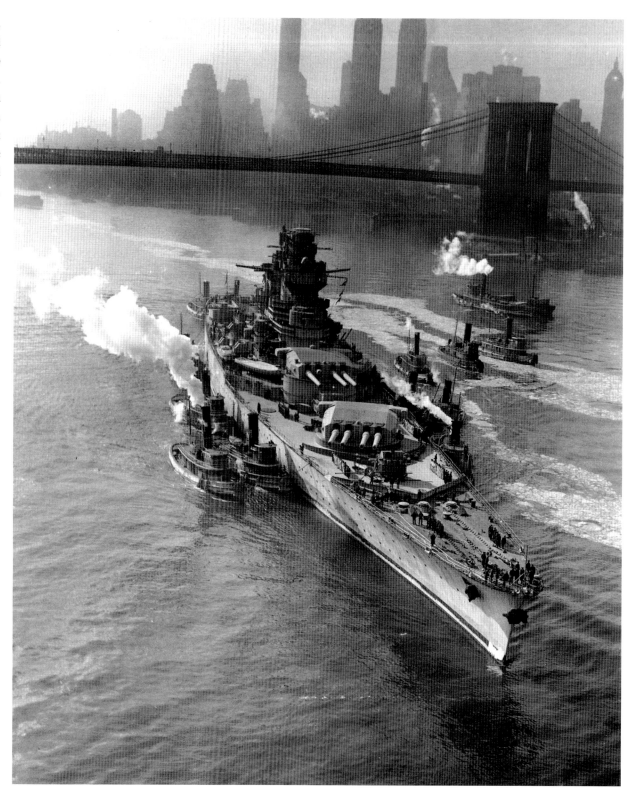

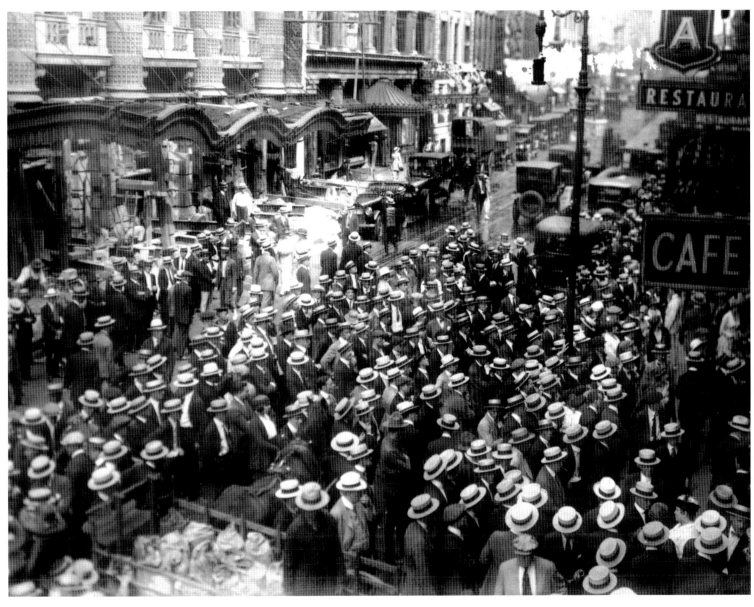

The first strike in the history of American theater occurred in New York City in August 1919. Actors objected to paying for their own costumes, rehearsing hours on end without pay, and being fired without notice. Stagehands honored the strike, and that closed down all theatrical productions in the country. The crowd in this 1919 image is demonstrating on 45th Street in Manhattan.

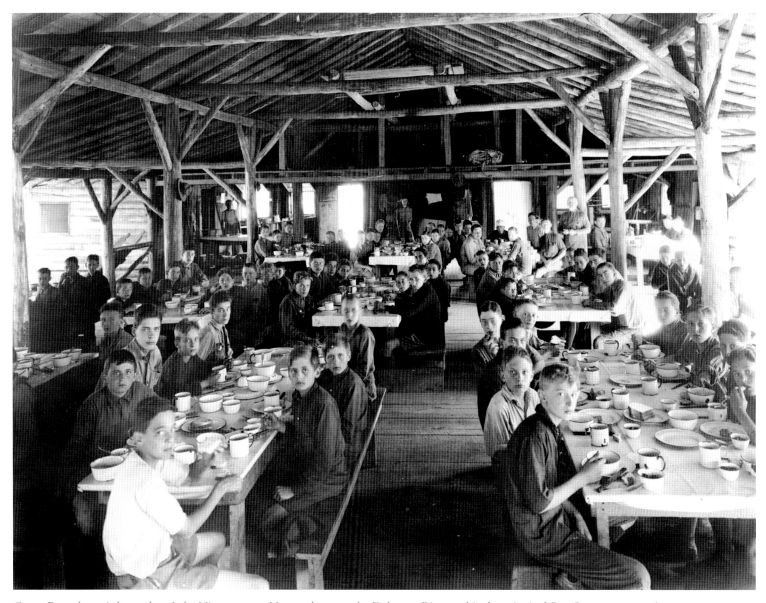

Camp Ranachqua is located on Lake Nianque near Narrowsburg on the Delaware River and is the principal Boy Scout camp serving the Hudson Valley. This image, made August 8, 1919, shows campers in the dining hall eating a meal served family-style. Swimming, sailing, hiking, handicrafts, marksmanship, archery, scouting skills, and more are provided at this outstanding 12,000-acre summer camp that still operates today.

The National Park Bank on Broadway between Ann and Fulton streets in Manhattan was under construction between 1901 and 1904. The Second Empire–style structure, richly decorated in granite and limestone, was designed by architect Donn Barber. A giant arched window on the façade provided a flood of light in the high-ceilinged banking room. Labor-saving devices considered novel and modern at the beginning of the twentieth century included telephones, pneumatic tubes, electric elevators, dumbwaiters, and a refrigerating plant to provide ice water throughout the building.

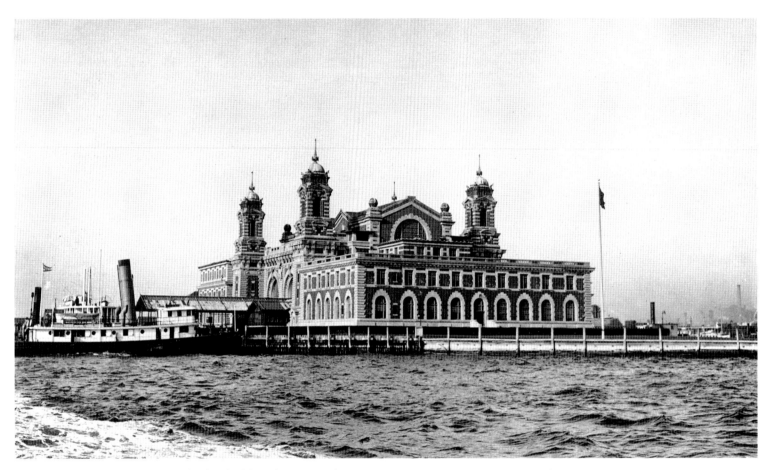

Opening on December 17, 1900, the first building that twentieth-century immigrants to America saw was this impressive structure on Ellis Island in New York Harbor. Designed in French Renaissance Revival style, the grand facility is a brick-and-limestone structure with three triumphal arches at the entrance and impressive towers at the corners of the façade. Between 1892 and 1954, more than 12 million immigrants passed through Ellis Island, many of them through this building. Since 1990, the facility has been open to the public as the Ellis Island Immigration Museum.

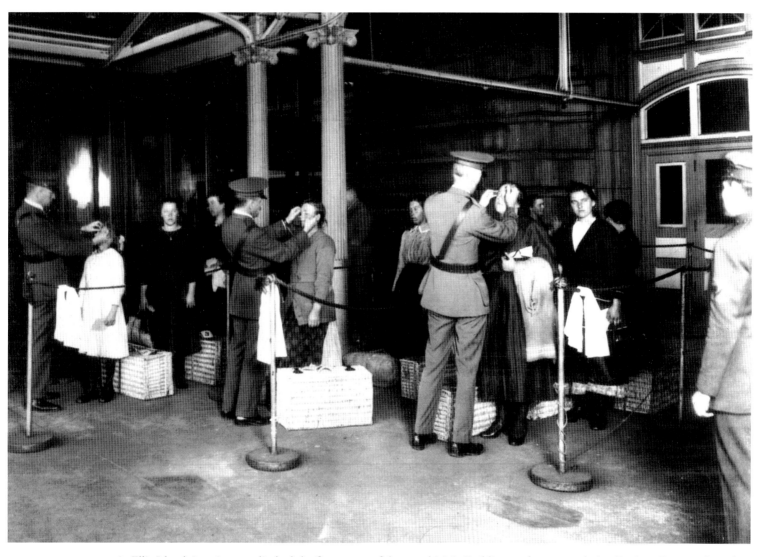

At Ellis Island, immigrants climbed the front steps of the grand Main Building to the great, echoing Registry Room, where they faced legal and medical inspections, like those being administered in this photograph from 1923.

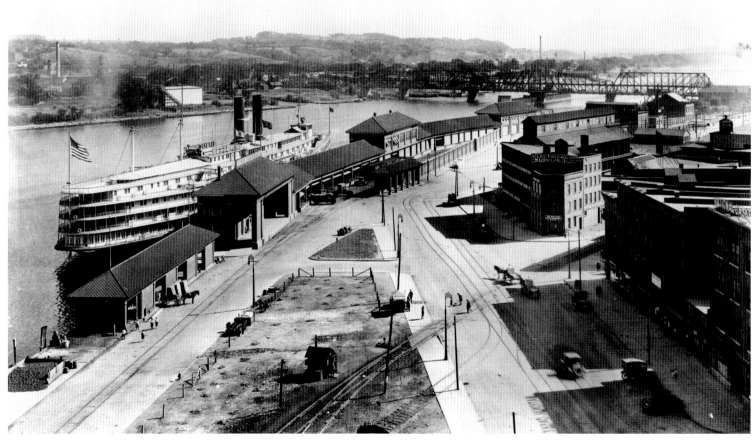

Here is a bird's-eye view of the Albany wharf along the Hudson River as it appeared in 1921. A large passenger steamship, the *Berkshire,* is moored wharfside. The bridge in the background crosses the Hudson to the town of Rensselaer, across the river from Albany. Very little of what appears in this image remains standing today.

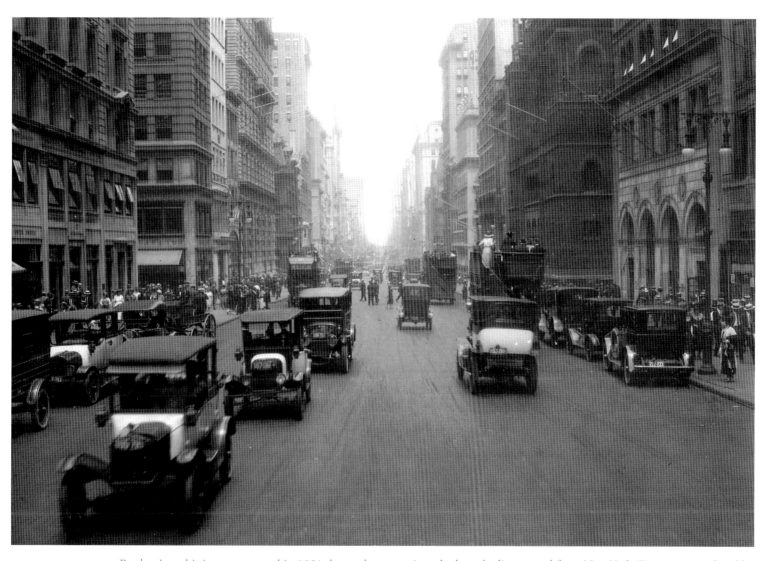

By the time this image appeared in 1921, horse-drawn carriages had nearly disappeared from New York City streets, replaced by early twentieth century automobiles. This is Fifth Avenue in Manhattan at a time when the avenue had two-way traffic. One thing that remains the same is the pedestrian-crowded sidewalk. Prominent in this image are the double-decker buses, replete with a curving staircase that leads to the open-air floor at top.

The tortuous Storm King Highway hugs the sheer mountainside on the west side of the Hudson River in Storm King State Park early in the twentieth century. A stone barrier helped prevent vehicles from falling over the steep cliff.

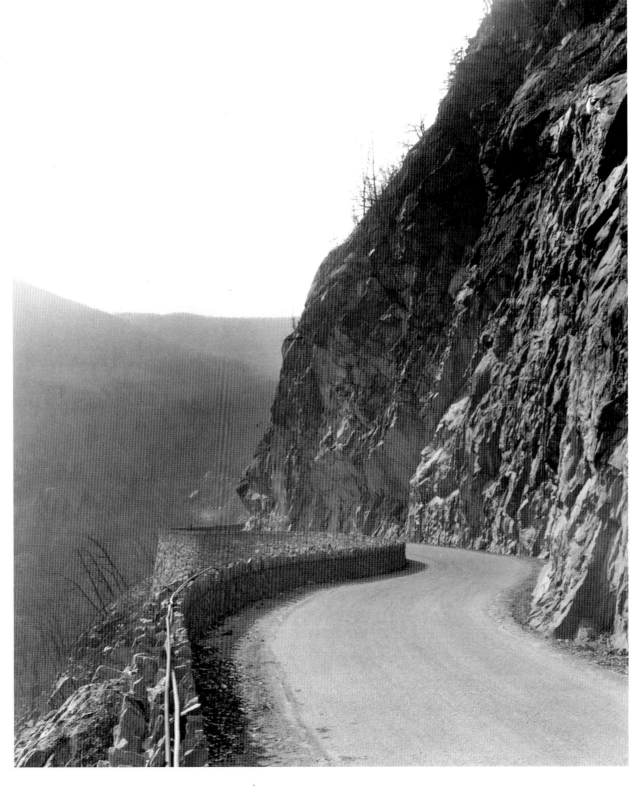

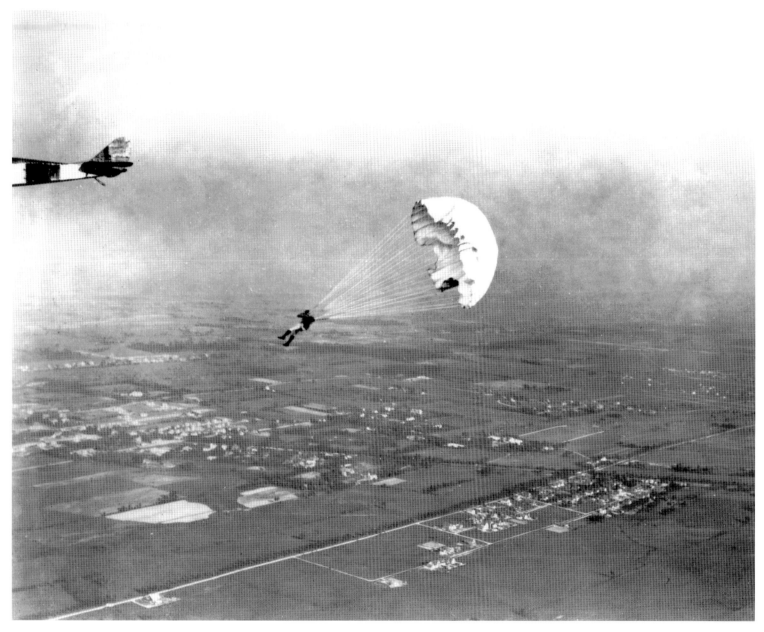

Irving Air Chute Company in Buffalo, with six other factories around the globe, became the world's largest maker of parachutes. The Buffalo factory was founded by Hollywood stuntman Leslie Irvin, who in 1919 became the first person to jump from a plane in free fall with a parachute. Early parachutes were made of cotton, but it was bulky, and Irvin (the "g" was added to the company name) persuaded silk makers to produce a superior silk for chutes. In this 1922 image, George Starr makes a practice jump near Buffalo.

Sir Arthur Conan Doyle (1859–1930), Scottish writer of detective stories and historical romances and creator of Sherlock Holmes, visited New York City with his wife and three children in 1922 during a visit to the United States to give lectures on Spiritualism. Here, on April 10, the family views the city from the observation deck of a Manhattan skyscraper. Conan Doyle was a friend of escapologist Harry Houdini, with whom he visited during his stay in New York.

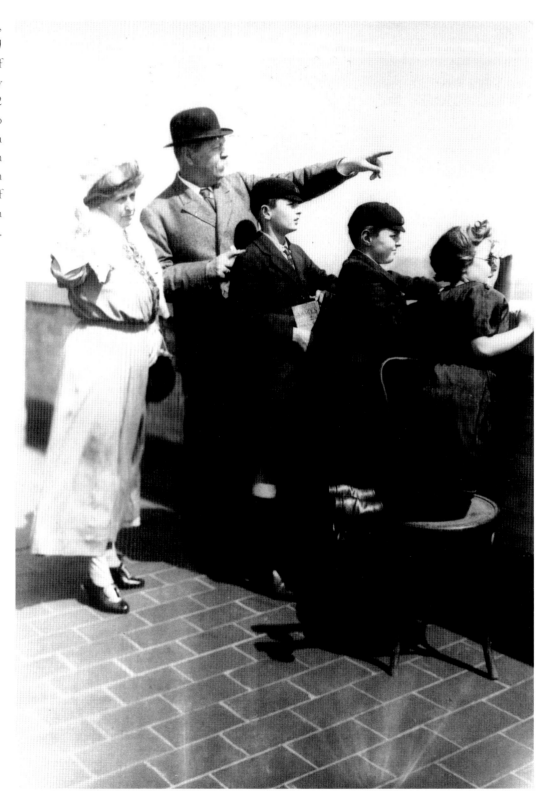

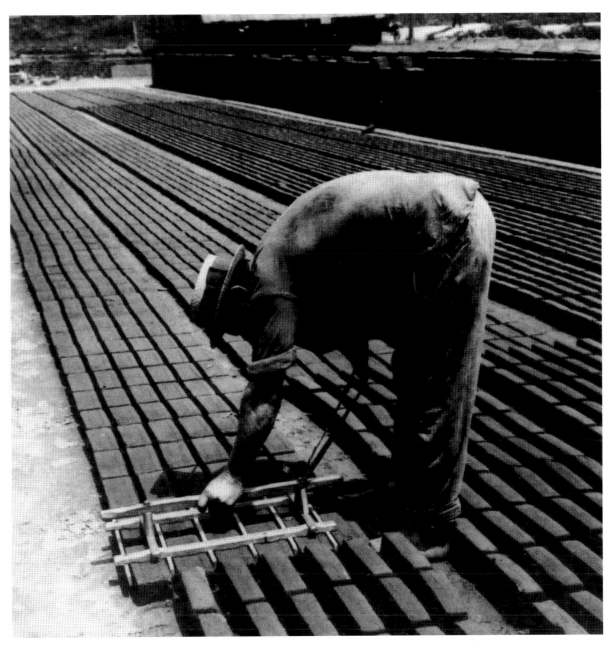

The village of Haverstraw is located on the west side of the Hudson River at its widest point. Haverstraw was once renowned for brickmaking made possible by the abundance of shoreline clay formed by the river, and at one time more than 40 brickmaking factories lined the Hudson River in the village. Many of the brownstone and brick structures constructed in New York City in the 1890s and early 1900s were built of Haverstraw brick. In this image, bricks are turned repeatedly to help them dry evenly.

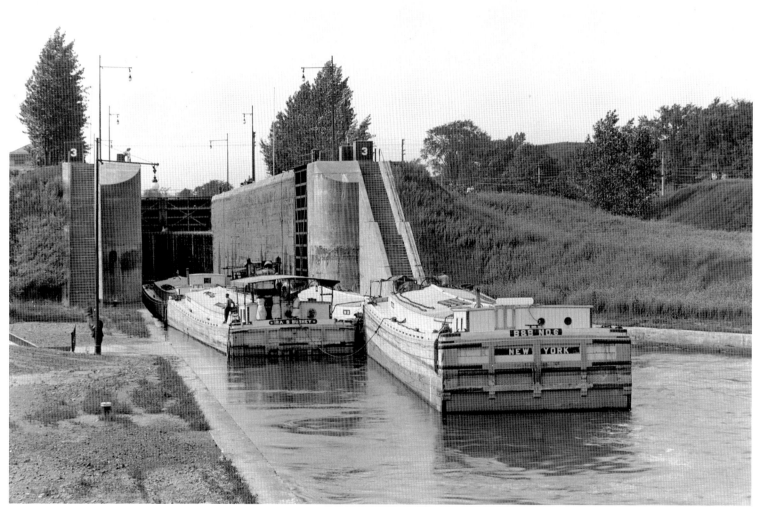

Waterford is a village at the junction of the Erie Canal, which proceeds west, and the Champlain Canal, which runs north. Here in 1925, commercial barges wait their turn to enter at the low entrance of Lock 3 to be raised to the next level of the Erie Canal as they make their way west.

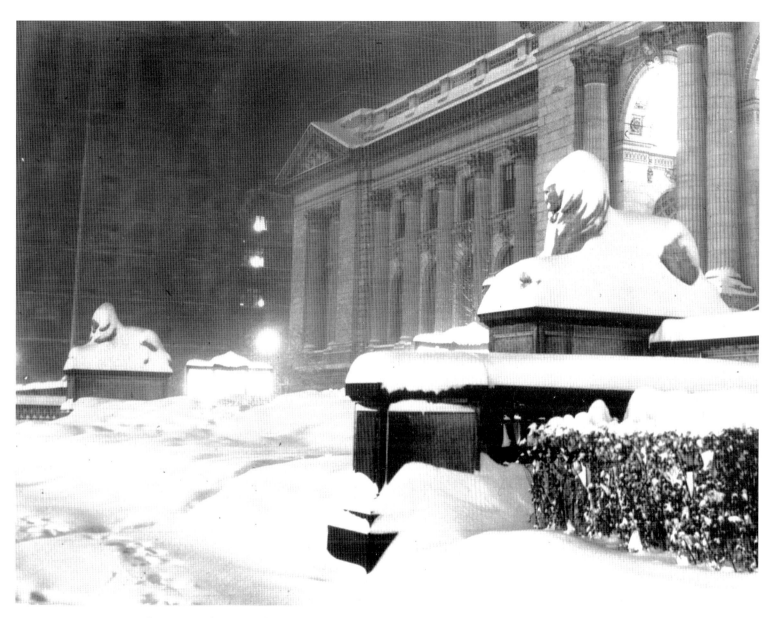

A fierce December storm has covered the stone lions flanking the entrance to the New York Public Library on Fifth Avenue in Manhattan, where the massive façade stretches two blocks (350 feet) between 40th and 42nd streets. Architects Carrère and Hastings created one of the finest examples of Beaux-Arts design in America from the finest white marble available. The chief architect, John M. Carrère, was killed in an automobile accident just before the library opened. He lay in state in the great hall at the opening in 1911.

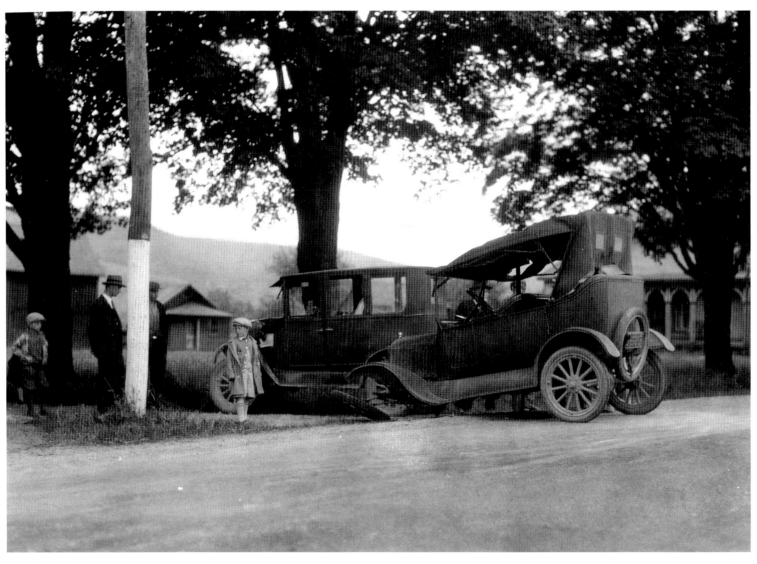

The village of Sidney is located in the foothills of the Catskill Mountains along the banks of the Susquehanna River. Here in 1928, on smooth asphalt pavement, an automobile accident has taken place, apparently a rear-end collision. The foothills are visible in the distance.

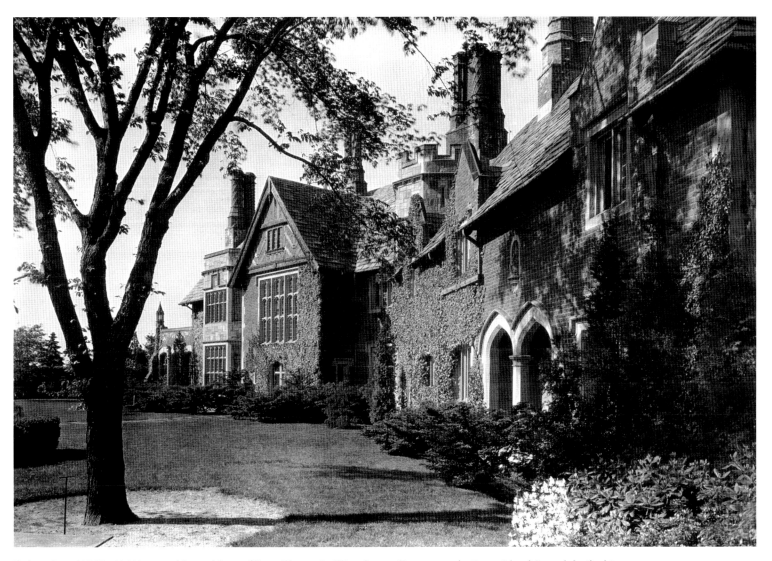

Robert Law (1852–1912), a wealthy resident of Port Chester in Westchester County on the Long Island Sound, built this impressive American Tudor–style mansion in the village. This photograph, made on June 2, 1927, depicts a large, rambling stone house with a double Gothic-arched entrance and elaborate stone chimneys.

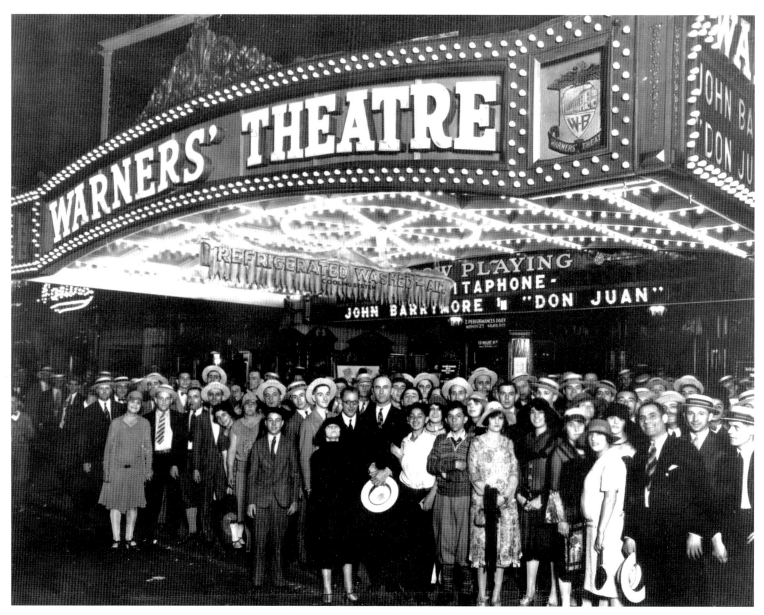

On the evening of August 6, 1926, a large crowd gathered in front of Warners' Theatre in New York City to watch the premier performance of *Don Juan* with John Barrymore in the title role. Warner Brothers owned the theater from 1926 to 1952, when it was demolished. In the silent movie, John Barrymore plays two parts: the aging father betrayed, and the indoctrinated son.

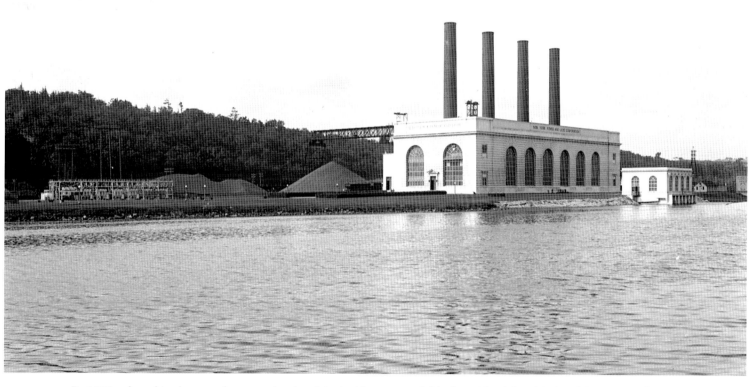

By 1928, when this photograph was made, electricity had become available for residential and industrial use. Manufacturing, which had depended on waterpower, especially in Amsterdam, now obtained electricity from this New York Power and Light Corporation steam-electric power plant on the banks of the Mohawk River east of Amsterdam. The largest carpet-manufacturing plants in the country, Bigelow-Sanford and Mohawk Carpet, were located in Amsterdam.

The German ocean liner SS *Bremen* was noteworthy for its low streamlined profile and speed, which enabled the ship to cross the Atlantic in five days. The *Bremen* made its maiden voyage to New York City in July 1929, beating all records with a total crossing time of 4 days and 18 hours. New York gave the crew a ticker-tape parade down Broadway. This image shows the motorcade drowning in white ticker tape and confetti as crowds extend greetings.

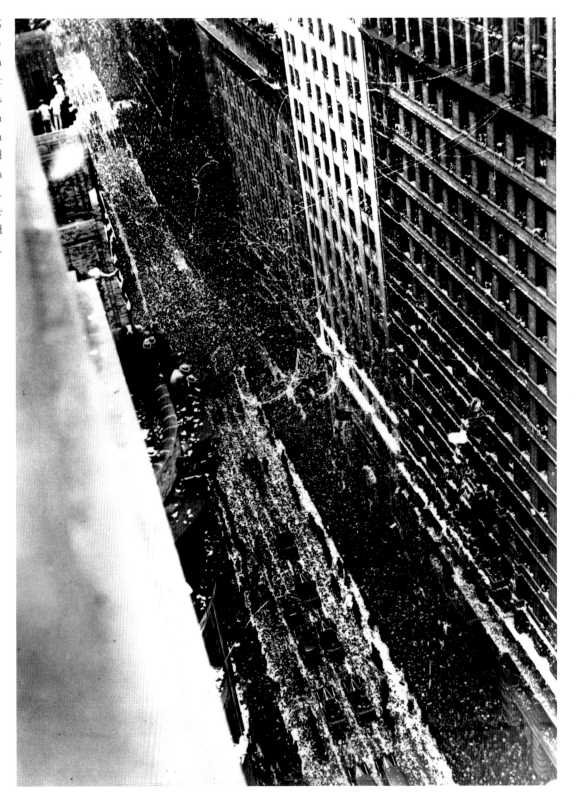

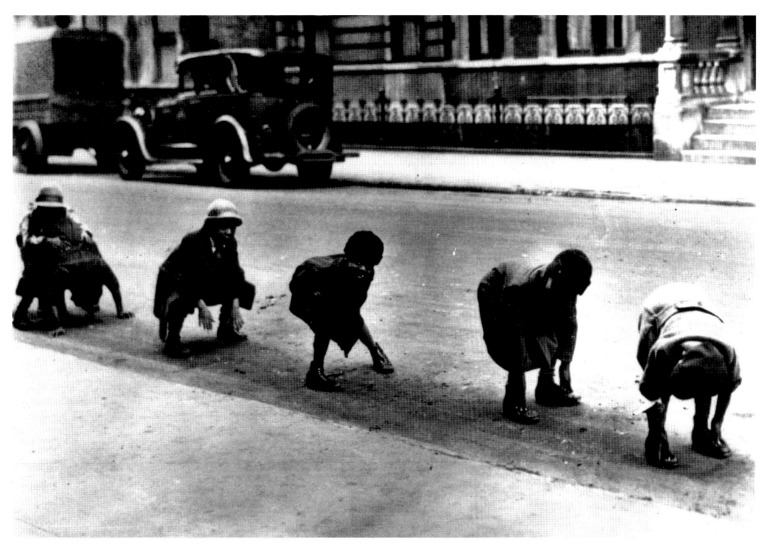

The Great Depression was hurting the American economy in 1930, but children don't worry as much about those things. One day that year, neighborhood children joined forces for a game of leapfrog on a meticulously clean street in Harlem, Manhattan.

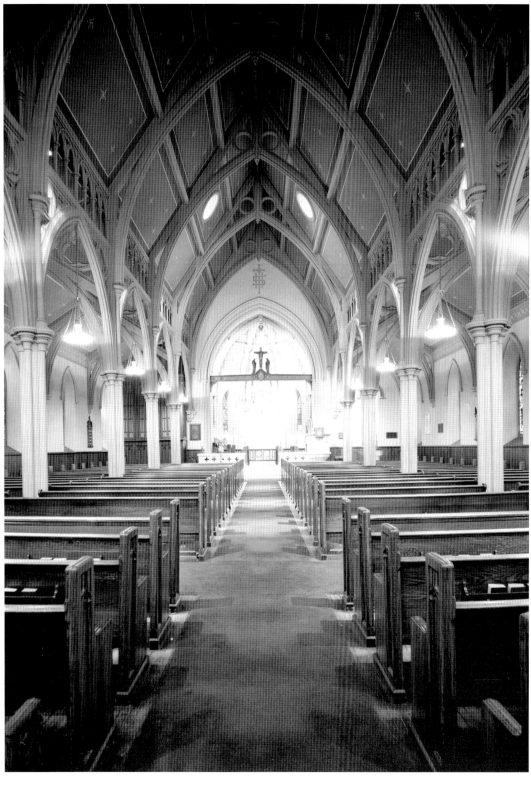

In the 1850s, Richard Upjohn, America's foremost architect of the Gothic Revival style, designed this church, Christ Episcopal, at 187 Washington Street in Binghamton. Upjohn designed many churches in New York State, but he is most famous for Trinity Church at Wall Street and Broadway in Manhattan. Pictured here is the sanctuary of Christ Episcopal Church, with its high, pointed arches, creating the soaring space for which Gothic Revival structures are noted.

This is a New York City subway car photographed in 1933. City officials are shown inspecting the newly installed ventilating system, visible at the top. The ventilating devices introduced and circulated outside air when the subway car's windows were closed. Still in use today, the subway system dates to 1904.

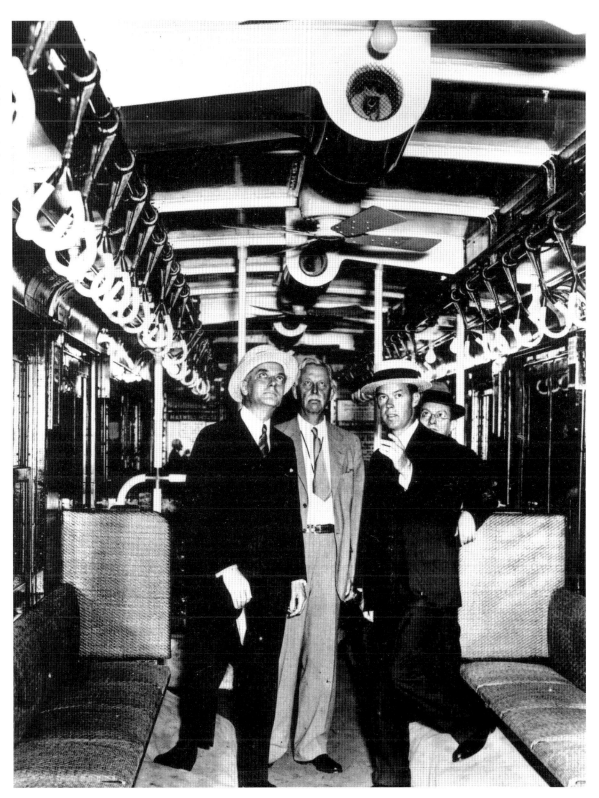

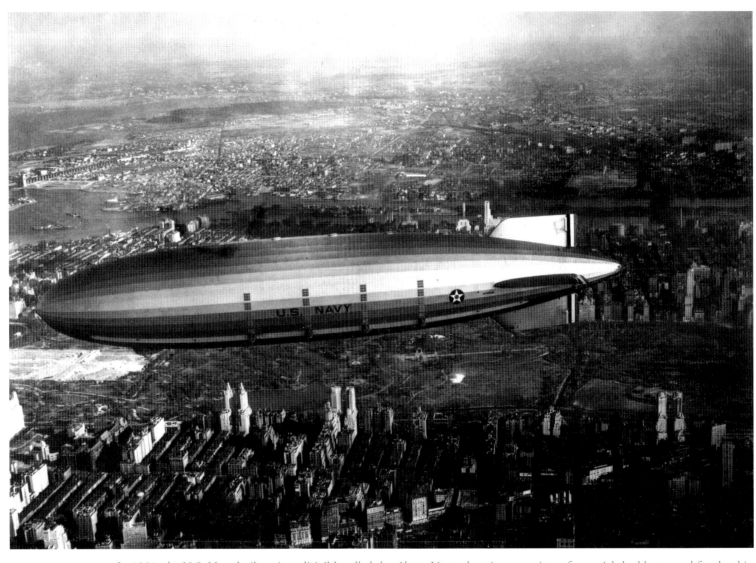

In 1931, the U.S. Navy built a giant dirigible called the *Akron*. Up to that time, a variety of materials had been used for the skin of airships, including the intestines of cattle. On the look for a better material, the Navy asked Goodyear-Zeppelin to develop a substitute. The result was a cotton fabric treated with gelatin-latex to give it superior strength. The USN *Akron* is seen here in 1932 flying over New York City. Manhattan landmarks are visible beneath the airship, including Central Park's Lake and Sheep Meadow.

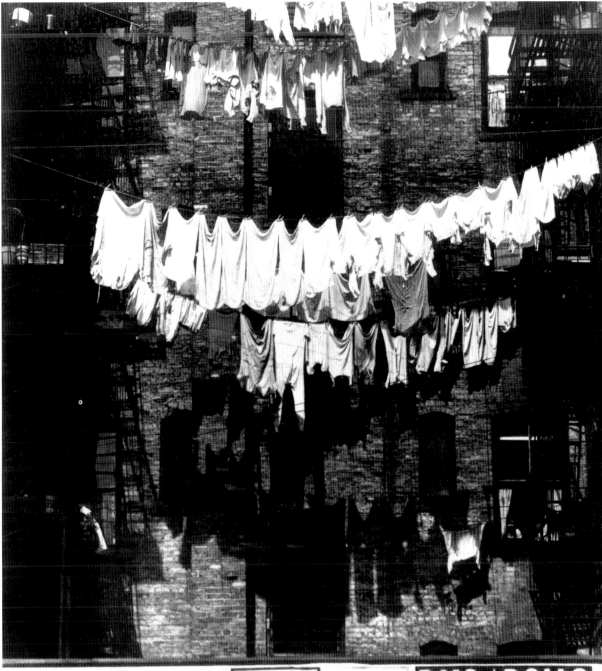

This was a common washday scene in 1935 New York City. Rows of laundry are suspended between apartments with a system of ropes that could be reeled in and out from a window, sometimes with the loss of a few pieces of laundry on a windy day. At bottom are posters for coming attractions at the Roosevelt and Apollo theaters, both venues located on the Lower East Side.

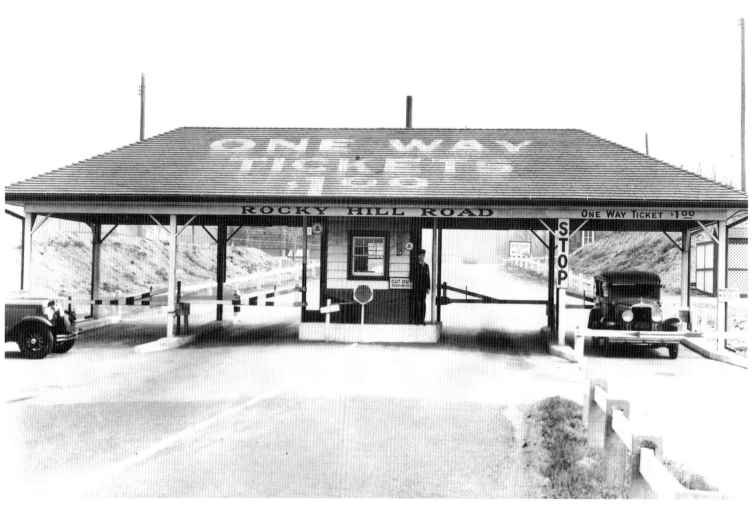

Rocky Hill Road was the brainchild of William K. Vanderbilt, Jr., who with help from wealthy friends on the Gold Coast of Long Island constructed a limited-access, landscaped parkway 9 miles long. Built of reinforced concrete, the road opened in 1908 and was eventually lengthened to run from Queens to Lake Ronkonkoma, 48 miles from end to end, making it the longest toll road in America at the time. Here is the main tollgate as it appeared in 1931, with the toll collector standing beside the ticket booth.

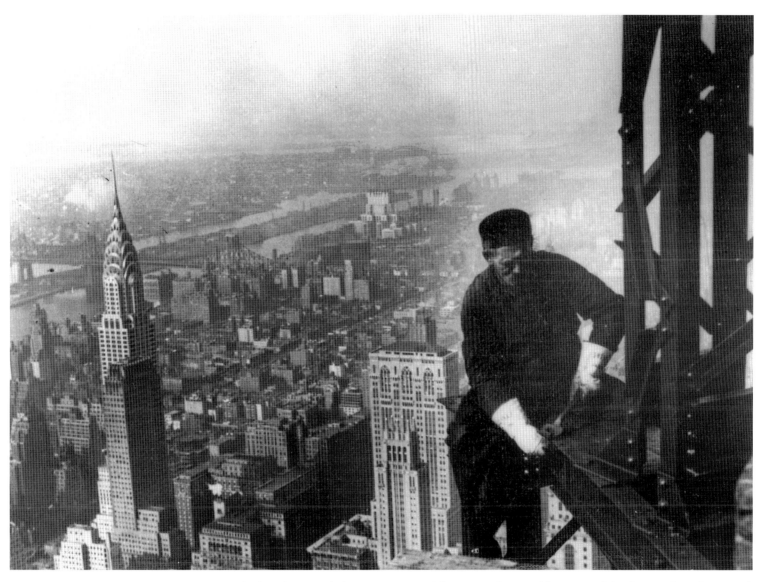

In 1930, Lewis Hine was asked to photograph the construction of the Empire State Building, named for the moniker of New York State. He spent two years following the vertical progress of the tall structure, fearlessly climbing the building along with the workers. This workman is perched on the end of a beam bolting together steel framework. At left is the Chrysler Building, which was the tallest building in the world (1,046 feet) in 1930—a claim it relinquished to the Empire State Building (1,250 feet) in 1931.

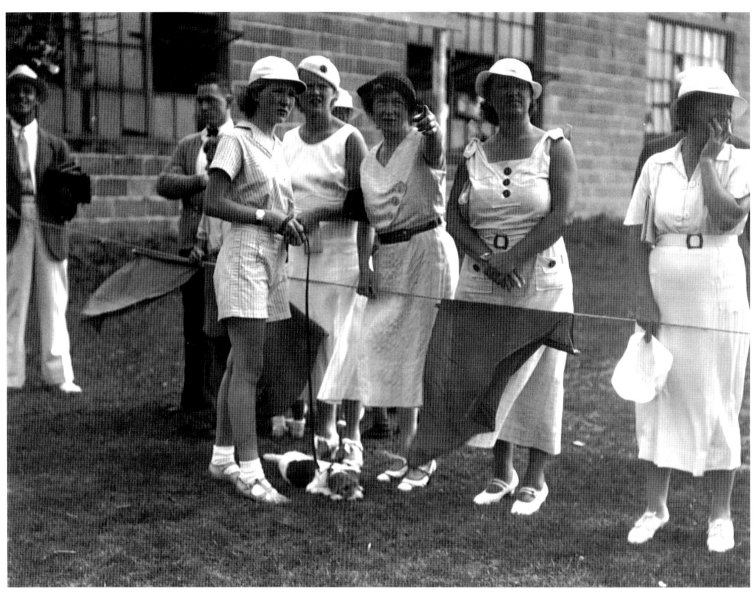

In East Hampton, Long Island, summer playground of the rich and famous, it is reasonable to expect a dog show. Here are a group of five ladies dressed in white, a weary contestant, and several onlookers at the summer event. This image was recorded by Arnold Genthe (1869–1942), whose subjects included politicians, socialites, literary figures, entertainment celebrities—and dogs.

The Senate House in Kingston on the Hudson River was built in 1676 and was the residence of the Van Gaasbeek family. The Dutch-style house was constructed of Ulster County limestone. When British forces occupied New York City during the Revolutionary War, the fledgling state government escaped the city, moving to Kingston, where the courthouse served as the capitol and quarters for the Supreme Court. The State Assembly met in a tavern, and the 24 members of the Senate, at the invitation of the Van Gaasbeeks, met here.

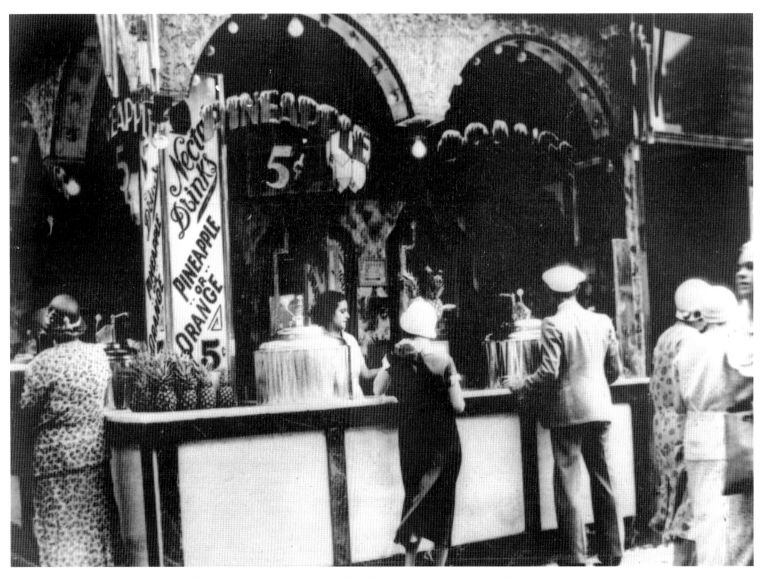

It is July 1932 in New York City, and the temperatures call for a cool pick-me-up like pineapple and orange nectar drinks. They were available at this outdoor refreshment stand for a nickel.

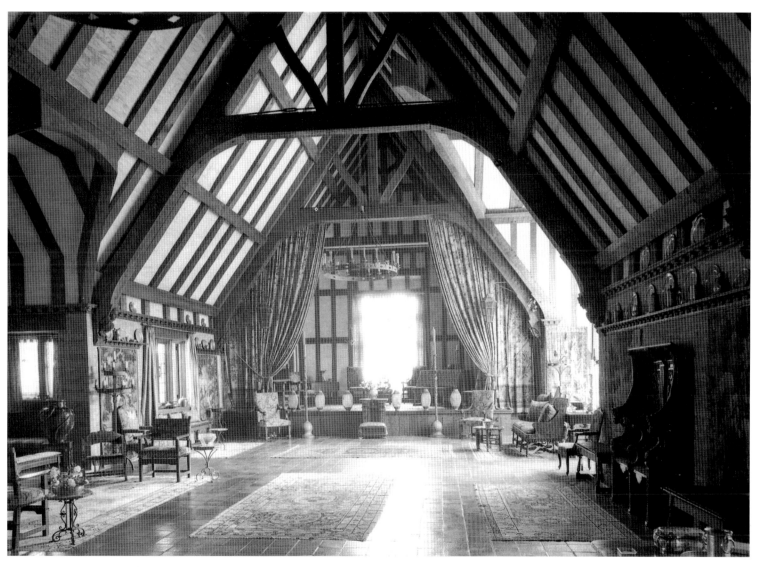

In 1916, philanthropist Mrs. Lorenzo E. Woodhouse restored an old house in East Hampton, Long Island, to make it into a theater to showcase the performing arts—theatrical and musical. The heart of the house is a great hall, which was designed like the hull of a ship. The dramatic rafters soar 35 feet in height, reminiscent of a historic English manor, including gargoyles, leaded windows, and a loft that contains an Aeolian-Skinner pipe organ. Today this Elizabethan-style structure is the setting for concerts and plays.

Organized crime in New York City burgeoned in the twentieth century. The Mafia was dominated by the Five Families (Gambino, Genovese, Bonanno, Colombo, and Lucchese), who often fought one another. In the aftermath of a 1931 gun battle with police, a bullet-riddled taxi is parked beside the bodies of two gangsters. Officials survey the scene while a crowd of onlookers is kept at a distance.

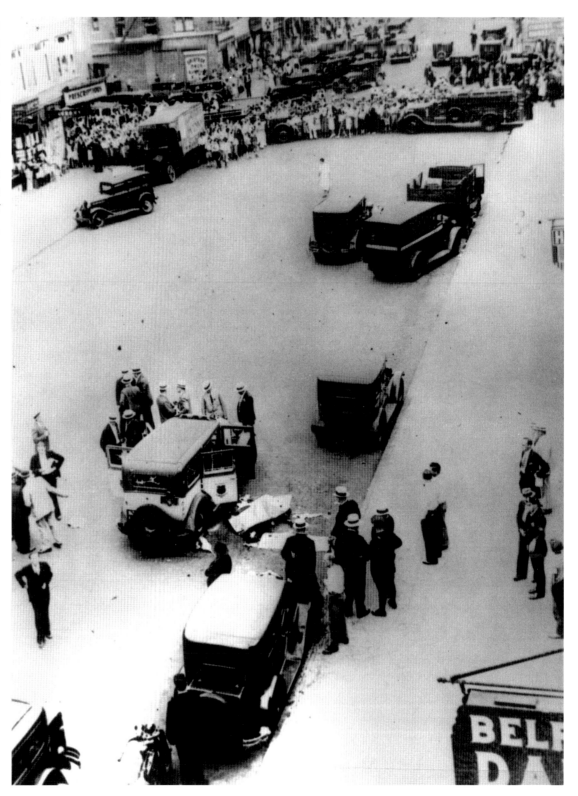

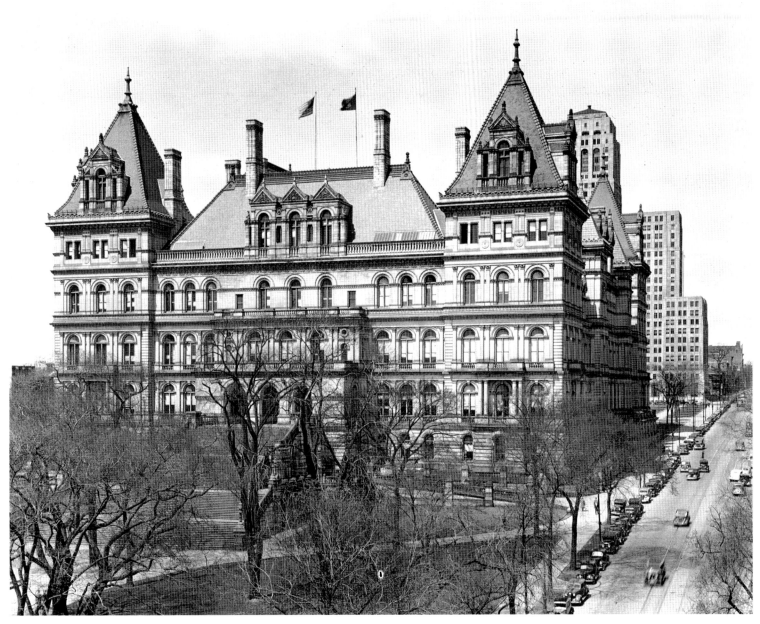

The booming industrial, commercial, financial, and agricultural growth brought about by the Erie Canal made New York the Empire State. By the middle of the nineteenth century, the state needed a new capitol to match its national prominence. Thirty-two years and four architectural firms later, the new capitol at Albany was finally completed. Thomas Fuller created the first design. After seven years of slow progress, two new architectural firms were hired, Leopold Eidlitz and Henry Hobson Richardson, both of whom were dismissed for being associated with the skyrocketing costs. Isaac Perry finished the massive building, which is shown here around the 1930s.

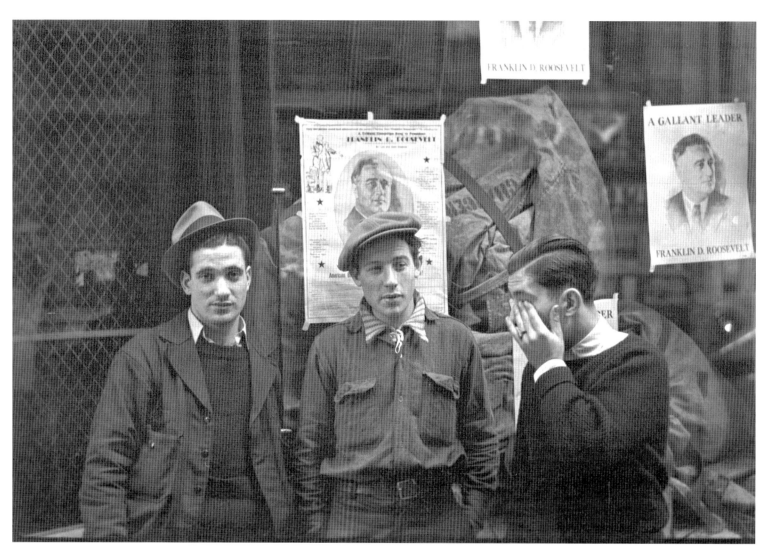

This is the scene at Seventh Avenue and 38th Street in Manhattan in November 1936. Franklin Delano Roosevelt has just been reelected to a second term as president of the United States. Three young men stand in front of a display window, to which are taped campaign posters promoting Roosevelt as a "gallant leader."

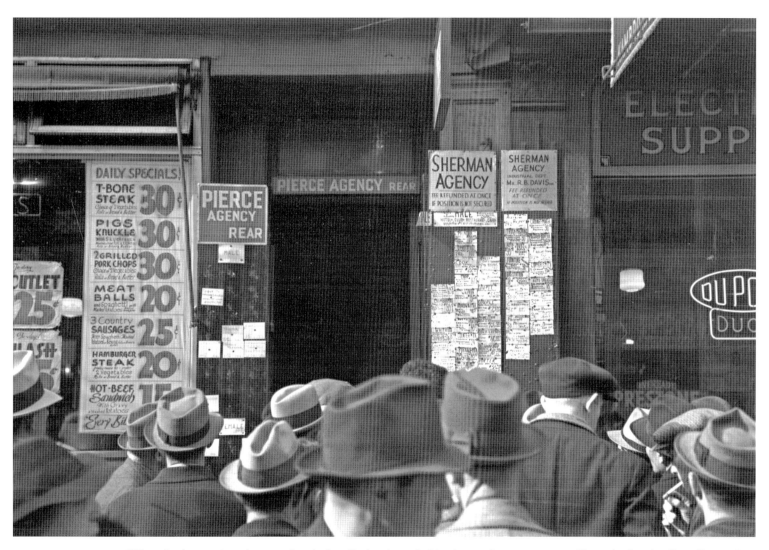

When *Look* magazine photographer Arthur Rothstein took this picture, the country was still weathering the Great Depression. Unemployed New Yorkers gather at the Sherman Employment Agency on Sixth Avenue in Manhattan to read the list of jobs available. Next door, a restaurant advertises meals from 30 cents for a T-bone steak to 15 cents for a hot beef sandwich.

In the unusually cold winter of 1938, the American Falls at Niagara completely froze. When efforts failed to keep a massive ice buildup away from the Falls View Bridge, popularly called Honeymoon Bridge, it was closed when officials recognized that it would fail. Suddenly, at 4:20 P.M. on January 27, a particularly cold day, the bridge collapsed. Robert H. MacClaren of the town of Niagara Falls was the only witness to the event. He had a camera, and this is the shot he took.

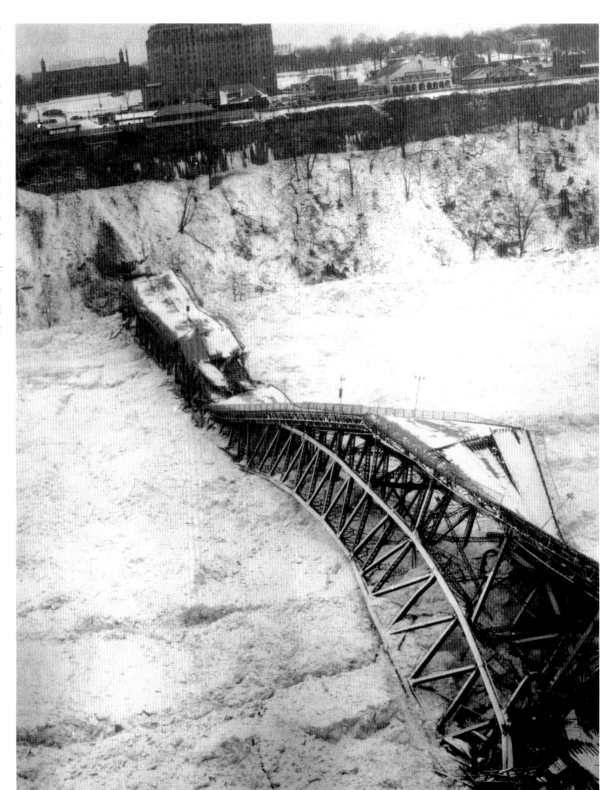

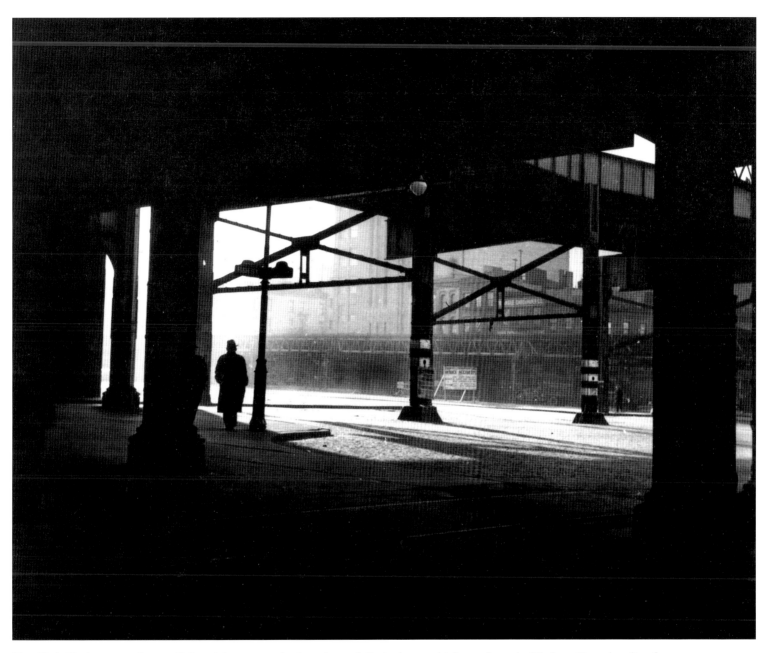

New York City's master planner, Robert Moses, conceived an elevated, limited-access highway along the Hudson River shoreline for automobiles only. It allowed trucks to travel underneath between the Hudson River piers and warehouses and factories inland, while automobile traffic flowed unimpeded overhead. On January 3, 1937, photographer David Robbins found a lone man in hat and overcoat in the solitary, eerie space beneath the West Side Highway.

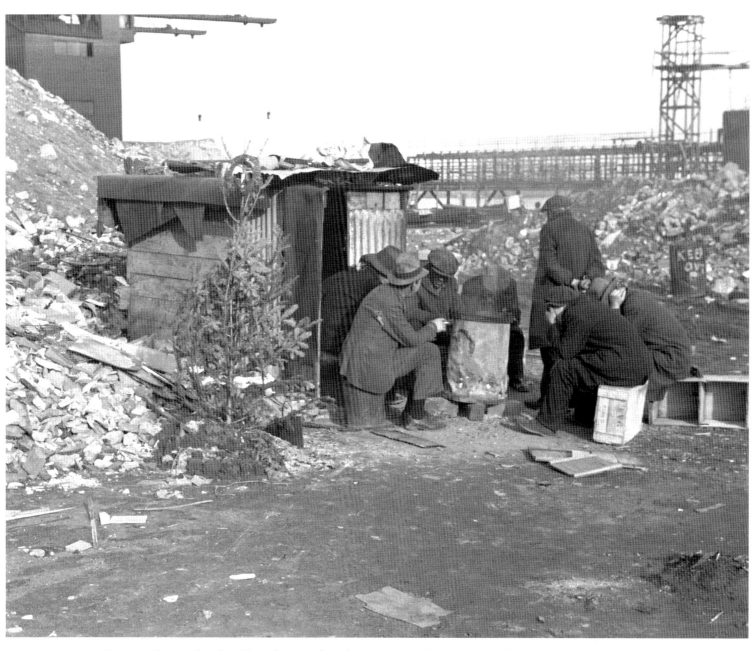

A group of unemployed and homeless people gathers on East 12th Street in Manhattan with empty crates as seats and an adjacent shack as protection from the weather. It is January 1938 and a withering Christmas tree stands in front of the shack. Industrial waste surrounds the area. Within a year of the stock market crash in October 1929, unemployment in the U.S. rose to 9 percent. In 1933, it was 25 percent, and in 1938, despite six years of the gallant efforts of FDR, it was 19 percent.

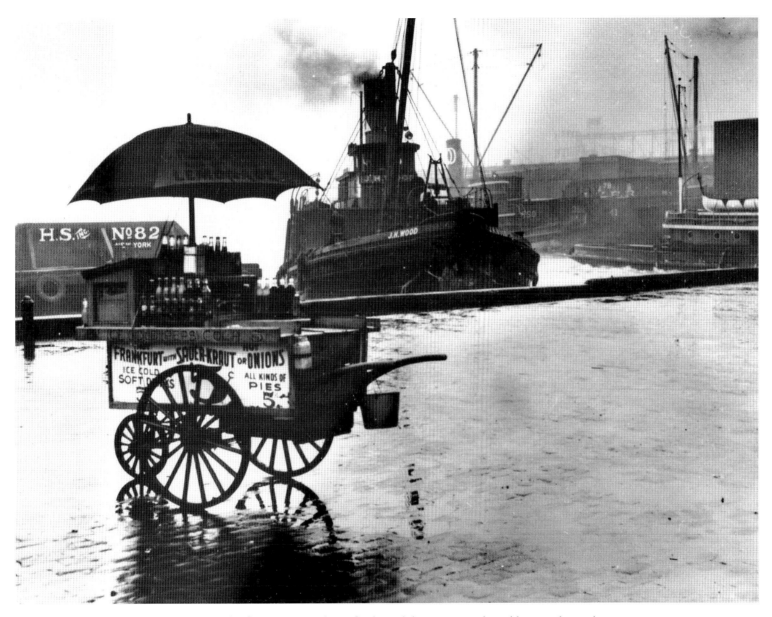

On this rainy day on the New York City wharf in 1939, a pushcart food stand, heavy on supply and lean on demand, rests unattended. Frankfurters with sauerkraut or onions are 5 cents, as are "all kinds of pies" and ice-cold soft drinks. The *J. H. Wood* coughs up a whiff of smoke as it idles dockside in the rainstorm.

August 8, 1937, was a hot, sultry day in South Harlem. The city's Juvenile Aid Bureau hooked a water spray to a nearby fire hydrant and positioned it in the middle of the street to cool and entertain tenement children in the days before air conditioning.

The 1939 New York World's Fair staged in Flushing Meadows in Queens was one of the largest world's fairs of all time. It focused on the future at a time when the Great Depression still had a tight hold on the nation. This night view at the fair depicts the Consolidated Edison lighted fountains with the 700-foot-tall Trylon, painted pure white, visible in the background. New York would host a third world's fair on this site in 1964. The first one was held in 1853 on the site of today's Bryant Park in Manhattan.

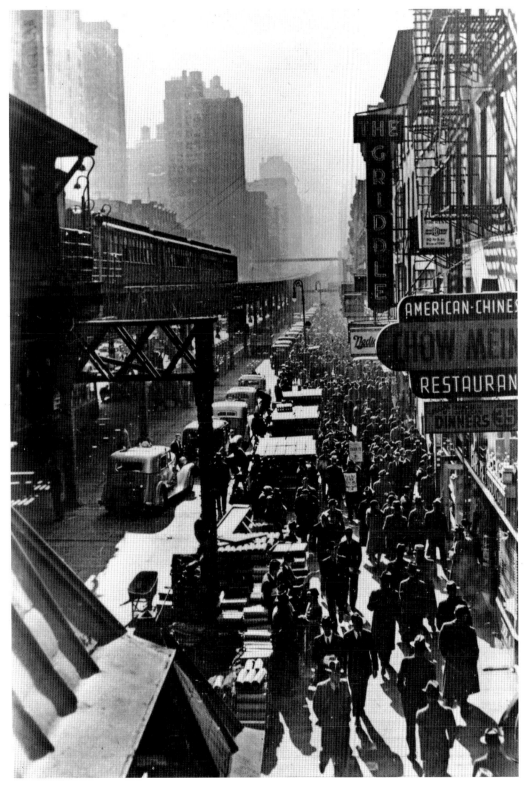

In 1940, Sixth Avenue in Manhattan still had an elevated railway, which is visible at left in this image. The sidewalks are crowded with pedestrians and the street filled with cars and taxis. On the right are signs for eateries like Chow Mein American-Chinese Restaurant, The Griddle, and Nedick's. In midtown Manhattan's grid, the avenues run generally north and south, its streets east and west, with Broadway intersecting most of them, often at key historic points of interest.

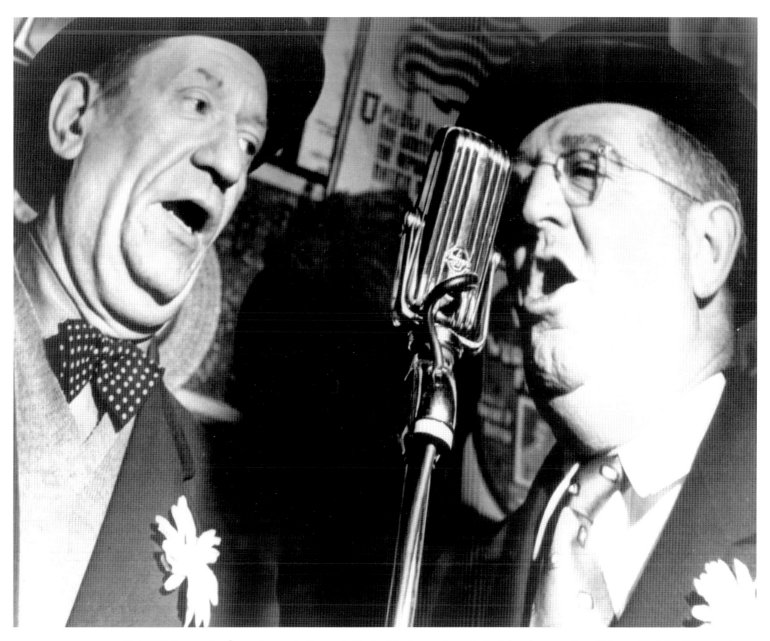

This 1940 portrait of two singers in Sammy's Bar in Manhattan is typical of the photographs of Lisette Model, whose work was published regularly in *Harper's Bazaar*. Model was primarily a portrait photographer whose images were close-up, unsentimental, and unretouched revelations of vanity, insecurity, and loneliness. From 1951 to her death in 1983, she taught photography at the New School in New York City. One of her pupils was Diane Arbus.

An October sun in 1941 creates somber dramatic lighting, and long shadows in the main concourse of Grand Central Station at 42nd Street and Park Avenue in Manhattan. John Collier, Jr. (1913–1992), who worked for the Farm Security Administration and the Office of War Information as a photographer from 1941 to 1943, captured this scene. His photographs were shown in a number of exhibitions, including "The Bitter Years, 1931–1941."

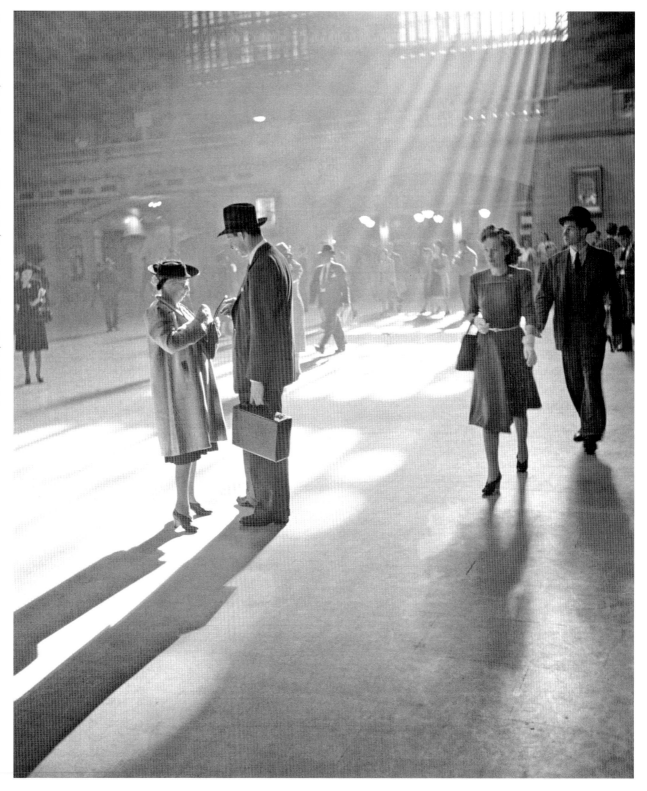

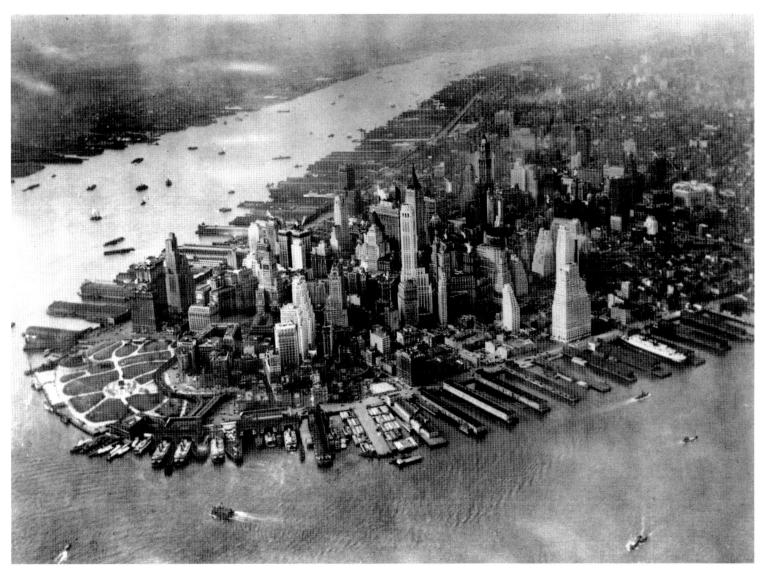

This 1942 wartime photo of the tip of the island of Manhattan shows boats in the Hudson River at left and the East River at right. Wharves line the shore around all of the island pictured, except for Battery Park at the southernmost tip. Skyscrapers dominate the cityscape, with the 57-story Woolworth Building dating from 1913 among the tallest.

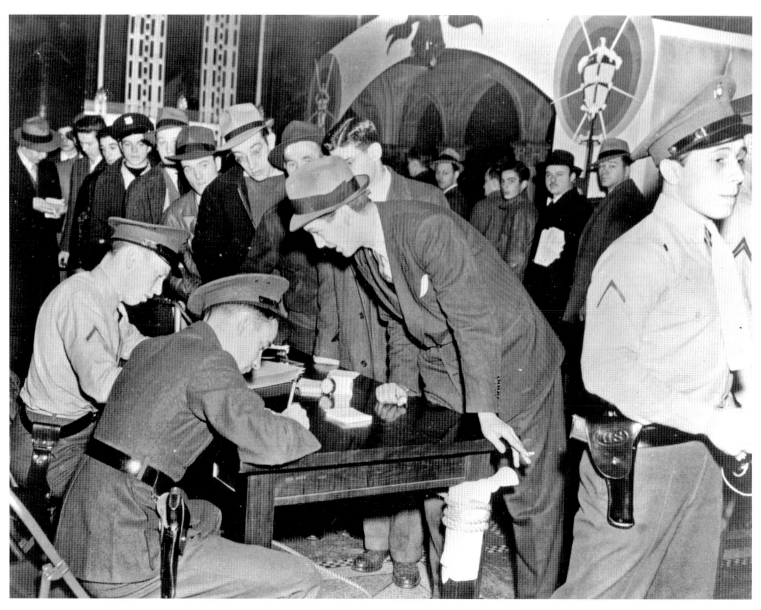

Young men line up at a recruiting station in New York City in January 1942 to enlist for wartime military service. With the advent of World War II after Pearl Harbor in December 1941, the number of enlistments shot upward.

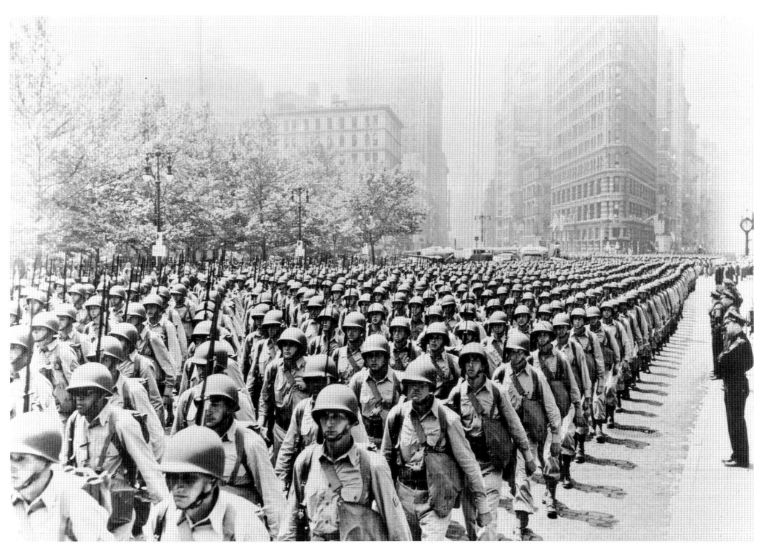

In June 1942, massed infantry units march in formation up Fifth Avenue to demonstrate America's strength and determination to win the war. In the distance, the Flatiron Building is visible at the intersection of Fifth Avenue, Broadway, and 23rd Street. Completed in 1902 and widely noted as one of the very first skyscrapers, the 21-story steel-framed tower is 286 feet tall and a mere 6 feet wide at its prow.

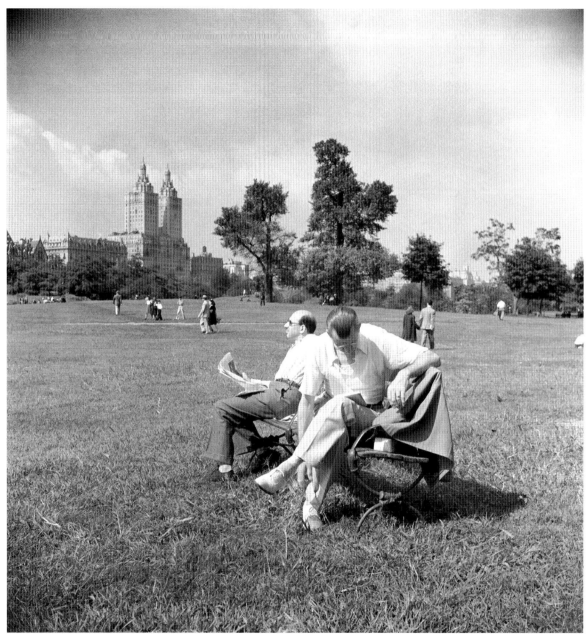

Two men have brought folding chairs to the great lawn of Central Park in central Manhattan in order to enjoy a sunny afternoon in September 1942. The park was designed by the great American landscape architect Frederick Law Olmsted in 1856 and was under construction for some years afterward. In the background are the twin towers of the San Remo, one of the world's greatest residential skyscrapers at 145 Central Park West, between 74th and 75th streets. The beautiful, 27-story San Remo is the masterpiece of architect Emery Roth and was completed in 1930.

An automobile bridge looms into view on Route 28 over the Moose River in McKeever, Adirondack Park, on March 13, 1942. The sign at right restricts heavy vehicles by height and weight. In 1963, New York State purchased 50,000 acres of remote land along the Moose River from Gould Paper Company and added it to the Adirondack Park Preserve. It is largely flat floodplain with many lakes and wetland surrounded by hardwood and pine forests.

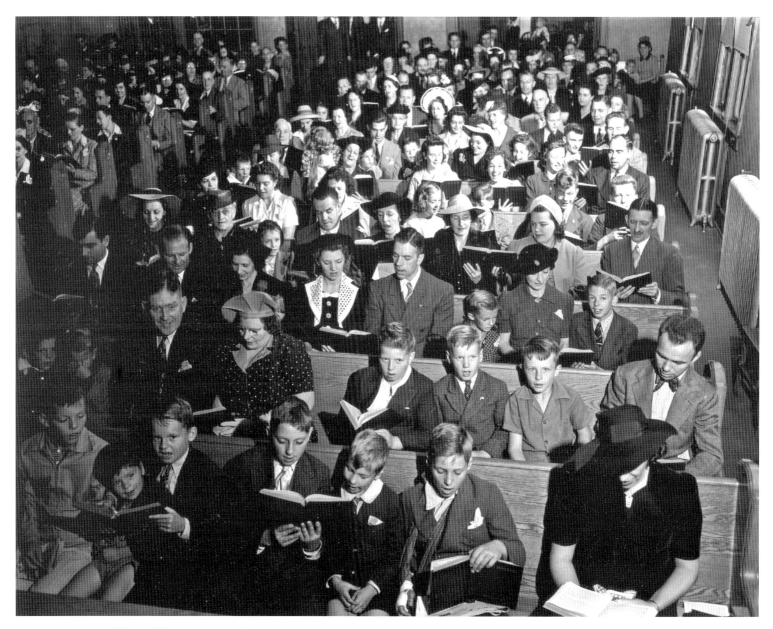

In 1943, the U.S. Office of War Information hired photographer Ralph Amdursky to follow a designated family and depict their life of freedom in America. Amdursky selected a family in Rochester, taking photos of typical activities in their pursuit of happiness, including this picture at a Sunday church service that testified to religious freedom in America. Amdursky also photographed for *Time, Life,* and *Fortune* magazines. He later joined Eastman Kodak in Rochester as a staff photographer on many assignments, including photos for the 18 x 60–foot Kodak Colorama in Grand Central Station.

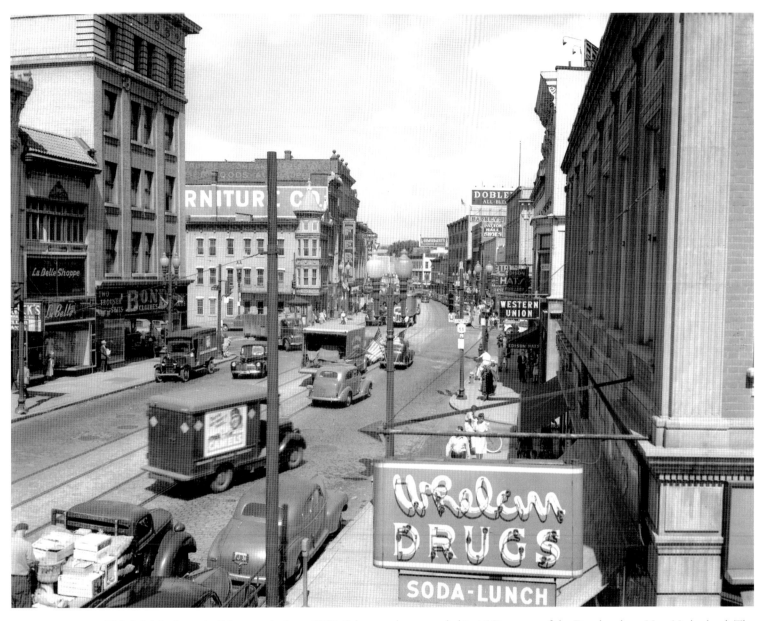

This is Main Street in Schenectady, June 1943. Schenectady was settled in 1661 as part of the Dutch colony New Netherland. The city lies beside the Mohawk River near Albany. Thomas Edison established General Electric Company here in 1892, and the city bustled in the 1940s as GE manufactured products for the war effort.

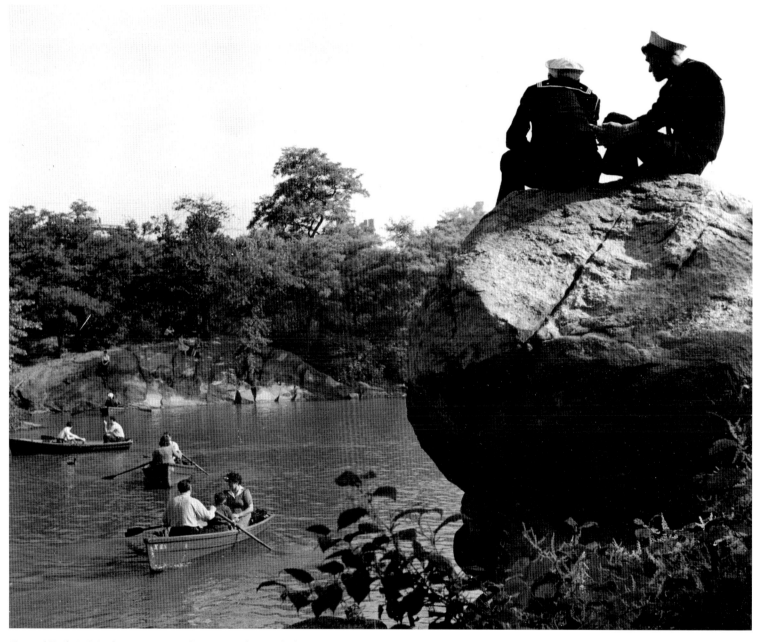

Central Park in Manhattan covers 843 acres and extends from 59th Street to 110th Street. Boaters enjoy rowing on the Lake on a Sunday in September 1942 as two sailors on shore leave watch from a large boulder. Frederick Olmsted and Calvert Vaux created the 18-acre lake out of a large swamp that once occupied the site.

During the Second World War, when most able-bodied American men were serving in the military forces, many homeland duties fell to women, including working for the railroads. Here in 1943, women serving as locomotive cleaners wave to their foreman at the Long Island Railroad yards in Morris Park, Queens, Long Island.

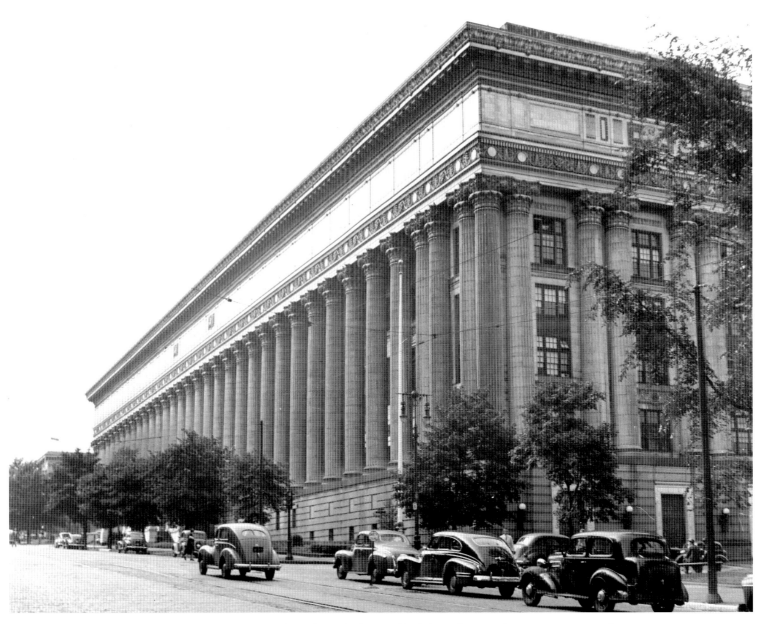

The grandiose New York State Education Building, with a colonnade that is a block long, faces Washington Avenue in Albany. It was built between 1908 and 1912 from a Beaux-Arts design by Henry Hornbostel (1867–1961). Although the building appears to be a colossal stone structure, beneath the classic exterior is a skeleton of steel. The massive fluted columns are steel shafts clad with marble. The Corinthian capitals are terra cotta, as is the decoration on the entablature.

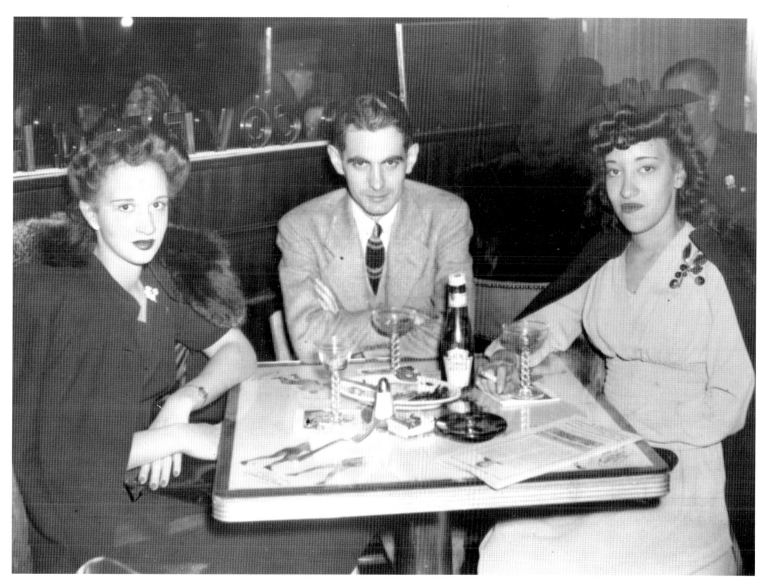

For nearly 40 years, boxing legend Jack Dempsey ran his Broadway Bar and Cocktail Lounge at Broadway near 49th Street in Manhattan. Paying Dempsey's a visit during the war years are Thomas N. Cox of Chattanooga and two companions. Veteran of the Signal Corps in the Pacific theater, Cox would sail for home aboard a hospital ship torpedoed en route. He survived the war, retiring years later in Lake Wales, Florida, to the United States Postal Carriers community at Nalcrest.

In 1943, Miss Mildred L. Bunel is working as a conductor on a Long Island Railroad train, here consulting a timetable for a passenger. An advertisement tells us that *Hello, Frisco Hello*—a 1943 romantic musical with Alice Faye, John Payne, Jack Oakie, and Lynn Bari—is playing at the Roxy. Or one might prefer to see Chico Marx and his orchestra.

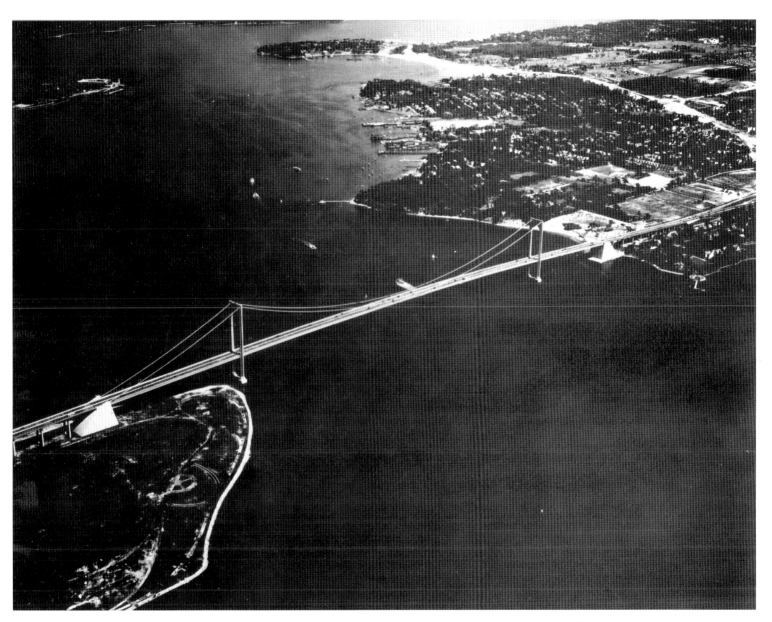

The streamlined Bronx-Whitestone Bridge spans the East River connecting Ferry Point Park in the Bronx with Whitestone in Queens. The sleek Art Deco bridge opened April 29, 1939, in time to provide a direct route from New England to the New York World's Fair. At the time, this bridge was the fourth-longest suspension bridge in the world. When the Tacoma (Washington) Narrows Bridge collapsed in 1940 during a windstorm, engineers rethought the Bronx-Whitestone Bridge, which incorporated the same design concept, and added stiffening trusses.

This appears to be a wartime double-wedding picture. Two newly married couples pose on a rustic wooden bridge in White Plains. One of the bridegrooms wears an Army uniform; the other, a tuxedo. The brides look so much alike that they could be sisters. During World War II, marriages often took place before servicemen were sent overseas, the idea being for soldiers to establish some permanent aspect to their lives before leaving to fight a war.

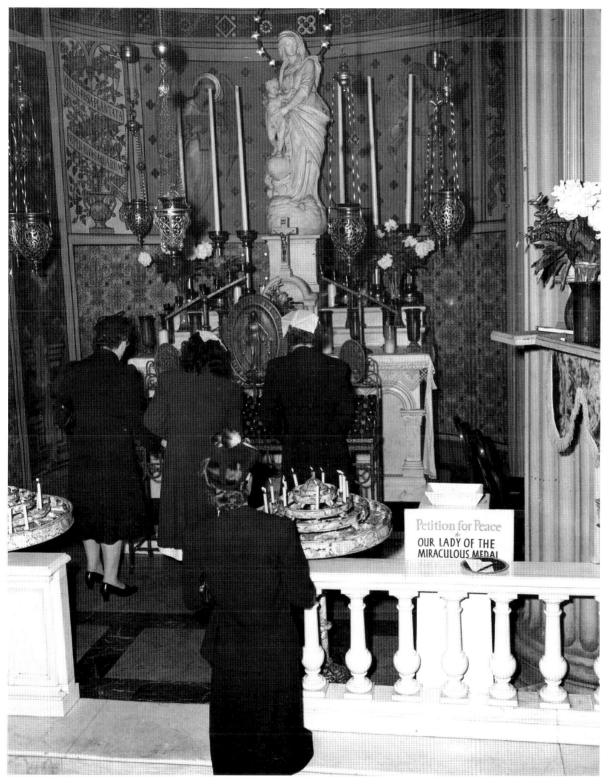

D-Day was the military term for the actual day of the Allied invasion of Normandy, June 6, 1944. A coordinated effort to cross the English Channel and put 130,000 troops on French soil under intense enemy fire, the operation was the largest in the history of humankind. On hearing of the invasion, people thronged to churches to pray for the welfare of the troops. Worshipers here are gathered at St. Vincent de Paul Catholic Church at 123 West 23rd Street in Manhattan. D-Day casualties were high: 1,465 Americans were killed and 6,603 wounded. The invasion would lead to victory in Europe eleven months later.

Petition for Peace
to
OUR LADY OF THE
MIRACULOUS MEDAL

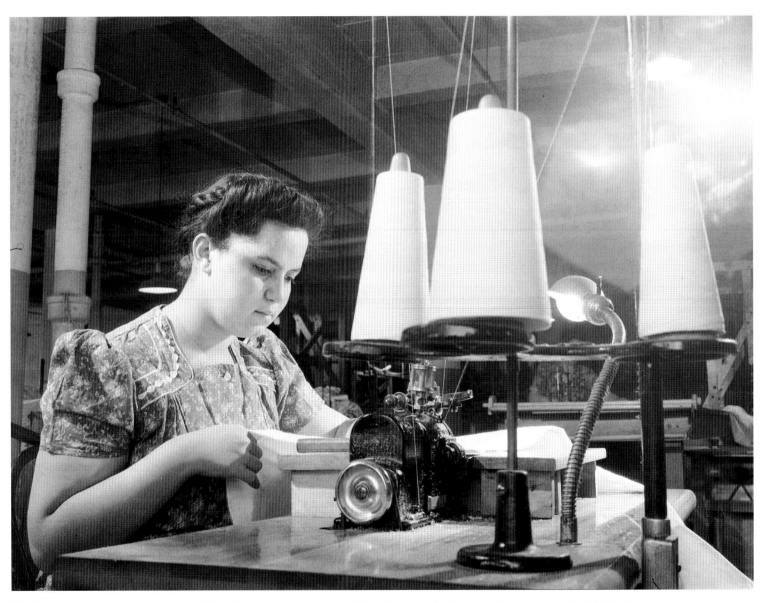

The Lighthouse is incorporated as the New York Association for the Blind. The organization contributed to the World War II effort by manufacturing products ordered by the federal government and fulfilled by blind workshop employees. The Lighthouse also provided services for soldiers newly blinded in the war. In March 1944, Grace Vasques, a vision-impaired worker at the Lighthouse, produces pillowcases at the workshop, 111 East 59th Street in Manhattan.

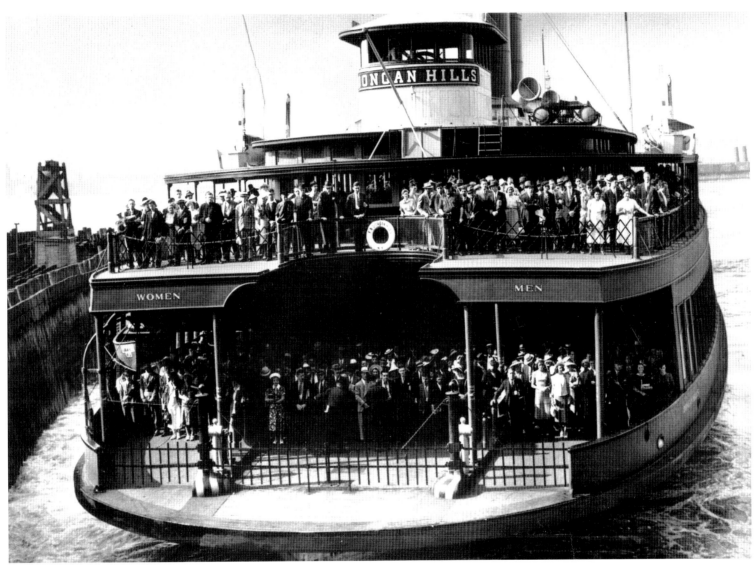

The Staten Island Ferry runs between Staten Island and lower Manhattan. Five ferryboats handle the daily commutes. This is the *Dongan Hills* with a full load of passengers about to dock at a pier in lower Manhattan in 1945. Fifteen years later, in 1960, the *Dongan Hills* would be hit by a Norwegian tanker while making the same Staten Island to Manhattan trip. In 1945, a one-way fare was 5 cents; today, the service is funded through tax dollars and the city does not charge a fare.

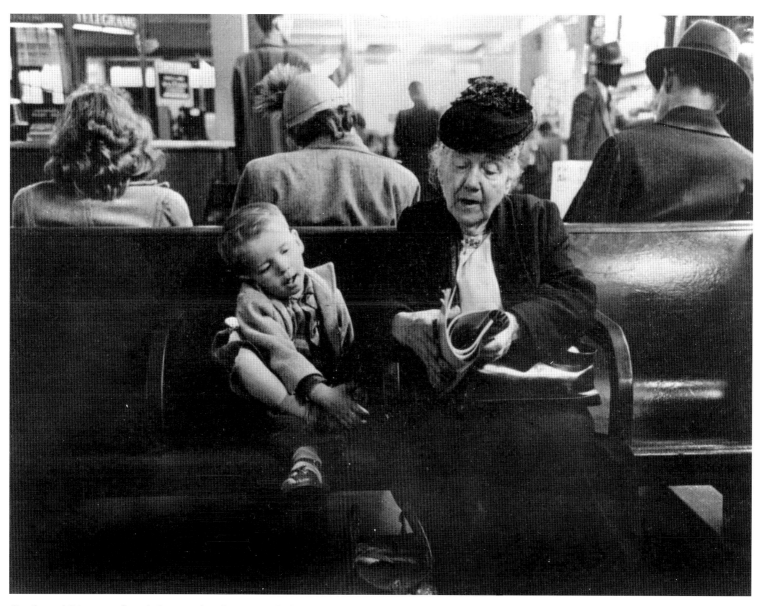

Greyhound Lines was founded in 1914 and operates the largest intercity bus transportation system in America. In New York City, Greyhound's station is at the Port Authority, 625 Eighth Avenue, in Manhattan. In this July 1945 photo, an elderly woman entertains a young boy in the waiting room of the Greyhound Bus Station, while preparing for a bus trip.

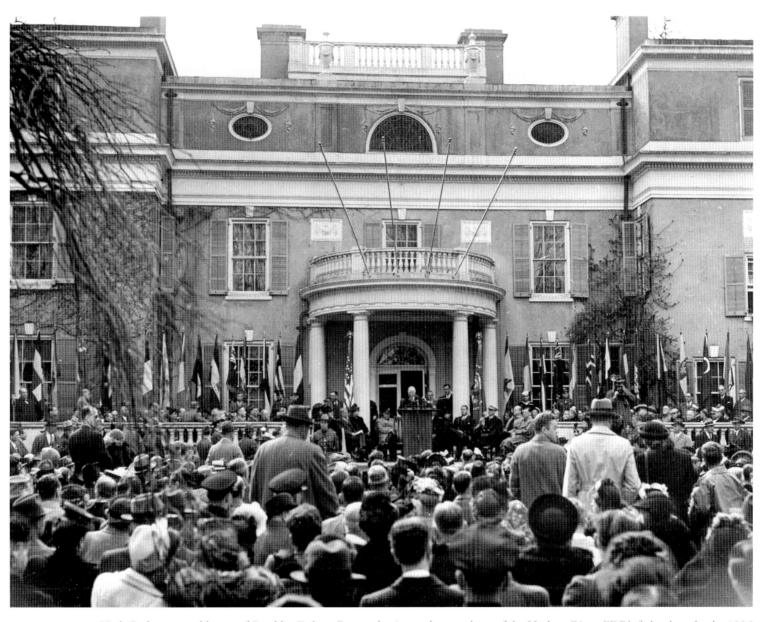

Hyde Park, ancestral home of Franklin Delano Roosevelt, sits on the east shore of the Hudson River. FDR's father bought the 1826 house in 1867, and it was rebuilt and enlarged several times into the Colonial Revival mansion seen here. In 1946, President Harry S. Truman, at the lectern in front of the portico, dedicated the home as a National Historic Site. Some of the thousands who attended the ceremony are seen here. Franklin and Eleanor Roosevelt are buried in the Rose Garden.

The Metropolitan Museum of Art on Fifth Avenue at 82nd Street is gigantic, and the art inside is even more impressive.
Art from every part of the world and every epoch of human creativity is represented. There is so much art, the excess is
housed in storage rooms like the one depicted in this whimsical photograph.

A CHANGING WORLD

(1946–1967)

The Second World War changed everything, not least of which was that it put everybody back to work and ended the Great Depression. After the war, the conversion of factories to peacetime production was led by New York State. One-third of the nation's clothes were manufactured in Manhattan's garment district. The world's largest flour mill, General Mills, produced cereals at its operation in Buffalo. Bethlehem Steel's manufactory in Lackawanna was the fourth-largest steel plant in the world. Carrier, IBM, and Kodak provided production jobs at wages that were 10 percent higher than in the rest of the country. General Electric became one of the largest manufacturing companies anywhere.

The Great White Way was triumphant in the 1940s and 1950s, with Broadway productions of *Brigadoon, Oklahoma, Kiss Me Kate, South Pacific, Guys and Dolls, Wonderful Town, The King and I,* and *My Fair Lady.* Museums across the state and especially in New York City expanded and proliferated, with the most outstanding addition being the Guggenheim Museum, an architectural masterpiece by Frank Lloyd Wright, built on Manhattan's Fifth Avenue in 1960. On the city's west side, President Eisenhower laid the cornerstone for Lincoln Center in 1958.

Built in the 1950s, the 496-mile-long New York State Thruway became the longest toll superhighway system in the United States. The St. Lawrence Seaway, which was completed in 1959, linked the Great Lakes region to global markets.

Although New York experienced industrial, commercial, financial, and artistic success in the postwar years, by the 1960s, social unrest began to unravel these gains. In the big cities, delinquent teenagers "rumbled," and blacks became increasingly isolated and restless in urban ghettos.

Urban renewal was proposed to alleviate these social ills. The most dramatic redevelopment took place in Albany, where a megaproject cleared a neighborhood in downtown Albany adjacent the capitol. More than 9,000 African-Americans lived in the neighborhood and were shunted off to low-income housing elsewhere. In its place, a 100-acre plaza was erected between the massive State Capitol at one end and a comparably huge building housing the state museum, library, and archives at the opposite end. Between them is the plaza with reflecting pools bordered by four 23-story government office buildings on one side, and by the "Egg," housing two theaters, and the 44-story Corning Tower on the other. The whole plaza is linked together by an underground concourse. The Empire State Plaza may be impressive, but it did not solve Albany's social problems, nor did urban renewal in other cities.

Sammy's Bowery Follies in lower Manhattan was a popular nightclub. It was the only Bowery saloon with a cabaret license. Painted portraits of Skid Row barflies decorate the bar. Here in December 1947, a patron takes a nap while the bar's resident cat enjoys a free beer.

The Taft-Hartley Act in 1947 placed new restrictions on unions as well as management in cases where strikes damaged the economy. Unions were prohibited from a list of actions considered "unfair labor practices." But labor could continue to strike, and picket lines were not supposed to be crossed to benefit management during a strike. Here in 1948, at the United Financial Banking Company in New York City, a striking employee jeers at a businessman for crossing the picket line. Two police officers with nightsticks look on dispassionately.

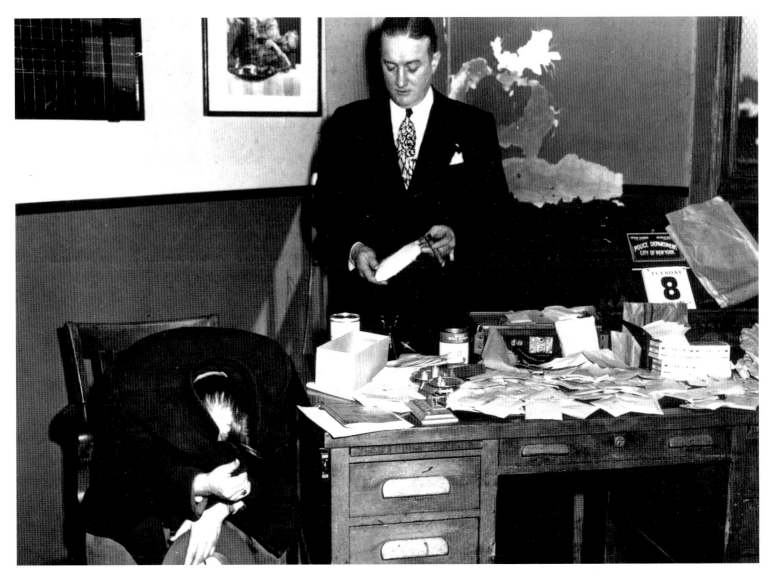

Narcotics—such as opium, heroin, and morphine—were a societal problem in 1949 as much as they are today. Joseph Basile, a drug dealer, has been arrested along with the seizure of $25 million worth of narcotics and hides his face from the photographer with his coat. Standing is Chief of Detectives William T. Whalen of the New York City police department. The desk is cluttered with some of the drugs.

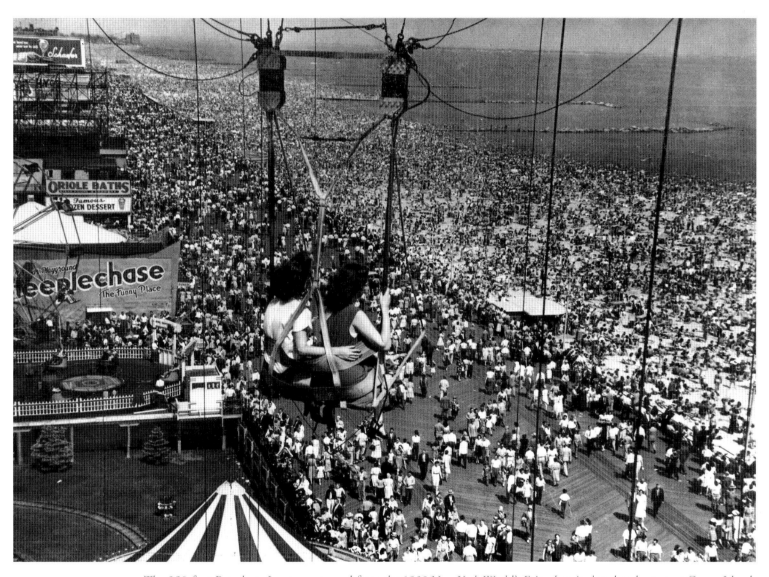

The 250-foot Parachute Jump was moved from the 1939 New York World's Fair when it closed and set up at Coney Island. The 40-cent ride lasts 15 seconds, and the girls are belted in for a thrilling drop, which slows as the parachute fills. The float to earth is vertical with guy wires holding the course, and there are shock absorbers on the ground. On this summer day in 1950, these girls enjoy the view just before the "jump."

The Madison Square Boys Club, founded in 1884, is located at 350 Fifth Avenue. The club provides after-school and summer programs for boys, aged 6 to 18, from poor or dysfunctional families. In decades gone by, a rooftop pool at the club offered these four boys the opportunity to row a boat. Their view was both unusual and spectacular, with the Chrysler Building and other distinctive skyscrapers surrounding the man-made lake.

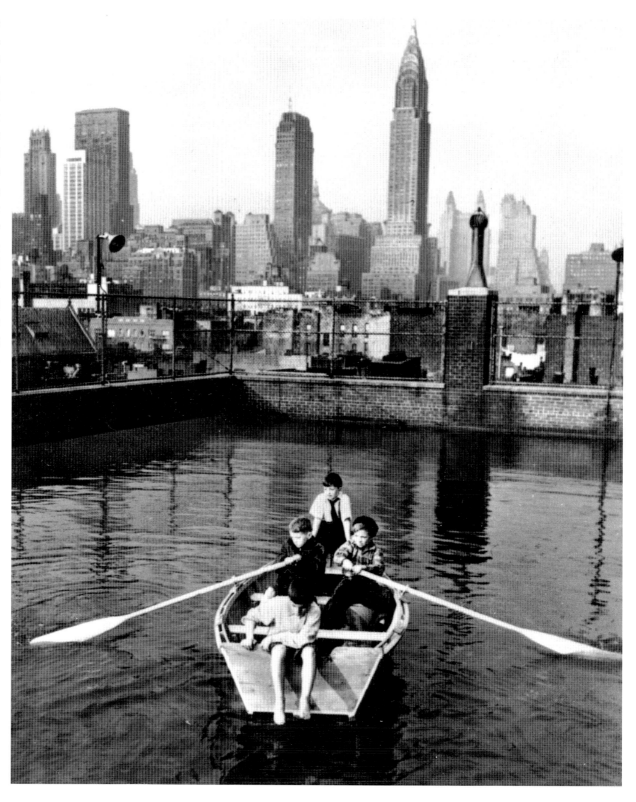

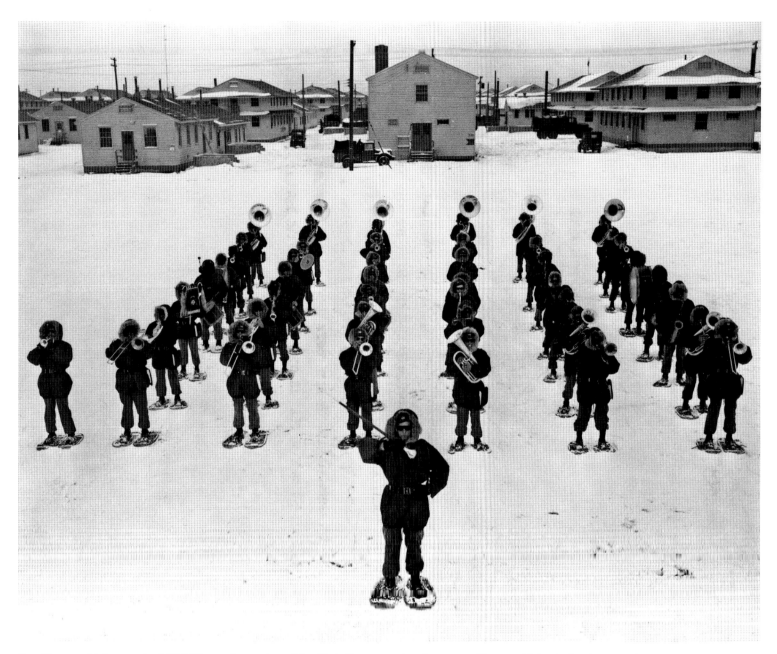

Fort Drum, which occupies 107,265 acres in northern New York State near the picturesque Thousand Islands, has been used for military training since 1908. In this 1953 photo, the U.S. Army's 82nd Airborne Division marching band rehearses in frigid winter weather. The band members wear snowshoes to permit them to march on the snow-covered ground. A large number of the 800 buildings at Fort Drum are seen in the background.

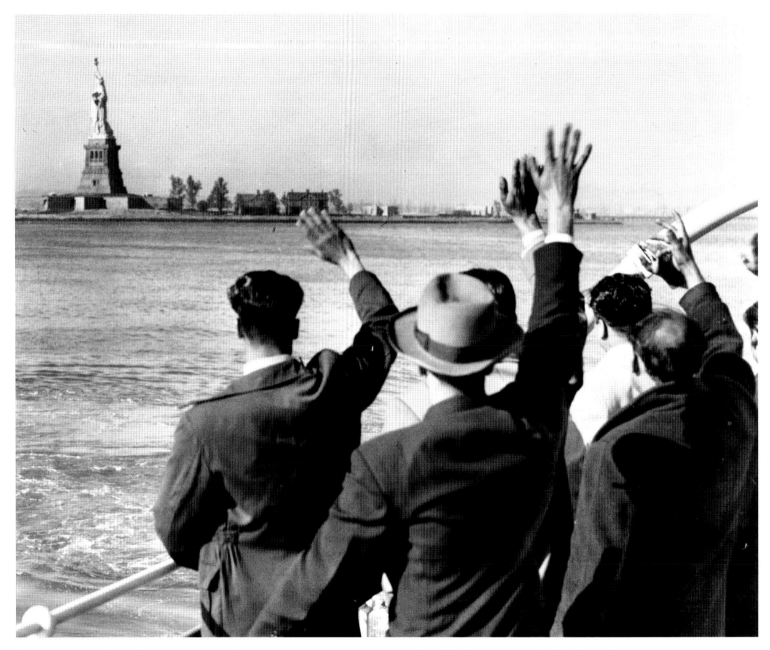

Any alien in the United States is subject to deportation for a number of reasons. The 171 aliens aboard this U.S. Coast Guard cutter arrived in 1952 and got as far as the immigration station on Ellis Island. There they were classified as illegal aliens and deported. They wave good-bye to America after their brief visit, as they are transported to Hoboken, New Jersey, where they will board the Home Lines ship *Argentina* for repatriation.

We're Sorry

But Roy Campanella is ill
not be able to appear

A very disappointed Stephen Cummings, age five, wearing his baseball uniform and carrying his bat and glove, sits on a New York City sidewalk contemplating the cancellation of Roy Campanella's visit. Roy Campanella (1921–1993) was considered one of the greatest catchers in the history of baseball. He played for the Brooklyn Dodgers until his career was cut short after he was paralyzed in an automobile accident in 1958. All is not lost for Stephen Cummings, however. Willie Mays of the New York Giants would pinch-hit for Campanella at this event.

This 1959 photo was taken at the Poplar Street police station in Brooklyn. Four teenage gang members have been arrested for the fatal shooting of a Brooklyn youth. The arresting police officers are Transit Patrolman Ernest Fatoruso and New York City Patrolman Frank Collins. A few years earlier, such grim real-life dramas were raw material for creative expression by two New Yorkers, composer Leonard Bernstein and lyricist Stephen Sondheim, who produced the Broadway musical *West Side Story* in 1957.

In 1882, the U.S. Congress authorized $300,000 to build a federal building in Rochester. In 1886, the masonry work of this massive Richardsonian Romanesque structure was completed to the second floor. The government, in its infinite wisdom, decided to authorize an additional $200,000 for a bigger building, so plans had to be redesigned. In 1978, the building was renovated to become Rochester's City Hall. A west entrance shown here in 1967, replete with fallout-shelter sign, emphasizes the arched entrances and windows and the rusticated Medina sandstone of the Romanesque style.

199

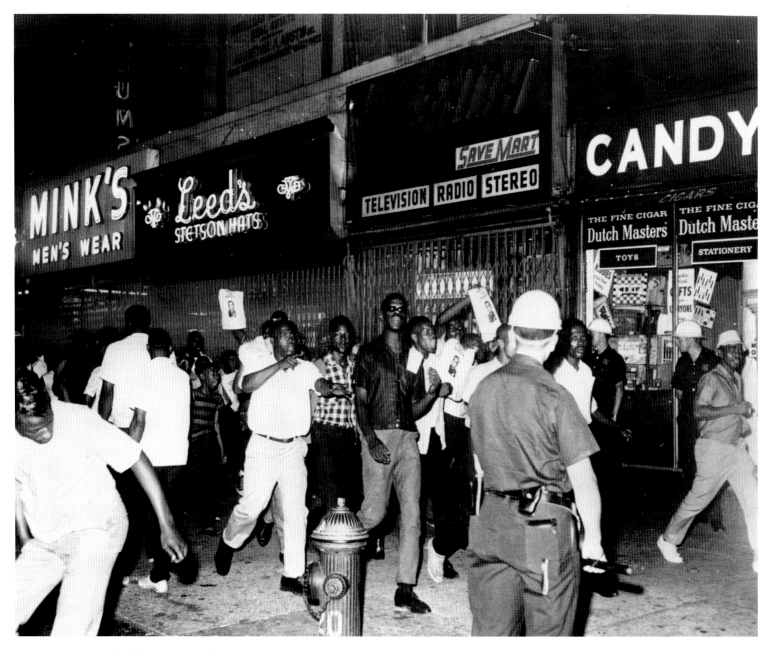

In the 1960s, decades of inner-city strife sparked race riots across America. New York City experienced one of them. In 1964, a riot started in Harlem after a plain-clothes police officer fatally shot a black high-school student, with police brutality and continuing racial inequality cited to justify the uprising. In this photograph, a young crowd chants slurs while surging along 125th Street near Seventh Avenue. The riot lasted six days.

Notes on the Photographs

These notes, listed by page number, attempt to include all aspects known of the photographs. Each of the photographs is identified by the page number, photograph's title or description, photographer and collection, archive, and call or box number when applicable. Although every attempt was made to collect all data, in some cases complete data may have been unavailable due to the age and condition of some of the photographs and records.

II **Lake Placid, 1914**
Library of Congress
pan 6a11584

VI **Niagara Falls, 1911**
Library of Congress
LC-USZ62-93766

X **The Lake, Central Park, 1904**
Library of Congress
LC-USZ62-94238

2 **Accident at Niagara**
Library of Congress
LC-USZC4-4771

3 **Fredricks' Photographic Temple**
National Archives
208-PR-4K-001

4 **Governors Island**
National Archives
111-B-4804

5 **Band of the Eighth, 1861**
Library of Congress
LC-B8184-4545

6 **Lincoln Funeral Procession**
Library of Congress
LC-DIG-stereo-1s01776

7 **Metropolitan Fair**
National Archives
111-B-1937

8 **Nineteenth-century Artist Studio**
National Archives
111-B-2029

9 **Early Visitors to Niagara Falls**
National Archives
111-B-2163

10 **Grand Union Hotel at Saratoga Springs**
Library of Congress
LC-DIG-stereo-1s01726

11 **Irving's Sunnyside**
Library of Congress
LC-DIG-stereo-1s01728

12 **Vassar College, at Poughkeepsie**
Library of Congress
LC-USZ62-97790

14 **Liberty Enlightening the World, 1886**
Library of Congress
LC-USZ62-19869A

15 **Winter Camp in the Adirondacks**
Library of Congress
LC-USZ62-98542

16 **Grant Preparing His Memoirs**
Library of Congress
LC-USZ62-7607

17 **Colonel King's Electromagnet**
National Archives
77-A-12-014

18 **Hoffman House Grand Saloon**
Library of Congress
LC-USZ62-100245

19 **Batavia Train Wreck**
Library of Congress
LC-USZ62-12981

20 **Niagara Falls Frozen**
New York State Archives
NYSA_A3045-78_D47_NiG88

21 **Glens Falls Town Square**
Library of Congress
LC-USZ62-42232

22 **Library Interior at Albany State Capitol**
Library of Congress
LC-DIG-ppmsca-15347

23 **Fifth Avenue Terminal View, 1892**
National Archives
208-PR-4K-002

24 **Thomas Indian School Girls at Table**
New York State Archives
NYSA_A1913-77_B1_F1

25 HERALD SQUARE, 1895
Library of Congress
Library of Congress
LC-USZ62-94716

26 TREE PLANTERS ON THE
NEW YORK CENTRAL
New York State Archives
NYSA-14297-87_1657

27 THE CONFERENCE
HOUSE AT STATEN
ISLAND
Library of Congress
LC-USZ62-64166

28 TUGBOATS AT GRANT'S
TOMB
Library of Congress
LC-USZ62-110717

29 BROADWAY, SARATOGA
SPRINGS, 1890s
New York State Archives
NYSA_A3045-78_D47_SbB

30 AT INSPIRATION POINT,
CATSKILL MOUNTAINS
New York State Archives
NYSA_A3045-78_D47_
CcI3

31 MANHATTAN EL, 1895
Library of Congress
LC-USZ62-96201

32 BATTLE OF JOHNSTOWN
HISTORICAL MARKER
New York State Archives
NYSA_A3045-78_D47_
JhG_full_jpg

33 JOHN BROWN'S GRAVE,
NORTH ELBA
Library of Congress
LC-USZ62-93540

34 HAMBURG STREETCAR
Library of Congress
LC-USZ62-90134

35 ONONDAGA STREET,
SYRACUSE
New York State Archives
NYSA_A3045-78_D47_
SyB8

36 ICE PALACE AT NIAGARA
FALLS
Library of Congress
LC-USZ62-107533

37 OSWEGO LIGHTHOUSE
AND PORT
Library of Congress
LC-D4-12161

38 ROYCROFTERS AT WORK,
1900
Library of Congress
LC-USZ62-90618

39 SCENE AT ROYCROFT
CAMPUS, EAST AURORA
Library of Congress
LC-USZ62-90617

40 LACKAWANNA ORE
WORKS
Library of Congress
LC-USZ62-111697

41 THOMAS INDIAN SCHOOL
BOYS AT HARVEST
New York State Archives
NYSA_A1913-77_B4_103

42 ADIRONDACK OPEN-
SIDED CABIN
Library of Congress
LC-USZ62-135811

43 FISHING BOAT AND
CREW AT PORT
National Archives
22-CG-269

44 HOFFMAN ISLAND
IMMIGRANTS, 1901
Library of Congress
LC-USZ62-124474

45 NEW YORK CITY
DUMBBELL TENEMENTS
National Archives
196-GS-014

46 ROOSEVELT AT THE
ANSLEY WILCOX
HOUSE, 1901
Library of Congress
LC-USZ62-96529

47 EASTER SUNDAY ON
FIFTH AVENUE, 1900
National Archives
30-N-18827

48 TRAFFIC IN THE WILD
National Archives
30-N-49-1481

49 HARLEM RIVER
REGATTA
Library of Congress
LC-USZ62-124583

50 PAN-AMERICAN
EXPOSITION, BUFFALO
Library of Congress
LC-USZ62-112750

51 ANGLER'S PARADISE
Library of Congress
LC-USZ62-98718

52 SMITHTOWN WATERMILL
New York State Archives
NYSA_A3045-78_D47_
SmM

53 THE DAKOTA, NEW
YORK CITY
Library of Congress
LC-USZ62-101590

54 THE PALISADES, 1903
Library of Congress
LC-USZ62-119398

55 ALBANY CITY HALL
New York State Archives
NYSA_A3045-78_Dn_AkH

56 DREAMLAND, CONEY
ISLAND
Library of Congress
LC-uSZ62-116412

57 DREAMLAND, CONEY
ISLAND, NO. 2
Library of Congress
LC-USZ62-115624

58 EYMARD SEMINARY AT
SUFFERN
Library of Congress
LC-DIG-ppmsca-18394

59 THE VANDERBILT CUP
RACES AT HICKSVILLE
Library of Congress
LC-USZ62-111971

60 ERIE CANAL AT
SYRACUSE
Library of Congress
LC-DIG-det-4a12105

61 SILVER BAY AT LAKE
GEORGE
Library of Congress
LC-USZ62-127531

62 BIRD'S-EYE VIEW OF
UTICA
Library of Congress
LC-USZ62-105643

63 USS PLUNGER
Library of Congress
LC-USZ62-89935

64 EMPIRE STATE WINE
COMPANY VAULTS
Library of Congress
LC-USZ62-91921

65 SYLVAN BEACH AT
ONEIDA LAKE, IN THE
FINGER LAKES
Library of Congress
LC-USZ62-116331

66 PROFILE ROCK AT
LITTLE FALLS
National Archives
208-LU-35WW-9032

67 TRINITY CHURCH,
MANHATTAN
National Archives
208-LU-36B-002

68 PORT OF BUFFALO
Library of Congress
LC-USZ62-111698

69 VISITORS AT GOAT
ISLAND, NIAGARA
FALLS
Library of Congress
LC-USZ62-107049

70 STONY BROOK
Library of Congress
LC-USZ62-117344

71 PEEKSKILL TROLLEY
Library of Congress
LC-USZ62-70953

72 FIFTH AVENUE, AT ST.
PATRICK'S CATHEDRAL
National Archives
208-EX-237-001

73 MACY'S
Library of Congress
LC-USZ62-123584

74 MANUFACTURING AT
TROY
Library of Congress
LC-USZ62-96094

75 THE CHAUTAUQUA
ASSEMBLY
Library of Congress
LC-USZ62-115140

76 NEW YORK CITY WIDOW
AND CHILDREN
Library of Congress
LC-DIG-nclc-05349

77 ROCHESTER SNOW
FROLICS
Library of Congress
LC-USZ62-135334

78 MOTORIST
MISADVENTURE
Library of Congress
LC-USZ62-111975

79 NEW YORK TO PARIS
AUTO RACE OF 1908
Library of Congress
LC-DIG-ggbain-00133

80 UNION DEPOT, SARANAC
LAKE
Library of Congress
LC-D4-71219

81 SARANAC LAKE
MIDWINTER CARNIVAL
Library of Congress
LC-D4-36985

82 FARMHOUSE NEAR
HERKIMER
Library of Congress
LC-USZ62-112796

83 SCHENECTADY NEWSIES
Library of Congress
LC-DIG-nclc-03457

84 GREENWOOD LAKE AT
BELLVALE MOUNTAIN
Library of Congress
LC-USZ62-95803

85 BUFFALO VOCATIONAL
SCHOOL CLASS
New York State Archives
NYSA_A4199-78_B1_001

86 COUNTRY LANE NEAR
STONE RIDGE
New York State Archives
30-N-6004

87 YOUNG PATIENT AT SEA
BREEZE HOSPITAL,
BROOKLYN
Library of Congress
LC-USZ62-124114

88 REMINGTON STANDARD
TYPEWRITER PLANT,
1911
New York State Archives
NYSA_A3045-78_8676

89 CRESCENT ATHLETIC
CLUB OF BROOKLYN
Library of Congress
LC USZ62 111277

90 SHOWER BATHS FOR
HORSES
Library of Congress
LC-USZ62-99958

91 LAKE CHAMPLAIN FROM
MOUNT DEFIANCE
New York State Archives
NYSA_A3045-78_764

92 ATWOOD TAKEOFF NEAR
NYACK
Library of Congress
LC-USZ62-100393

93 FIRE AT DREAMLAND
Library of Congress
LC-USZ62-101974

94 SCENE AT JAMAICA,
QUEENS
National Archives
30-N-7747

95 HIPPODROME CHIMP
Library of Congress
LC USZ62 112118

96 WHITEFACE MOUNTAIN
New York State Archives
NYSA_A3045-78_Dn_
AW36

97 HOTEL AUSABLE CHASM
NEAR KEESEVILLE
New York State Archives
NYSA_A3045-78_Dn_Av2

98 NEW YORK CITY
STEVEDORES
National Archives
69-R-1K-002

99 BOY SCOUTS IN THE
BRONX, 1912
Library of Congress
LC-USZ62-107478

100 AT THE RACES,
SARATOGA SPRINGS
Library of Congress
LC-USZ62-120652

101 LONG ISLAND CITY
STEEPLECHASE FOR
BOYS
Library of Congress
LC-USZ62-106479

102 QUAKER RIDGE
RAILROAD STATION AT
NEW ROCHELLE
Library of Congress
LC-USZ62-94026

103 THOUSAND ISLAND
FISHING
New York State Archives
NYSA_A3045-78_A10097

104 HOUDINI IN NEW YORK
HARBOR
Library of Congress
LC-USZ62-66403

105 STATE CAPITOL
ASSEMBLY HALL
Library of Congress
LC-USZ62-95464

106 MANHATTAN SUFFRAGE
DEMONSTRATION
Library of Congress
LC-USZ62-110997

107 THE HELL GATE ARCH
BRIDGE
National Archives
30-N-41-1323

108 ANARCHISTS BERKMAN
AND HARRIS
Library of Congress
LC-USZ62-133028

109 NEWTON'S GARAGE,
LAKE RONKONKOMA
Library of Congress
LC-USZ62-94999

110 BROOKLYN TROLLEY
EXCURSION
Library of Congress
LC-USZ61-663

111 TOYMAKERS AT WORK,
1915
Library of Congress
LC-USZ62-113568

112 CONSTRUCTION OF THE
BRONX RIVER PARKWAY
Library of Congress
HAER NY-327-89

113 TURTLE BAY,
MANHATTAN
Library of Congress
LC-USZ62-137886

114 BARROOM OF THE ARION
SOCIETY CLUB
Library of Congress
LC-USZ62-75570

115 KNITTING INMATES
OF SING SING, AT
OSSINING
Library of Congress
LC-USZ62-98906

116 THE JENNIE MCGRAW
TOWER AT CORNELL
Library of Congress
LC-USZ62-116666

117 THE SENIOR PARLOR AT
VASSAR
Library of Congress
LC-USZ62-100847

118 NYACK'S SOUTH
BROADWAY
Library of Congress
LC-USZ6-2071

120 OFFICERS IN TRAINING
AT PLATTSBURGH, 1917
Library of Congress
LC-DIG-hec-07336

121 PAGEANT REHEARSAL AT
HUNTINGTON
Library of Congress
LC-USZ62-136038

122 FIRST AMBULANCE
COMPANY OF NEW YORK
NATIONAL GUARD
Library of Congress
pan 6a30023

123 TO WALL STREET FOR
WAR BONDS
National Archives
165-WW-240F-001

124 WHITE PLAINS RALLY
Library of Congress
HAER NY-327-96

125 THE LANGLEY NIGHT
BOMBER
Library of Congress
LC-USZ62-100390

126 EAST RIVER
BATTLESHIP ESCORT
National Archives
208-LU-36N-001

127 ACTORS' STRIKE, 1919
Library of Congress
LC-B2-4997-10

128 CAMP RANACHQUA NEAR
NARROWSBURG
Library of Congress
LC-USZ62-130733

129 NATIONAL PARK BANK,
MANHATTAN
Library of Congress
LC-USZ62-124927

130 ELLIS ISLAND FROM THE
HARBOR
Library of Congress
LC-DIG-npcc-00224

131 IMMIGRANTS AT ELLIS
ISLAND, 1923
National Archives
90-G-885

132 ALBANY ALONG THE
HUDSON
Library of Congress
LC-USZ62-113326

133 FIFTH AVENUE, 1921
National Archives
30-N-23555

134 THE STORM KING
HIGHWAY
New York State Archives
NYSA_A3045-78_Dn_
Hu66

135 PARACHUTE JUMP AT
BUFFALO, 1922
Library of Congress
LC-USZ62-99494

136 CONAN DOYLE AND
FAMILY WITH A NEW
YORK VIEW
Library of Congress
LC-USZ62-98125

137 HAVERSTRAW
BRICKMAKER
Library of Congress
LC-USZ62-94329

138 CANAL JUNCTION AT
WATERFORD
New York State Archives
NYSA_A3045-78_Dn_Bc42

139 SNOWS OF THE NEW
YORK PUBLIC LIBRARY
National Archives
306-NT-609K-020

140 COLLISION AT SIDNEY
National Archives
30-N-35-726

141 PORT CHESTER
MANSION, 1927
Library of Congress
LC-G612-T-07295

142 NOW PLAYING AT
WARNERS'
National Archives
208-LU-28N-001

143 MOHAWK RIVER
POWER PLANT NEAR
AMSTERDAM
New York State Archives
NYSA_A3045-78_Dn_M5

144 BROADWAY TICKER-TAPE
PARADE, 1929
National Archives
306-NT-958J-001

145 LEAPFROG IN HARLEM,
1930
National Archives
306-NT-171611

146 CHRIST EPISCOPAL
CHURCH, BINGHAMTON
Library of Congress
HABS NY,4-BING,10-7

147 NEW YORK CITY
SUBWAY CAR, 1933
National Archives
306-NT-671-001

148 ZEPPELIN OVER
MANHATTAN
National Archives
80-G-458713

149 SHEETS TO THE WIND,
1935
National Archives
208-PR-3F-009

150 VANDERBILT'S ROCKY
HILL ROAD
National Archives
30-N-31-1631

151 EMPIRE STATE BUILDING
National Archives
69-RH-4K-001

152 EAST HAMPTON, OF THE
RICH AND FAMOUS
Library of Congress
LC-G39-T-8045-E-002-x

153 THE KINGSTON SENATE
HOUSE
National Archives
208-LU-35XX-004

154 NEW YORK PICK-ME-
UPS, 1932
National Archives
306 NT 172539

155 WOODHOUSE HOUSE AT
EAST HAMPTON
Library of Congress
LC-G612-T01-20220

156 KILLINGS IN NEW YORK
CITY
National Archives
306-NT-168013

157 ALBANY STATE
CAPITOL, 1930s
New York State Archives
NYSA_A3045-78_Dn_AkG

158 SCENE AT SEVENTH
AVENUE, IN MANHATTAN
Library of Congress
LC-DIG-fsa-8a21073

159 UNEMPLOYED SCENE IN
MANHATTAN
Library of Congress
LC-DIG-fsa-8a09276

160 COLLAPSE OF THE
FALLS VIEW BRIDGE
National Archives
208-LU-35WW-1575-00

161 BENEATH THE WEST
SIDE HIGHWAY
National Archives
69-N-ANP-13-P759-070

162 HOMELESS ON EAST
12TH
Library of Congress
LC-DIG-fsa-8a22559

163 RAINY DAY ON THE
WHARF
National Archives
208-EX-236-044

164 COOLING OFF IN
HARLEM
National Archives
69-N-16199

165 TRYLON AND FOUNTAINS
AT 1939 WORLD'S FAIR
Library of Congress
LC-G613-T01-35354

166 ELEVATED RAILWAY AT
SIXTH AVENUE
National Archives
208-EX-236012

167 TWO SINGERS AT
SAMMY'S BAR
Library of Congress
LC-USZ62-100156

168 LONG SHADOWS AT
GRAND CENTRAL
Library of Congress
LC-DIG-fsa-8c33205

169 AERIAL VIEW OF
MANHATTAN, 1942
National Archives
30-N-42-1864

170 ENLISTEES FOR THE
WAR EFFORT
Library of Congress
LC-USW33-000138-ZE

171 INFANTRY AT THE
FLATIRON
Library of Congress
LC-USW33-000137-ZE

172 ON THE GREAT LAWN
Library of Congress
LC-DIG-fsa-8d22221

173 BRIDGE OVER THE
MOOSE AT MCKEEVER
National Archives
30-N-43-1739

174 SUNDAY SERVICE AT
ROCHESTER
Library of Congress
LC-USW3-021724-C

175 MAIN STREET,
SCHENECTADY
Library of Congress
LC-USW3-033719-C

176 ON THE LAKE AT
CENTRAL PARK, 1942
National Archives
208-LU-36R-7862

177 RAILROAD ROSIES
Library of Congress
LC-USZ62-119160

178 ALBANY NEW YORK
STATE EDUCATION
BUILDING
National Archives
208-LU-35XX-003

179 DEMPSEY'S BROADWAY
BAR INTERIOR
Thomas Cox Collection

180 SCENE ABOARD THE
LONG ISLAND LINE
Library of Congress
LC-USW3-034169

181 AERIAL VIEW OF THE
BRONX-WHITESTONE
BRIDGE
National Archives
30-N-43-2100

182 WARTIME WEDDING
Library of Congress
HAER NY-327-114

183 D-DAY PRAYER VIGIL AT
MANHATTAN CHURCH
National Archives
208-LU-36G-001

184 LIGHTHOUSE
PILLOWCASE MAKER
Library of Congress
LC-USW3-041492

185 DONGAN HILLS FERRY,
1945
National Archives
306-FS-135-023

186 WAITING FOR THE
GREYHOUND BUS
National Archives
306-PS-49-14503

187 TRUMAN SPEECH AT
HYDE PARK
National Archives
208-LU-35YY-001

188 STORAGE ROOM
SCULPTURES AT THE
MET
National Archives
306-NT-694H-003

190 BEER CAT AT THE
BOWERY FOLLIES
National Archives
306-NT-945J-002

191 JEERING STRIKER AT
PICKET LINE
National Archives
306-NT-1363-H-001

192 DRUG DEALER IN
CUSTODY, 1949
National Archives
306-NT-1375-002

193 THE CONEY ISLAND
PARACHUTE JUMP
National Archives
306-PS-50-7260

194 ROOFTOP ROWING AT
THE MADISON SQUARE
BOYS CLUB
National Archives
306-NT-953-002

195 FORT DRUM 82ND
AIRBORNE BAND
Library of Congress
LC-USZ62-136653

196 DEPORTATION OF
ILLEGAL ALIENS, 1952
Library of Congress
LC-USZ62-137829

197 CAMPANELLA
CANCELLATION
Library of Congress
LC-DIG-ppmsca-18915

198 BROOKLYN GANG
MEMBERS IN CUSTODY
Library of Congress
LC-USZ62-136366

199 ROCHESTER FEDERAL
BUILDING WEST
ENTRANCE
Library of Congress
HABS NY,28-ROCH,21-3

200 RIOTERS IN HARLEM,
1964
Library of Congress
LC-USZ62-136895